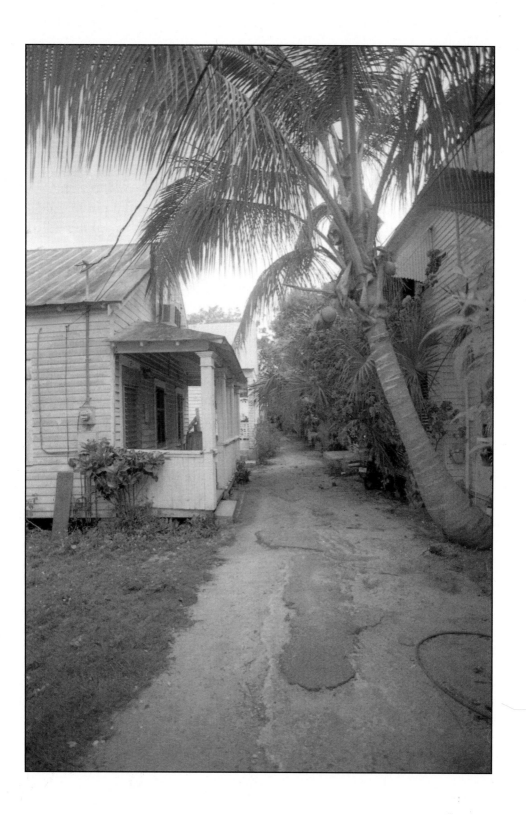

Grits & Grunts

Folkloric Key West

Stetson Kennedy

Pineapple Press, Inc.
Sarasota, Florida

A todos los Cayo Huesanos
que andan por el mundo

Inquiries should be addressed to:

Pineapple Press, Inc.
P.O. Box 3889
Sarasota, Florida 34230

www.pineapplepress.com

Library of Congress Cataloging-in-Publication Data

Kennedy, Stetson.
 Grits and grunts : folkloric Key West / Stetson Kennedy. -- 1st ed.
 p. cm.
 Includes bibliographical references and index.
 ISBN 978-1-56164-419-3 (hardback : alk. paper)
 1. Tales--Florida--Key West. 2. Key West (Fla.)--Folklore. I. Title.
 GR110.F5K46 2008
 398.209759'41--dc22

 2008015616

First Edition
10 9 8 7 6 5 4 3 2 1

Design by Shé Heaton
Printed in the United States of America

Contents

1930s map of The Rock

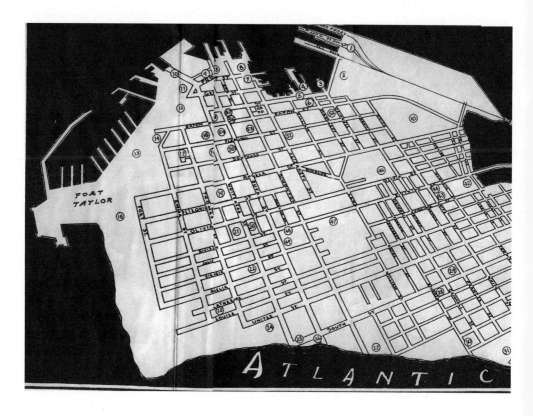

1. Train Ferries and FEC Terminal
2. Model Farm
3. Sponge Docks
4. Turtle Crawls
5. Ice Plant
6. Curios Shop
7. Fish Market
8. Fish Wharf
9. Havana Madrid Club
10. Tropical Aquarium
11. Lighthouse Offices
12. U.S. Naval Stations
13. Mahogany Grove
14. Marine Hospital
15. Sponge Loft
16. County Courthouse
17. "Garden of Roses"
18. Fort Taylor
19. Tropical Grove
20. Hemingway Residence (Private)
21. Key West Lighthouse
22. "Traveler's Palm"
23. Nelson English Park
24. Coral Park
25. Cable House
26. Northernmost House (Private)
27. Coral Isle Casino
28. Natural Rock House
29. Parker Plantation
30. Casa Marina

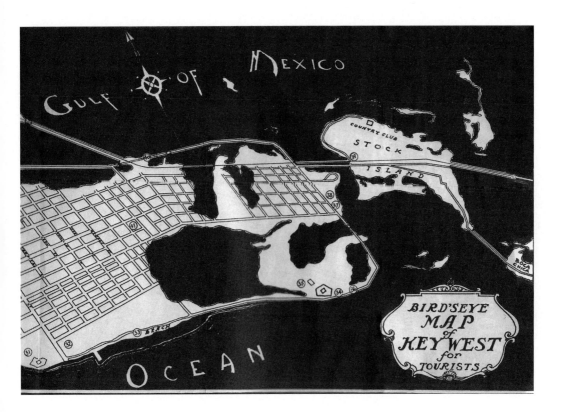

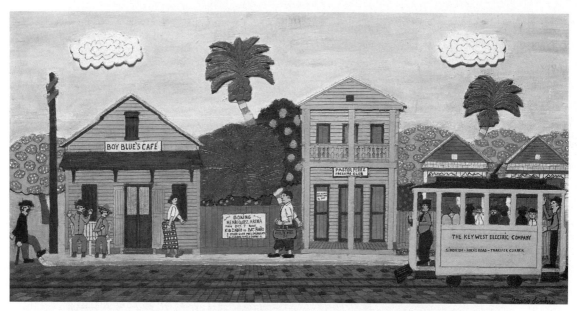

Mario Sanchez portrays here life on Division Street, thus called because it divided the island, north to south, though now it's called Truman Avenue. The Key West electric trolley ran up and down Division.

Folks on The Rock

Like one of Darwin's Galapagos finches, a unique
species of folklife and culture evolved in the splendid isolation
afforded by the Florida Keys archipelago during the nineteenth and
first half of the twentieth centuries.

This string of uplifted coral isles, stretching 108 miles from
the tip of the Florida peninsula to Key West, and beyond through
the Marquesas and Dry Tortugas, was settled in the main by people
representing three disparate cultures: Anglo via the Bahamas,

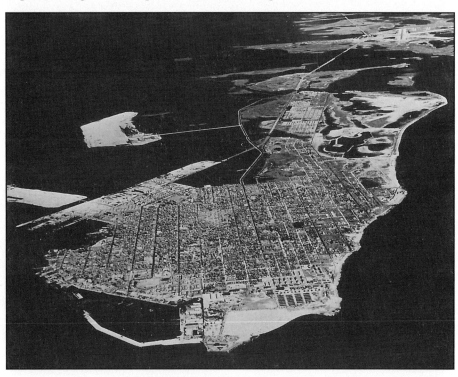

*The Rock, Key West, Cayo Hueso—no matter what you call it, it's one and
the same piece of limestone, three miles wide and five miles long, surrounded
by the Atlantic Ocean on the east and Gulf of Mexico on the west. Here lived
the thirteen thousand–odd people who comprised the community described
in this book.*

1

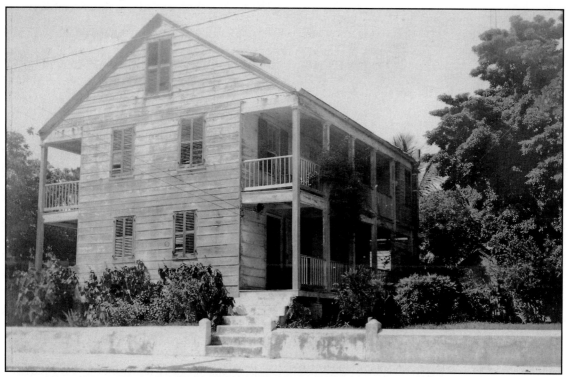

Residential Key West was two-faced—one which looked like this, two-storied Bahama-style homes held together with wooden dowel pins instead of nails . . .

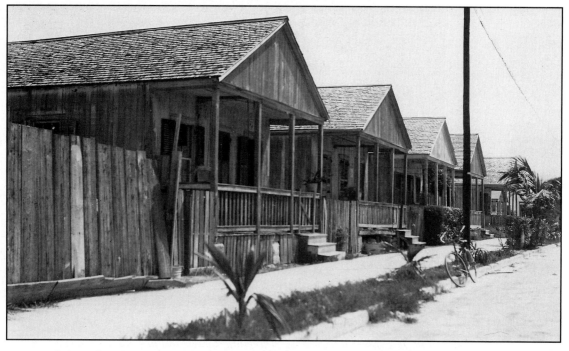

. . . and the other which looked like this—small one-story cottages, most of which were built by the Gato Cigar Factory to house its imported Cuban cigarmakers. Before the FERA Feds took over the island in 1935, you could turn almost any corner in Key West, and this is what you would see—unpainted silver-gray wooden structures, which salt air, sun, wind, and rain had given a satinlike patina on which you could write your name with a fingertip.

Hispanic via Cuba, Afro from both of those islands, and a bit of Anglo and Afro from the American mainland as well.

Given its geographic dimensions—Key West being just three miles by five—separatism was a physical impossibility. Intimate coexistence and shared environment, resources, and experiences were all dictated by the circumstances, so "togetherness" was a must. Everybody knew everybody, by sight if not by nickname. It was this combination of factors, especially during the long period when the only communication was by sea, that gave rise to a distinct Florida Keys culture.

In those halcyon days Key West, in its splendid isolation, was Mother Nature's social laboratory, in which she demonstrated that different peoples could not only get along, but also share diverse cultures and actually enjoy one another's company.

This is not to say that there was never any friction or conflict. To begin with, Key West was very much a Jim Crow town. The Ku Klux Klan, composed entirely of Anglos—never a Latino—was very much in evidence. Even so, Ellen Welters Sanchez, born in 1902 and interviewed in 1982 by Christopher Cox for his excellent book *A Key West Companion*, had this to say:

"Key West was wonderful when I was a girl. It was the manner in which we lived. Everybody had a feeling for each other. . . . There

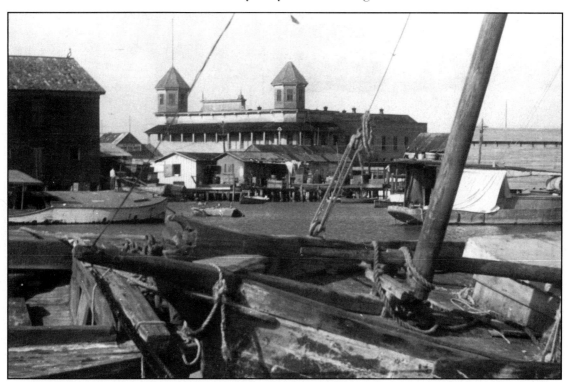

In 1940, the Key West waterfront, like the street fronts, was looking beat-up, unpainted, and picturesque.

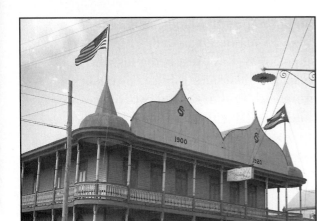

The Cuban Club, or Sociedad Cuba, built in 1900 and burned in 1981, was for generations the focal point of the Latin community's social life. Here the menfolk played dominoes until all hours and Grand Balls were held on weekends, with all maidens duly chaperoned.

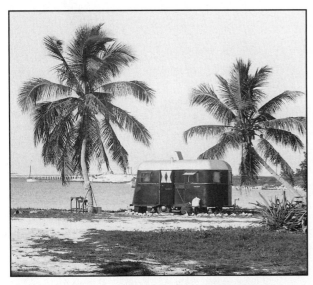

Time was (up until World War II) when living room in Key West and the Keys was not just a prerogative of the rich. You could pull your travel trailer over to one side or the other of the Overseas Highway and live it up without answering to anyone. And you could purchase an outlying Key for a few hundred bucks in back taxes.

were no problems. Where I was born, over on Smith Street, it was white and black on the block—judges, lawyers, doctors all lived down there among us. All their children and we sang together, danced together; we didn't know any differences. I have some of those friends now. When they meet me, they be glad to see me. It makes you feel so good. They feel good and I feel good."

There was a tendency for the Conchs, being Anglo-Saxon and English-speaking, to fancy that they were a cut above the darker-skinned and Spanish-speaking Cubans. But then, as intellectual, literary, and artistic figures in the Cuban community began to assert themselves, any pretence of Conch superiority was hard put to defend itself. Happily, in short order intermarriage rendered the question moot.

There was a time, however, when there was a tangible border between the area known as Conchtown and the Cuban sector known as Gato's Village. One segment of that boundary came to be known as Hell Street because of the rock-throwing melees that took place between Conch and Cubano youth. Large crates were used as fortresses, and Concos even trained their dogs to recognize and attack Cubans, and vice versa.

By far the most densely populated of the islands, Key West has always set the tone, for better or worse, for folks on the other Keys. To establish residence anywhere between Florida City on the mainland and Key West was "going back to nature" in

the absence of the amenities of "civilization." Key West, on the
other hand, by virtue of being a deep-water maritime port and
strategically located naval base (not to mention its earlier status
as a world capital of shipwreck salvage and auction) has always
manifested a pronounced cosmopolitan flavor.

Key West's status as a cultural oasis (second only to New
Orleans) in the feudal South was markedly enhanced during the
latter quarter of the nineteenth century by the coming from Havana
of the hand-rolled-cigar industry. Besides making Key West the
largest city in Florida, and most affluent per capita in the U.S., the
industry brought with it a certain erudition not to be found among
the workers in other Southern industries.

The Cuban cigarmakers hired *lectores* to sit upon a platform
and read to them all day—not only newspapers, but also the
classics such as those of Cervantes, Hugo, and Tolstoy. In addition,
they brought in opera, theatre, and dance troupes from Europe and
Latin America. As folk lives went, theirs was urban, not rural, and
sophisticated rather than provincial.

For decades *comparzas* embellished the Key West cultural
scene. This colorful street dance is said to have evolved in Cuba,
based on the manner in which slaves, being bound together with
a long leg chain, were obliged to kick their bound legs in unison

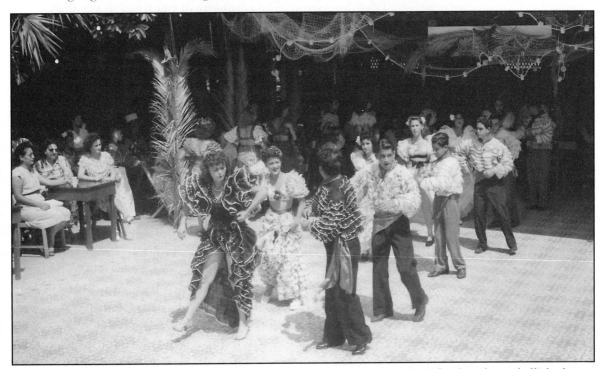

*Abelardo Boza, founder and director of the comparza dance group which for decades embellished
the Key West cultural scene, is shown in foreground with his wife, during a performance at the
Havana Madrid Club. The dancer on his right is Edith Aguilar Ogden, wife of the author.*

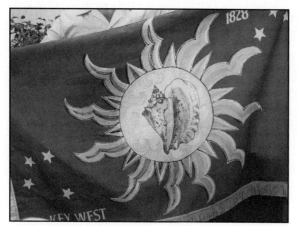

Periodically peeved at something Uncle Sam is or is not doing, Key Westers are in the habit of "seceding" from the Union and proclaiming a Conch Republic. This flag, featuring a conch rampant against a blazing sun, was hoisted in 1982.

as they were marched from one place to another. Abelardo Boza founded and directed a *comparza* dance group that performed regularly at the Havana Madrid Club on Front Street. In the 1940s *comparzas* enlivened street dances and public celebrations. By 1988 the *comparza* was on its last legs. Boza complained that "the remaining Cuban girls aren't interested, and the Concos can't move their hips right, no matter how hard they try."

In the relatively free-for-all cultural give-and-take that occurred on The Rock, there was some tendency for one culture to predominate in certain areas of folklife, and others in others. In time the sense of common identity that came to embrace all the peoples on the Keys found expression in their adoption of the appellation "Conch." Today, after seven years' residence in Key West, one becomes a "freshwater conch."

Originally a title proudly worn by Anglo-Bahamians, it came to be a generic label for any and all residents of the Keys, regardless of race or culture of origin. No comparable degree of common identity has ever been achieved on the Florida mainland, where the appellation "Cracker" continues to be reserved "for whites only."

Conch identity, on the other hand, has reached such a stage that whenever Tallahassee or Washington promulgates something distasteful to Keys folk, they threaten to secede and form a "Conch Republic." This predilection for self-government goes way back, even unto 1821 when Florida became a territory of the United States and Key Westers decided to designate their head man not "Mayor" but "President."

Although Key West cannot claim to have lived under eight flags like its coastal counterpart Fernandina at the northern end of the state, it has seen flags enough, including the skull-and-crossbones emblem of pirates, known as the Jolly Roger. Key Westers like to tell how, during the Civil War when The Rock remained in Union hands, Caroline Lowe periodically unfurled the Stars and Bars of the Confederacy from the balcony of her home at Duval and Caroline Streets. It always disappeared before irate Union soldiers could climb the stairs, and it was not until after the war that its hiding place—a hollowed-out rail—was discovered.

During that war any number of Conchs became engaged in

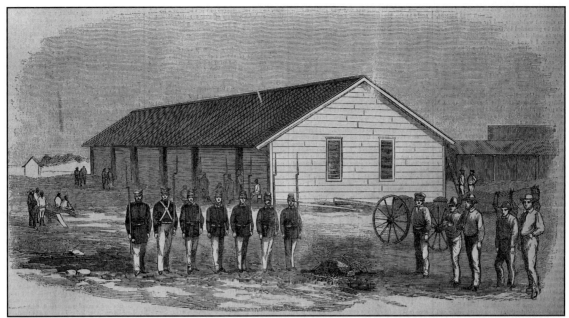

"Barracoon" built by Key Westers to house the slaves "rescued" at sea from an illicit slave smuggler. Hundreds died here while waiting to be shipped back to Africa and hundreds more died on the way.

smuggling goods to the Confederacy through the Union blockade. On one occasion when a boatload of blockade-runners was halted out in the Gulf Stream by a Union gunboat demanding to know their nationality, the men on board hoisted a conch shell on an oar and replied "Conch." The Navy men, not being well versed on the nations in the Caribbean, let it pass.

A great deal of acculturation had already taken place between Africans and their "host" cultures prior to arrival on the Keys, and the process continued despite the constraints of the legally and extra-legally imposed system of racial segregation which was part and parcel of the process of "Americanization" throughout the South. Needless to say, during slave days the status of both the slaves and free blacks was very different from that of anyone else. Abolition of the slave trade prompted legislation prohibiting free blacks to enter and settle down in Florida. Some Key Westers had some misgivings about this "Free Negro Act."

Justice of the Peace Richard Fitzpatrick, for example, was highly indignant, and brought a court case in which he argued, "The [Florida Territorial] Legislature could not have intended to say, that a free person of colour in traveling from New York to Louisiana, shall not pass along the publick roads of Florida, or if he did, should be taken up and confined in jail until it was convenient to the arresting officer to send him out of the Territory; nor could they have intended to say that a vessel passing on a voyage from

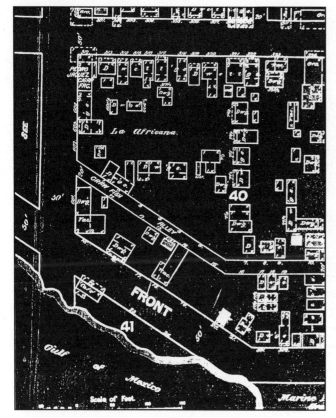

La Africana was a catch-basin on Front Street across from the Marine Hospital, where runaway slaves, slaves rescued from slave ships, free persons of color who put into port as hands on merchant ships, and slaves freed by the Emancipation Proclamation—as well as a few Cuban émigrés— were consigned during the latter half of the nineteenth century. A latter-day tourist book describing La Africana says, "Businesses thrived there and residents lived harmoniously in this close-knit community. White residents living in the vicinity were not intimidated by the presence of their colorful neighbors."

New York to New Orleans, with a crew of free colour'd persons on board, shall not stop at Key West or St. Marks to repair damages after a gale of wind, without incurring the liability of having those crews seized and sent to jail." In a later decision, the judge held that a free black who had been a resident of Florida prior to enactment of the law could leave the state and return without running any risk of deportation.

Evidently not satisfied with such interpretations, the City Fathers of Key West adopted Black Codes of their own. An ordinance of 1847 made it unlawful for any ship's captain to bring any free blacks or mulattoes into Key West, and an 1854 refinement provided that if a ship having free blacks among its crew was driven into Key West by storm or other such exigency, the captain would not be punished, but the blacks would have to remain on board, or at least not venture off the wharf.

A curfew bell was rung each night at nine o'clock. Blacks away from their homes at the sound of the bell were allowed a half-hour in which to get where they belonged. After that, any white person could seize them and take them off to prison, the penalty being a fine of $2, or up to thirty-nine lashes, at the discretion of the mayor. Exemptions were allowed if the colored person was accompanied by some white, or had a note attesting that they were on some errand on behalf of owner or employer.

The curfew also forbade any colored person to "beat a drum, or play upon a tambourine, or violin, or any musical instrument or any thing whatever, by which the peace and quiet of the citizens may be disturbed." This taboo went into effect at the sound of the bell. The edict went on that colored persons "shall not assemble

The Flat-Foot Floogies. This barefoot ensemble of foot-slapping dancers appeared spontaneously outside of Hemingway's house during World War II, dancing to a hit tune of the day, "Flat-Foot Floogies with a Floy-Floy."

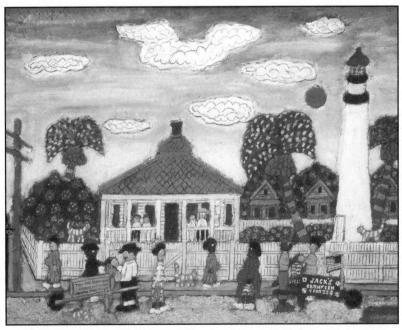

Mario Sanchez called this "Protein for the Hot Women," as you will note that the vendors are selling fish and all the women here are pregnant. But also note that the scene on this Key West street is racially mixed (except for the cats, which are all orange in the original).

together . . . for the purpose of dancing, singing, praying or for any other purpose whatever, without first obtaining the written permission of the Mayor or of some member of the Corporation (township)."

During 1860 on the eve of the Civil War U.S. gunboats brought into Key West a total of 1,432 slaves who were found aboard a slave ship. Key Westers hastily constructed a frame "barracoon" (temporary slave barracks) 225 feet long and 25 feet wide on Whitehead Point. While housed there, 294 slaves died and were buried in a trench on the beach. The survivors were turned over to the American Colonization Society for "repatriation" to Liberia.

Without waiting for Lincoln to issue his Emancipation Proclamation, the Union commander in Key West, a Colonel Morgan, proclaimed in 1862 that thenceforth he was going to pay wages to the forty-odd slaves he had leased from their Key West owners to work on the construction of Fort Taylor. Prior thereto, the U.S. had paid the slave owners a total of $1,200 per month for their collective labors.

In both the Bahamas and Cuba the "color line" was far more flexible than in America, and more a matter of societal practice than anything else. Segregation imposed by law was something entirely new to the immigrants who came to the Keys from those islands. And, of course, much more than segregation was involved. The system of white supremacy that prevailed throughout the South, the Keys included, imposed gross discrimination against blacks in the educational, vocational, political, and social spheres.

The newcomers to the Keys sorted themselves out racially with such grace as they could muster, and there were few if any instances of the laws being invoked to diagnose anyone's racial identity. A notable exception to this came in 1889, when circuit judge James Dean, a black who had finished first in his law class at Howard University, was defrocked by the governor of Florida for having married a white man and a black woman. The man in the case insisted that he was half black, although he looked white. Dean appealed to the U.S. Supreme Court, but his dismissal was upheld, and he died a pauper in Jacksonville.

Despite some juggling for status, the white community, where the Bahamian, Cuban, and American cultures coexisted, experienced a more or less egalitarian relationship with one another. Blacks, whether their cultural background was Bahamian, Cuban, or American, were compressed into a "colored town" on the southeastern end of Key West, on the west side of Whitehead Street, resulting in what might be described as compulsory acculturation.

There was some division along occupational lines, but these

were not rigid and no absolute monopolies existed. Sponging was
predominantly Bahamian, and cigarmaking predominantly Cuban.
But when it came to rumrunning and alien smuggling, everybody
got a piece of the action.

As to all the various elements that go to make up folklife and
culture, everyone kept what they wanted and borrowed what they
wanted. Since the Bahamians shared with Americans the heritage
of language and such hand-me-downs as "London Bridge," they
felt that, unlike the Cubans, they didn't need any Americanization.
So, they clung to their out-island Bahamian dialect.

Cubans, especially those attending school at the Convent of
Mary Immaculate, run by French Canadians, learned mainstream
English. Although Spanish was discouraged (by whipping) on
Key West's public school grounds, it was as prevalent as English
everywhere else. The Rock became a bilingual community par
excellence.

Not until 1989 did dominant "good ol' boys" in the Florida
Legislature in its Panhandle wisdom enact an "English only"
official language statute. The rash of such jingoistic laws is
ironic at best in a land where the merits of diversity are touted
almost everywhere. The effect of such ill-conceived attempts at
cultural hegemony has always been cultural dissonance. Whether

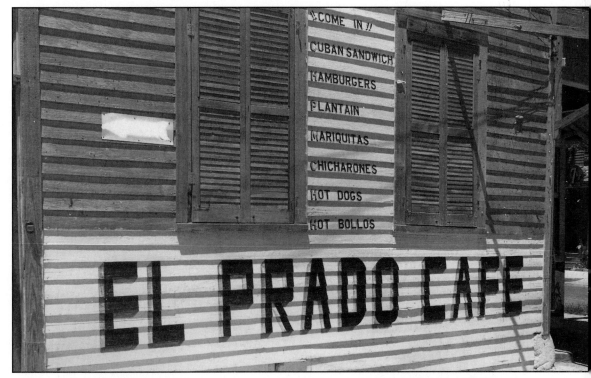

*Hot dogs and burgers, yes. But you haven't lived until you've tried such traditional Key West
goodies as platanos, mariquitas, chicharones, and bollitos.*

undertaken in Spain, France, Britain, America, or elsewhere, the establishment of an official language, like official religion, has ever been a harbinger of oppression and strife. In Florida's case the resulting cultural dissonance was exemplified the very next day after the law was passed. A silver-haired lady of Cuban descent, tending her *bodega* in Key West, was asked in Spanish by an obviously Anglo customer whether she had any ripe plantains for sale. Almost fainting for fear that a government agent was seeking to entrap her, she finally managed to whisper in English, "We aren't allowed to speak that language anymore."

It is a striking and significant fact that on The Rock the blacks who had Bahamian or Cuban backgrounds had been able to conserve far more of their African cultures than those coming from the American mainland. One such survival is the practice of black magic and the casting and uncasting of spells, which the Bahamians refer to as "obeah," the Cubans as "brujeria," and the Americans as "voodoo." One practitioner, "Chucker" Edwards, quoted in the *Key West Citizen* on the eve of World War II, boasted that he had a mojo idol that was "so tough it ate steel wool for breakfast."

But while the black African beat was to be heard, with infinite variation, in the musical idioms of all three groups, in the culinary realm it was the Creole Cuban cuisine that captured the island. Everybody on The Rock, whether Cuban, Bahamian, Afro,

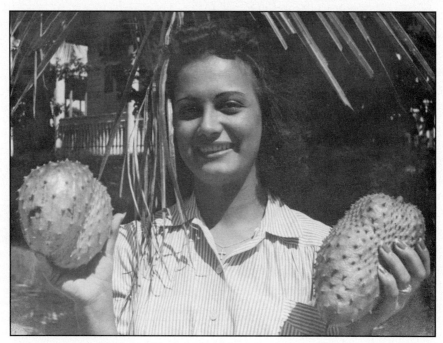

Author's wife Edith, with a tropical fruit known as soursop, Key West, 1938.

Cracker, or Yankee, was hooked on Cuban bread, Cuban sandwiches, Cuban coffee, yellow rice, black beans, garbanzo soup, paella, and, for dessert, flan (caramelized egg custard) or guava shells with cream cheese. If an after-dinner demitasse is served, it might as well have a splash of Bacardi.

Among snacks, too, it is the Cuban *bollos calientes* (hot balls) that dominated the Key West scene. Made of black-eyed pea meal and heavily seasoned with garlic and black pepper, then fried in olive oil, the *bollo*

These young entrepreneurs are peddling Spanish limes— which are not limes or any other kind of citrus, but a tropical fruit with one large seed and a bit of aromatic pulp.

is a cousin of the Cracker hush-puppy and the Arabic falafel. The aroma of their cooking once wafted over the entire island. The trade winds never smelled so good!

The Bahamian Conchs still fondly remember their traditional pigeon peas, rice, and loggerhead fin, but with sea turtles on the endangered species list (and even before that) they are as happy with the Cuban chicken and rice as anybody else.

Whatever their respective backgrounds, Key Westers know just what to do with such tubers as malanga and yucca and with such fruits as anon, soursop (guanabana), Spanish limes (mamoncillo), tamarind, papaya, sugar apple, and mango. For the former (boiled, sliced, and served cold like a potato salad), there is a bottled mojo dressing consisting in the main of liquefied garlic; and for the latter, recipes for both beverages and sherbets.

One cherished recipe is to Key West what the sazerac is to New Orleans. All you have to do is insert a jigger or two of rum into a coconut and then leave it out in the sun until it boils over. Another cross-cultural Key West concoction, a bit more complex, is *compuesta*, which calls for pouring anisette over rock sugar crystals and a twist of orange peel, and stirring with a stick of cinnamon.

A Conch contribution to the *lingua franca* to be heard on The Rock was "sour-belly"—which everyone understood to mean the red table wine that you could buy for fifty cents a gallon if you took your own glass jug to be filled. On the other hand, everyone took to

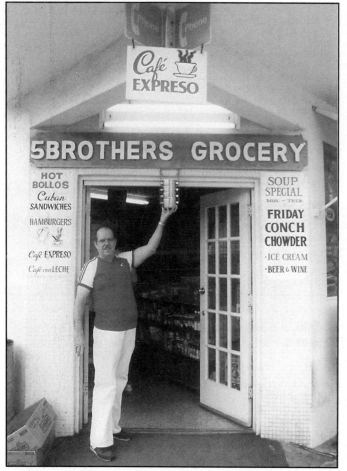

The cantina *was another of the venerable Spanish institutions that came to Key West via Cuba, put down roots, and flourishes to this day. One of the brothers is displaying a real five-tiered tin* cantina, *assuring a five-course meal with no mixing of sauces.*

the Cuban idea of the *cantina,* which often provided nothing but take-outs. Anytime you didn't feel like cooking, or eating out, all you had to do was send someone in the family to the *cantina,* where black beans and yellow rice could always be had, plus several *platos del dia.* If you didn't own a four-tiered tin *cantina,* you simply took a pot.

Another shared culinary institution on the Keys, no doubt of Bahamian origin since it is known to all as "sour," is a Coke bottle full of pure Key Lime juice, preserved with a teaspoon of salt. A bottle of sour was *de rigeur* on every table, whether household or café, like tomato ketchup on the mainland. You shake it on just about everything—salads (especially conch), fish, meats, soups, etc.

Sour is definitely a survivor, but many another tradition lives only in memory—such as the "walking dairy," the custom of milking from cows that were walked from door to door. Also not forgotten are the loaves of hot Cuban bread left on one's doorstep each morning and Brazo Fuerte (Strong Arm) coffee, dark-roasted over a buttonwood fire.

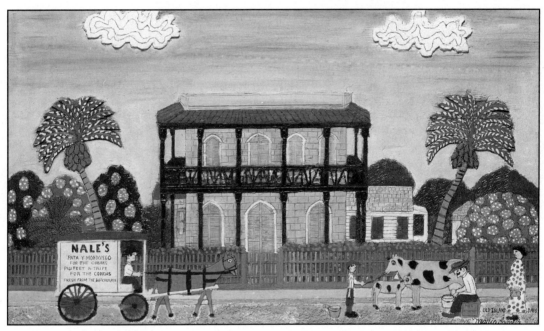

In this Mario Sanchez portrayal called "Old Island Days No. 33," the man to the right is milking the cow for immediate delivery of what his box says is "Milk on the Hoof."

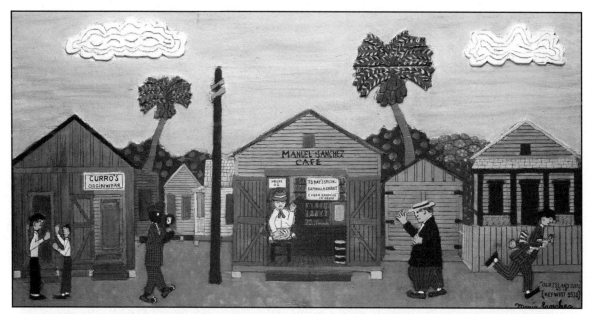

In the Depression days of the '30s, no one had much money. At the Manuel Sanchez Cafe, owned by Mario's uncle and shown here in the middle, "No Credit" was the motto, though occasionally friends were exempted. The man on the right was known as Kill'em Gray, the Chicken Thief.

Anything for a Living

The story of Key West, ever since whites and blacks displaced the natives, might well be told in terms of what its inhabitants have done for a living, namely: pirating, wrecking, fishing, turtling, sponging, rumrunning, cigarmaking, defense, and tourism.

Occupations, at all times and places, have always been a major determinant of lifestyles and cultures, and Key West has been no exception. In fact, whenever its occupations changed, whether for natural or man-made reasons, Key West changed.

One by one, these ways of making a living have come and gone, and today little remains but tourism. Globally, tourism has sometimes proven to be a blessing for the inhabitants, and sometimes even for the environment. But in the case of Key West, it has been devastating for both, leaving only the financially independent, pleasure-seeking newcomers happy. But let us save that for last and begin by taking a look back at some of the things that Key Westers did for a living in the past.

Brethren of the Coast

Original natives used the Keys as a fishing ground and point of departure for trade by canoe with Cuba. But when the Spaniards struck gold in Central and South America and started shipping it back to Spain by way of the Florida coast, pirates of many nationalities began to lie in wait for treasure ships.

When the United States "purchased" Florida for $5,000,000 in 1819, it dispatched Commodore David Porter, who had helped rid the Mediterranean's Barbary Coast of pirates, to set sail for Key West with orders to drive the "Brethren of the Coast" out of the Florida Keys. This was to be no easy task—there had been three thousand acts of piracy reported during the preceding six years.

At first he had no luck—his frigates could not pursue the shallow-draft vessels of the pirates in the shoal waters of the Keys. So he sent his frigates back north and brought in five twenty-oar barges, which he proceeded to name *Mosquito, Gallinipper, Midge,*

Gnat, and *Sandfly* in honor of the flying insects which made the lives of his men miserable. His task force had no impact whatever upon the biting bugs, but by 1830 he was able to report that the last of the pirates had been routed from Keys waters. Whether killed, captured, or routed, many of the brethren left buried treasure behind, as evidenced by findings through the years.

Wrecking

Ever since Europeans came to pillage the New World and ship the booty back to the Old, the Florida Keys, lying as they do athwart the Gulf Stream, were a major focal point of wrecks and wrecking. Running northward from ten to forty miles off Florida's Atlantic coast, the Stream is utilized by northbound traffic, while vessels headed south steer what was once a perilous course between the Stream and the coast. Regardless of whither bound, vessels encountering Big Blows were susceptible to being blown off course and onto the reefs.

Wrecking—salvaging goods from the wrecked ships—got to be a big thing in the Bahamas during the eighteenth century, and many of its practitioners moved their base of operations to the Florida Keys during the early part of the nineteenth century. Wreckers based on the Keys, as well as many operating out of the Bahamas and other islands of the Caribbean, were in large measure accustomed to take their prizes to Havana or Nassau for adjudication and auction.

In 1826 the U.S. government, with a view to stemming this lucrative outflow, ruled that thenceforth all salvage from any vessel wrecked in U.S. territorial waters had to be taken to an

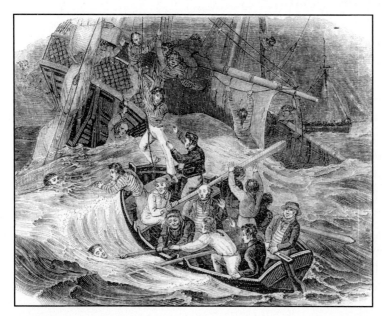

Of course the wreckers' first order of business was to save the crew. Only then could they turn their atttention to the cargo.

American port. This promptly put Key West on the map in a big way. While some of the salvaged merchandise made its way to St. Augustine, Savannah, and Charleston, the bulk was soon devolving upon Key West, which was closer to the action.

Under the laws of salvage, the first skipper of a wrecking vessel to get a line aboard a wrecked vessel was declared to be the wrecking master of that particular operation, and thus entitled to the lion's share of whatever salvage fee the court might allow. Other crews taking part were cut in, somewhat in proportion to their contribution to the task. The salvage fees were paid first out of the proceeds of the auctions, the remainder going to the original owners or insurers. The Key West court customarily awarded from one-third to one-half of the proceeds of sales and auctions to go to the salvor. True or false, rumor had it that a solitary wrecking master had best keep one eye behind his back, for fear of being knocked overboard by the runner-up.

If any of these Florida Keys wreckers were ever guilty of deliberately luring ships onto reefs, such was never proven. There was no denying that, in sallying forth into the teeth of gales in shoal waters they risked and sometimes lost their lives, while saving many others. Wrecking was, in short, an honorable profession in many ways and extolled as such in popular journals of the times.

Maritime traffic through the Florida straits was heavy. In the early 1830s there was an average of some 250 to 320 American vessels, and ten to twenty of foreign registry, putting into Key West. A partial roster of wrecked ships whose salvage was brought into Key West during the year 1831 gives some idea of the traffic:

A salty depiction of the wreckers themselves may be found in Jefferson B. Browne's classic *Key West: The Old and The New* published in 1912. Here are a handful of them:

"The King of the Wreckers" was "old Ben Baker," skipper of the eighteen-ton schooner *Rapid*. And rapid she was, as Old Ben outstripped all others in being first to get a line aboard foundering vessels. Browne described him as being "tall, gaunt, shriek-voiced, hook-nosed, and hawk-eyed." He lived in a two-story house at the corner of Whitehead and Caroline Streets—diagonally across from the building where the admiralty court decided his share of the spoils. Between salvage operations, Old Ben tended a pineapple plantation on Key Largo.

Old Ben's successor as Wrecking Master was Sylvannus Pinder, who, according to Browne, was "large, robust, handsome, jolly, the pride of 'up-town.'"

Next in line came "Old Captain Geiger," whose favorite vessel was his schooner the *Nonpareil*, which he boasted he had brought

through Nassau harbor with only his jibsail set, "just to show the Conchs what an American ship could do." In addition to wrecking, Geiger served as pilot for all Navy vessels entering and departing Key West harbor, and when Commodore Porter set out to round up the last of the pirates in the Keys, it was Geiger who showed him the way. He spent his last years in the lookout, which he called his "buffalo," atop his house, scanning the horizon with a spyglass in search of some ship in distress.

Manuel Costa, a Spaniard, was said to have "a grip like a vise and heart like a baby."

George "Rabbit" Demeritt, skipper of the schooner *Ida McKay*, was a master wrecker who was best known for having whipped his three larger brothers. Rabbit also served as sheriff and captain of the night watch on the customs dock.

Peter Smith, a native of Holland, discovered Key West by being wrecked on a nearby reef, after which he decided to take up wrecking as his trade. Broad-shouldered and powerful, at eighty-two he was still regaling the admiralty court with his tales of bringing up cargo deep in a ship's hold.

Being a skilled "bareback" diver was a definite plus in the wrecking trade, and "Bull" Weatherford and Tom Johnson were the best of the lot. They were frequently employed to dive down, cut out the damaged portion of a ship's hull, and bolt on a cover so the ship could be pumped out and refloated. Bull is best remembered for having sculled his becalmed seven-ton schooner *Hannah* all the way from Dog Rocks to Key West, just because the prominent Colonel William C. Maloney was on board and anxious to get home.

In 1848 and 1849, no fewer than 612 ships went aground off the Florida coast north of Cape Canaveral, with combined cargoes valued at $22,000,000. From this haul, wreckers collected $1,595,000 plus $2,566,000 for expenses. An equal number of wrecks occurred during the same period south of Canaveral.

Progress in reef lighting systems and navigational instruments, and the advent of steamships that were not so susceptible as sail to being blown off course, gradually reduced the number of vessels running aground. By 1921 the last of the wreckers was bought out and the District Court closed the register of wrecking licenses.

Of course the most fabulous salvage operation of all time was Mel Fisher's successful search for the wreck of the Spanish treasure ship *Atocha*, which foundered in a storm off the Dry Tortugas in 1622. The costly search, which went on for sixteen years and was marred by the drowning deaths of Fisher's son and daughter-in-law, was crowned with success in 1985. The value of the treasure came to more than $450,000,000. An impressive sampling of the

gold bars, coins, jewels, and artifacts are on display in Mel Fisher's
Key West waterfront museum.

Seafood Unlimited

When the first settlers, white and black, left the Bahamas and
came to Key West, it was not with any view to growing crops on
The Rock, but rather to harvesting the super-abundant marine
life afforded by the surrounding seas. When the fishing is good the
word gets around, and fisherfolk and seagulls converge from all
directions.

In variety and abundance, few if any fishing grounds in the
world could compare to the Keys waters. The settlers and their
subsequent generations lived good lives, extracting fish, sharks,
shrimp, lobster, turtles, and conchs from the briny deep and
shallows.

Key Westers often fished to put food on their tables,
particularly in the lean days of the Depression. But seafood
industries provided a variety of livelihoods—including commercial
fishing, selling bait, and peddling seafood. Sport fishing became
more and more significant as the tourism industry evolved. The
Gulf Stream runs seven miles offshore. There the sports fisherman
finds sailfish, marlin, dolphin, barracuda, bonito, and many other
species.

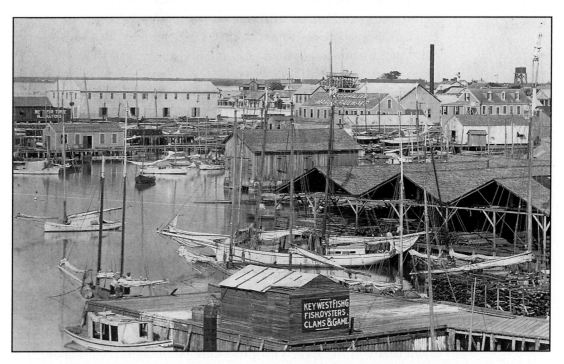

*Note the sign at the bottom. Before the turn of the century, the Key West Fish Company was
offering game as well as seafood. Could that be where all the Key deer went?*

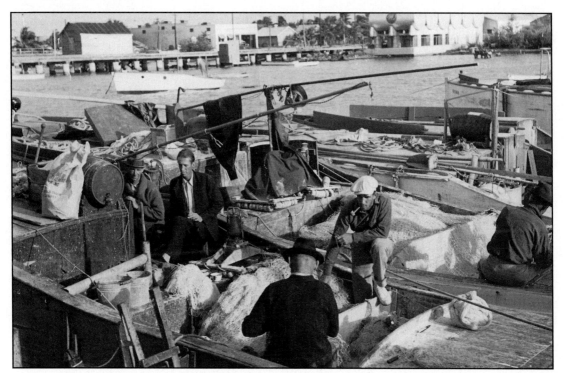

Life at the fish docks looked like this. "When the wind wasn't walkin' right" the fishermen spent their time mending nets and playing poker.

Commercial fishermen focused upon such choice edibles as red, pink, and yellowtail snapper, pompano, mackerel, and kingfish. Some species were caught by gill net and others by handline. Fishing equipment and methods remained the same for generations. Small boats were manned with two men, one to manage the fishing and one to manage the boat. The craft carried simple equipment consisting of heavy trolling nets, wire leaders, and metal squid hooks.

It took a lot of sharks to make a little money during the Depression—a seven-footer only brought $1.50. The livers went for oil, fins for soup, skins to the Ocean Leather Company of New Jersey, and all the rest of the shark went overboard.

During the first century of the fishing industry's operation on the Keys, ice had to be brought in by sailboat from Maine. Many Keys fishermen built their boats with "live wells," in which they brought their catches to the docks alive and swimming. Those fishermen who catered to the local trade often transferred their catches into floating pens, or "cars" at the dockside. Housewives would point out the fish of their choice and the fishermen would clean them on the spot. This procedure eliminated the costs of refrigeration, wholesalers, distributors, and retailers, and assured the customer of fish as fresh as can be.

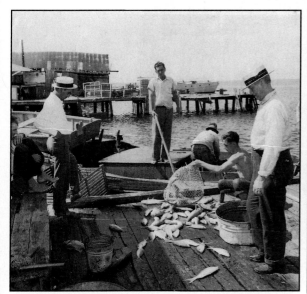

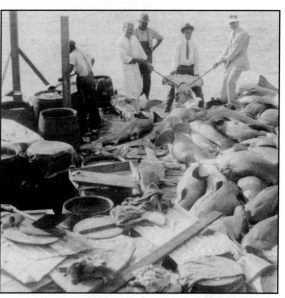

The man in the straw hat beside the washtub is Peter Roberts, whose dockside fish market dominated the scene in Key West for many years. Here Roberts inspects the catch of the day, yellowtail snapper.

The sharks shown here were being processed on Wisteria Island at the foot of Duval Street.

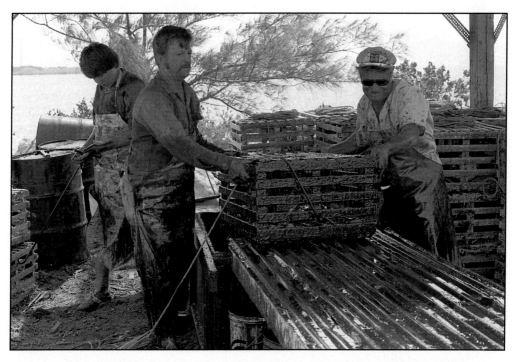

Getting ready for lobster season. Making the traps out of wooden slats keeps many people busy during the off-season. These are being treated with creosote to make them last longer.

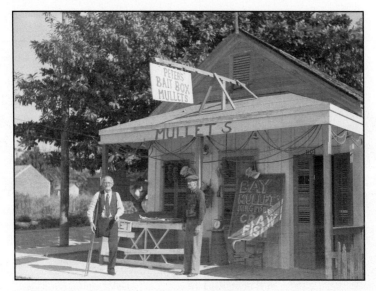

*On this fine day in 1935, this fish market was pushing bay
mullet, kingfish, and crawfish. Nowadays the latter are
marketed as "Key lobster." Unlike their Maine brethren,
they have no big claw.*

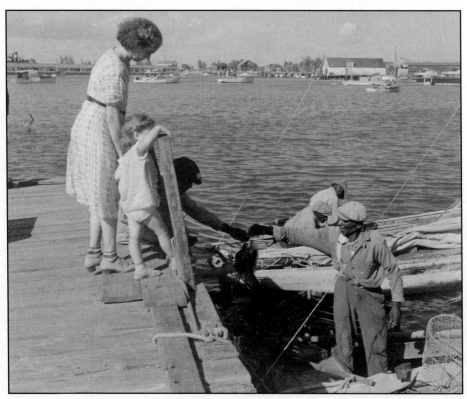

Mother and child, buying fish live at the dock, cleaned free while you wait.

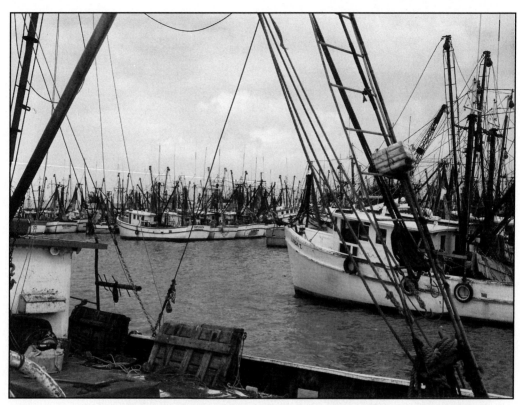

Ready to head out and scoop in the "pink gold."

Legend has it that the shrimping industry got started when an Italian named Salvador jumped ship near Mayport, Florida. After being rescued, he raced to the nearest telegraph office and cabled his Versaggi and Poli cousins in Italy: "Come on over! The ocean is full of shrimp!" These three families established a veritable shrimping empire along the south Atlantic and Gulf coasts.

Some decades later, the ocean was not as full as it had been. But then it was discovered that there were tons of big pink shrimp offshore from Key West that hid on the bottom all day and came to the surface to feed at night. A veritable "Pink Gold Rush" brought shrimp boats from all over the Atlantic and Gulf coasts to Key West harbor.

Time was when Key West was one of the turtling capitals of the world. One of the island city's few factories was engaged in making and canning green turtle soup. Turtles were brought in by boat from near and far. A principal source of supply was the Grand Cayman Islands. Boats manned by big men wearing rolled-rim straw hats caught turtles off the coast of Central America and brought them, a hundred or more at a time, to the market in Key West.

Each year, when the sea turtles came ashore on a moonlit night to lay their eggs in the sand on the Keys just north of Key West,

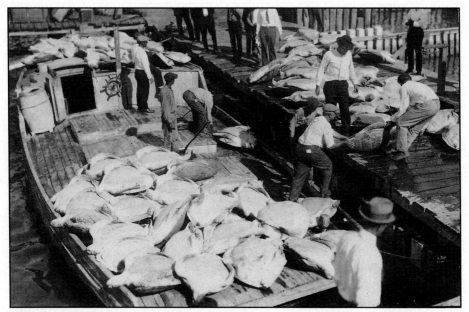

A load of "turned" turtles arrives at the Key West dock.

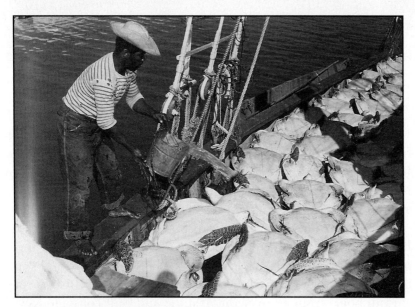

Water-cooling shipments of turtles was a must, unaccustomed as they are to turning their bellies to the sun.

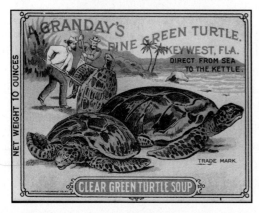

Where have all the turtles gone? One answer was the A. Granday Green Turtle Soup cannery, established in Key West in the 1880s by famous chef Granday, and sold to the island's big businessman Norberg Thompson in 1910. Large numbers of turtles were also shipped alive to the Fulton Fish Market in New York City.

they were intercepted by groups of men from Key West, on "turtle turning" missions. All one had to do was flip them over on their backs and they would lie there until hauled off. No one knows now whether or not they waited for the mother turtle to lay eggs.

Everyone fancied that the supply of seafood was inexhaustible, but of course it has been proven otherwise—to the detriment of the environment and to the work available to Key Westers.

Sponging

The sponging industry in the Florida Keys had its beginning in 1849, when a Key West Conch sent a batch to the New York market on speculation. When they were "gobbled up," he told his friends, "Boys, I'll buy all you can harvest!" During the next half-century, sponging replaced wrecking as the island's primary occupation, and Key West became the sponge capital of the world. Everybody who had a bathtub wanted a sponge, and the industrial demand was also high. The peak came in 1895, when there were three hundred boats and 2,500 men involved. Legend has it that one big-time sponge dealer made so much money he went to New York and brought back a solid gold dinner set from Tiffany's.

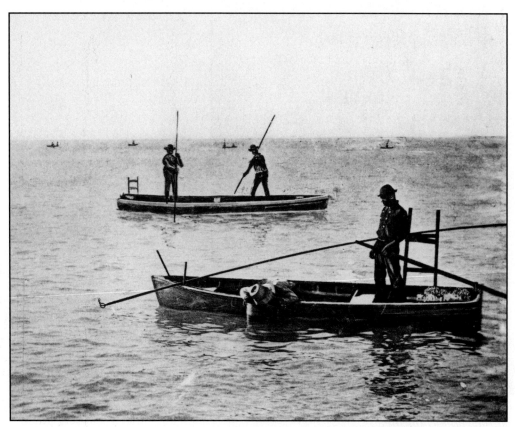

It didn't take much to become a sponger. First you need a boat like this, a 20–30-foot grapple pole, and a glass-bottomed bucket.

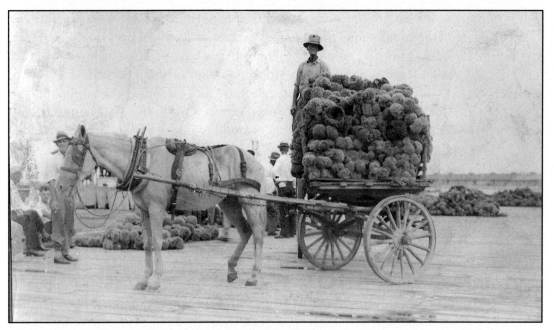

This two-wheel dray was a familiar fixture in old Key West transporting sponges to and from warehouse, dockside auctions, etc.

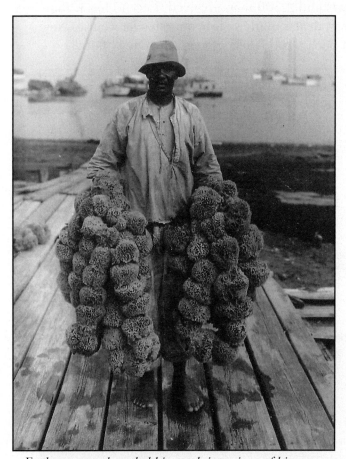

Each sponger threaded his catch into rings of his own color rope for identification.

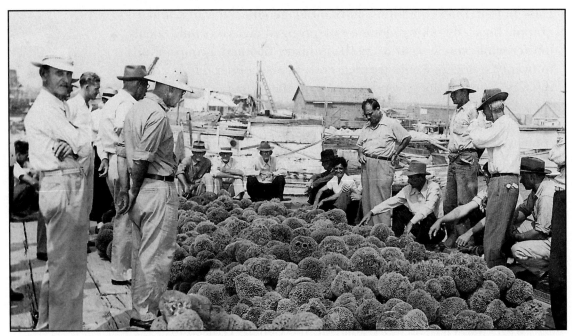

The bundles of sponges were piled on the sponge dock and sold at auction to dealers. While they were dying and drying, the smell was pretty awful.

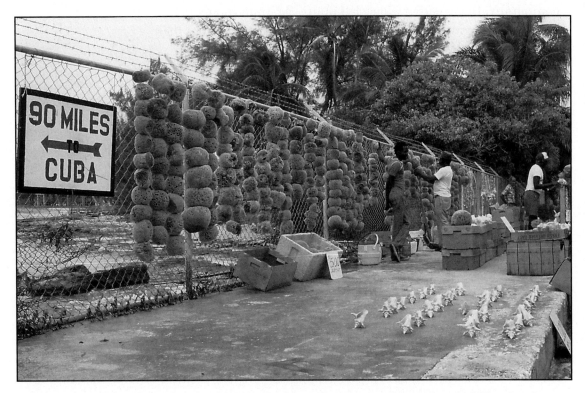

Sponge industry's last stand? A few spongers display their wares at the south end of Whitehead Street for retail sale to tourists.

It didn't take much to become a sponger—a small rowboat, a glass-bottom bucket, a bit of shark oil to smooth the water, and a grapple hook. By taking along a two-pronged gig, you could spear lobster while you were at it. As the industry boomed, groups of up to twenty spongers would tie their craft to a schooner and head up the Keys and stay for several weeks until the schooner was full of sponges.

Sometimes described as half plant and half animal, the sponges had to be spread out on the dock and beaten to death with a bat and the living tissue washed away in sea water. Each sponger tied his catch in loops with his own color of rope for identification. The bundles were piled on the sponge dock and sold at auction to dealers. While they were dying and drying, the smell was pretty awful. 'Tis said that some sightseers even fainted.

'Tis also said that when Greeks from Tarpon Springs, wearing their deep-sea diving suits with lead-soled shoes, tried to horn in, their vessels mysteriously caught fire at night, so they moved back up the coast to Tarpon Springs.

With characteristic individualism, the Conchs refused to organize a cooperative sponge market, such as the one that gave the Greek spongers at Tarpon Springs a great advantage. When World War II brought a Navy construction boom to Key West, the comparatively attractive wages led many old-time spongers to abandon sponging and take "real" jobs for the first time in their lives.

Sponging continued to be a "big thing" in Key West for four or five generations until the combined impact of a sponge blight during the 1920s and '30s, the invention of synthetic sponges, and jobs afforded by World War II put an end to it. Some years later someone tried to keep it alive by starting a sponge farm in the waters off Sugarloaf Key, but as soon as the crop was ready to harvest, poachers from Key West pounced upon it—and that was the end of that.

The Tabaqueros

The Rock was not only the sponge capital of the world; for many years it was also a major supplier of the world market for hand-rolled cigars. The sponges were already there, but the special kinds of tobacco needed for cigars had to be imported from Cuba. Likewise, the people who harvested the sponges were already in Key West, whereas the cigarmakers, like the tobacco, had to be brought in from Cuba.

It was a Key Wester, however, William H. Wall, who planted the seed of the industry by opening a small factory in 1831. The Cuban war of independence that began in 1868 spurred Cuban migration to Key West. Along with the Cubans came their cigars and their cigarmaking. Vicente Martinez Ybor moved his factory to the island from Havana. Samuel Seidenberg set up what was to become the largest factory. By the 1890s there were sixty-six factories, employing ten thousand cigarmakers, who produced one

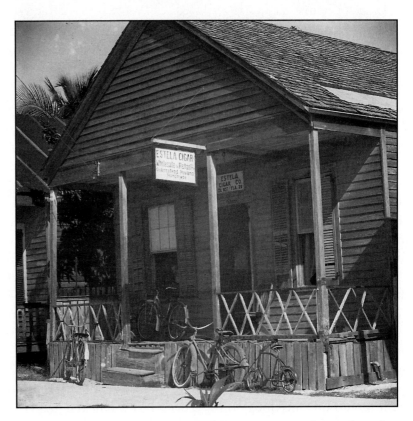

The Estella Cigar Store on Duval Street was one of a number of "cottage industry" one-man factories known as chichares, *some of which continued to operate long after the big factories were moved to Tampa.* Chichare *means something like "flea bag," but it is highly doubtful that there were any fleas, what with all the tobacco around.*

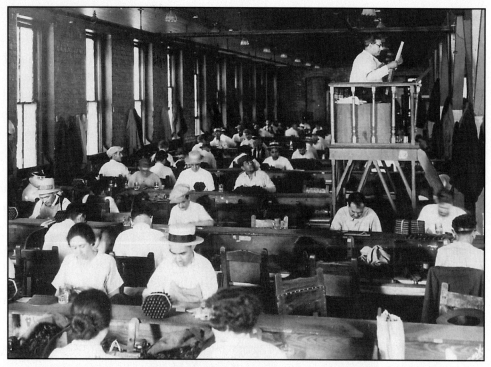

The lector *sat upon a platform in the cigar factories, reading in Spanish from the news of the day as well as literary classics, which often included Cervantes, Tolstoy, Voltaire, and Shakespeare. Chosen and paid by the workers, the* lectores *were thorns in the side of the manufacturers, who denounced them as "bums and anarchists." In fact, the* lector *was an admirable precursor of radio and TV. After years of listening, the workers had the equivalent of graduate work in world literature. This explains why, when the industry folded, many of them went on to pursue professional careers.*

hundred million cigars per year. With eighteen thousand people living on The Rock, Key West was the largest city in Florida and the richest per capita in the United States. After the Spanish-American War, Key West had ice, electricity, and a motion picture theater—what more could it ask for? My brother-in-law, Norberto Diaz, had been a skilled cigarmaker when the industry was in its heyday. He was so skilled, in fact, that periodically he would get up from his workbench and walk around helping those who were slower. "They paid off on Fridays, in silver dollars, *b'rrr* across the counter, like that! On paydays it was like a carnival outside the factory gates—*bolita* salesmen, Cuban lottery, the *piruli* man. People would buy anything—they'd even buy a chicken head on a stick!"

Making hand-rolled cigars is a highly skilled trade. The best quality leaves are selected for wrappers, the chopped tobacco sprinkled in, and wooden molds are used to shape the various forms and sizes. After being compressed and dried in molds for a day,

pickers would select those of the same color to go on the top layer of each box.

The factories all faced north, because it was believed that only with a bank of windows facing in that direction would the light enable the pickers to do their best work.

One would hardly suspect, gazing upon today's pleasure-seeking throngs, that Key West was once a hard-working industrial union town. During the decades before and after the turn of the nineteenth century into the twentieth, Key West was the "cigarmaking capital of the world." At the same time, the cigarmakers' Union de Tabaqueros was a national and international model of militancy and solidarity. When the Cuban war of independence was brewing, the union was so forthcoming with money and men that the "Apostle of Cuban Liberty," José Martí, a frequent visitor, bestowed upon Key West the mantle "Cradle of Cuban Independence."

Some of the manufacturers, loyal to Spain, took a dim view of these proceedings. One complained bitterly that while one member of a visiting delegation was in his office requesting permission to take up a collection, his colleagues were already in the factory doing it. The normal solidarity between the "brothers in the union" was broken when some of the Concos among them refused to donate to

For decades the Key West Cuban community was in the forefront of the campaign to win Cuban independence from Spain. The cigarmakers and their union were especially generous in their contributions. It was with good reason that Key West was hailed as "The Cradle of Cuban Independence."

the cause. Consequently, they were chased out of the factory.

It was customary for a vendor of sandwiches to tour the factories at lunchtime. But one day the sandwich man got into an argument with a supervisor, and the manufacturer threw the sandwich man out. The workers promptly walked out with him. "No sandwiches, no work!" they declared, and the strike went on to a successful conclusion.

Nothing pleased the Spanish authorities in Havana more than a cigarmakers strike in Key West, for it meant a cut-off of funds for the freedom fighters. So they sent a Spanish gunboat and some commercial vessels to offer free transportation of the striking workers "back to their Cuban homeland." Hundreds went, but most of them returned after a few weeks.

The biggest strike of all, for higher wages, was staged in December of 1869. Some manufacturers were vitriolic in their denunciations of the strike leaders as "gypsies and tartars" who spent their week's wages in a single night of gambling. Since the future of the industry depended upon backfilling a mountain of Christmas orders, the manufacturers hastily capitulated.

Hand-in-hand with Key West's unionism went a number of other groundbreaking institutions. In what was probably a first

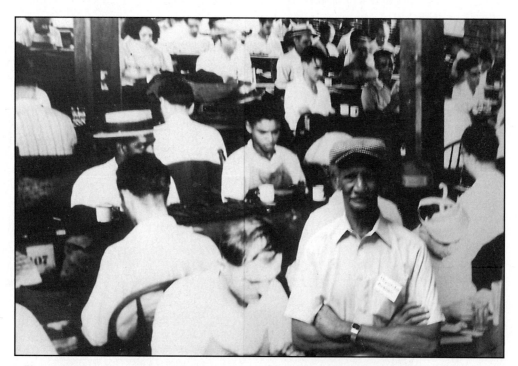

Time marches on . . . Hypolito Arenas, whose forebears were once cigarmakers in Key West, takes a stand in front of a large wall photograph of a cigar factory in Ybor City. The lad seated just over his left shoulder is himself, a half-century earlier.

Labels for the cedar cigar boxes (made in Key West) were works of art, and have long since become valuable collectors items. Topless Indian maids were a favorite motif, since any hint of pale-face nudity was taboo (except these little angels). Up to twenty tons of pressure was applied to emboss this label, which was then hand-lacquered and sprinkled with gold, bronze, or silver powder.

on the continent, prototypes of today's HMOs were introduced on the island. In one such, named Familia, the physician provided family coverage for 25 cents a week. The Afro community, not to be outdone, came up with a burial insurance plan called the "Grief Relief Association."

In 1886 a fire destroyed many of the factories. That calamity was followed by a decision on the part of some manufacturers to pull up stakes and try to escape from the unions once again. The manufacturers had outsourced their industries to offshore Key West in the hope of escaping the unions, but the unions had followed the industries. Then when strikes for better wages ensued, the manufacturers decided to move again, this time to Tampa, Florida. It was Vicente Ybor who led the way, and Tampa's Latin community has been called Ybor City ever since. A great many of the Cuban cigarmakers in Key West followed after, taking the union with them. The two communities have been kin for generations, and commuting and "intermarriage" has been a constant. I still remember my Key West sister-in-law, Adelpha, who took up residence in Ybor City, asking ruefully, "What can I do with a boyfriend in Key West?"

The Charcoal Makers

Every now and then the folks up on the Keys receive a 911 emergency call from some excited tourist who has strayed off the beaten path and stumbled upon what they think is a cause for alarm.

"I think there has been a flying saucer landing up here on No Name Key!" they cry. "There's a great big burned circle on the ground!"

Then the operator must explain that those circles are not the result of any flying saucer invasion, but only a spot where some charcoal maker once built his kiln.

Charcoal was long the principal source of heat for cooking

ETs on the Keys? The circles were caused by the firing of circular charcoal-making kilns, like this one on Sugarloaf Key, 1937. Time was when the Island City did most of its cooking with charcoal.

in both the Bahamas and in Cuba, and the same remained true for generations after people from both places settled in Key West. For more than a century a score or more of mosquito-bitten men, variously referred to as charcoal burners or woodcutters, lived precarious lives on the lower Keys, making charcoal to keep folks' cooking pots glowing.

An initial supplier of Key West's needs was Henry Geiger on adjoining Boca Chica Key, who hired a sixty-three-year-old black man, Robert Allen, to cut the wood. One of his customers, William Hackley, noted in his journal in 1853 that he consumed a sack of charcoal per month, at a cost of $1.50 plus 50 cents for delivery to his dock.

The census of 1870 listed George Wilson, the sole resident of Big Pine Key, as a charcoal maker, and two others on Sugarloaf. A decade later, the census listed thirteen burners on the lower Keys, all black but three, and also seven woodcutters, all white. Three decades later, in 1900, there were seven charcoal burners and no woodcutters; but by 1910 there were twenty-two "woodsmen" living between Cudjoe and No Name Keys. These counts do not include burners living in Key West and working on other Keys.

A goodly number of the burners were originally Bahamian blacks who had brought the craft with them. In the Keys as in the Bahamas, buttonwood was the material of choice. A cord

of buttonwood yielded about ten sacks of charcoal, which were transported to Key West in sloops, each carrying about 150 sacks. An observer in 1885 observed no fewer than eight sloops putting out from Key West in a single day, all bound up the Keys to pick up charcoal.

Long after the advent of gas and electric stoves in Key West, many householders continued to cook with charcoal, insisting that the buttonwood imparted special flavors to grilled and roasted meat. The roaster of Key West's favorite brand of coffee, Brazo Fuerte (Strong Arm), also used charcoal, for the same reason.

In 1939 I was driving along the Overseas Highway on Sugarloaf Key and spotted a charcoal makers' camp. I stopped the car, "walked the plank" across the roadside canal, and starting taking snapshots.

The kiln of stacked wood that was soon to be turned into charcoal was thirty feet in diameter, and twelve feet high. The thrown-together shack of the two Conch charcoal makers was about six feet square, and not quite high enough for standing room. Inside, each man had a plank shelf that served as a bed.

For all I know, it may have been the last charcoal to be "stood up" on the Florida Keys. I asked them to tell me how it was done, and so they did:

> This 'ere is the biggest coal kiln ever was stood-up on the Keys. Lots of strangers going along the Overseas Highway stops to 'ave a look at it; they hardly never looks long account of the mosquitoes.
>
> Me and my brother learnt 'ow to make coal kilns from our daddy. I think it was brought over, 'ow to make 'em, from the Bahaymees. They makes a 'eap of charcoal over to the Bahaymees. In Cuba they makes it, too, but not the same as 'ow we does 'ere. They digs a 'ole in the ground and lies the sticks in crosswise, one layer this way, one layer that, then fires it and covers it. We stands-up kilns Bahaymee style.
>
> The county 'as give us a permission to cut down all the trees we want along the highway; that fixes it so strangers can see the ocean better. We 'ave stood-up kilns on Big Pine Key, Saddlebunches, Cudjoe, Ramrod, No Name, Big Torch, Little Torch, and lots of others.
>
> Whenever we gets up the intention to stand-up a kiln, the first thing we does is pick out a good dry place with lots of trees. Most any kind of trees is good to make charcoal, but red mangrove and buttonwood is best.
>
> This little 'ouse, we built 'er out of driftwood what we

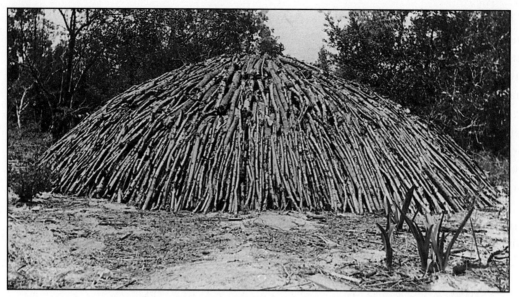

This kiln was said to have been "the last to have been stood up" on the Keys. But there have been one or two since then.

got to the beach, some cardboard, and tin for a roof. After the 'ouse was done built we cut us a long post and drove it in the ground where we wanted the kiln, leavin' it stickin' out as 'igh as we wanted the kiln to be. Then the cuttin' starts, with machetes and axes. We cuts mostly all sizes of trees, and carries 'em and leans 'em against the center post like a wigwam, only solid.

When it suits our 'umor to really work we can stand-up a big kiln like this in ten or fifteen days. To do that we 'as to get up at five in the mornin' and work till five in the evenin'.

After the kiln is stood-up, we packs grass all over it, about three inches thick. It don't make much matteration what kind of grass you use. We uses seaweed what we rakes up along the beach. Then we covers that grass with a layer of sand two inches thick. Mud hain't no good; you 'ave to use sand. The 'ole kiln is covered like that, 'ceptin' one little space at the top about a foot wide, called the "crown."

To fire it we build a fire and get a lot of red hot coals. Then we pull the center stake out from the kiln and pour them hot coals down through the crown and they fires the kiln, not flamin', but slow. Then we cover the crown perfectly up with a layer of grass and a layer of sand, like all the rest.

A kiln this big takes ten days to burn, and all that time somebody 'as to live 'ere in the little 'ouse to watch it day and night in case it breaks through and throws fire. If fire breaks through the grass and sand it shoots out like a cannon.

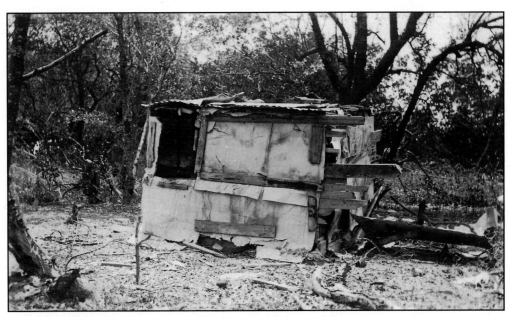

Two Conch charcoal makers lived in this cardboard and driftwood shack on Sugarloaf Key.

When that 'appens I mean it burns a 'ole in the wood, proper! That 'ole 'as to be filled up quick with a stump or more wood, packed down tight, and covered agin with grass and sand. Sometimes when we don't 'ave a stump or no extra wood 'andy we 'as to put in sacks of charcoal. If the 'ole isn't filled and covered mighty quick, the kiln will burn down to ash because of the air gettin' to it.

We carry lots of plantains, can food, and drinkin' water. The sun is hot-hot, and you need plenty of water, all right. Sometime we 'ave a gun an' we kill wild pigeons, rabbits, tobacco doves, and creatures like that, and 'ave us a feed. We gets young cocoanuts and drinks cocoanut water, and eats tamarinds, too. If we 'as a boat 'andy we goes out and catches a mess of grunts, and 'as grits and grunts for supper. Grits and grunts is our favorite eats.

I Gad, the mosquitoes! They're somethin' terrible! Specially when the wind is blowin' 'em our way. Them bloody boogers is so big and so many they just opens the door and walks in. True! One mornin' I woke up and they was so thick I thought it was still night. About the onliest thing we can do is wear 'eavy shirts and britches they can't bite through, and wave 'em off our faces with a leaf branch.

Sometime we build a fire and put on it mangrove, pigeon plum, and stopper leaves to make smoke to drive 'em away. Sand flies is worse than mosquitoes, and we 'as to spray the

screen of the shack with oil to keep 'em from comin' through. I'm tellin' you the truth now, mosquitoes is so bad on some Keys that they kills chickens, goats, and cows even!

Rain is good to keep away mosquitoes while it is rainin'. But rain is all the same as gasoline if it gets inside the kiln; if the kiln throws fire while it's rainin', then it burns up, for true.

When we think the kiln is ready to open, we opens a little 'ole down at the bottom to see if it 'as burned all the way down. If it 'as, then we uncovers it and waits about twenty-four hours for the charcoal to cool off. Then it takes about three days to sack it. We expect this kiln to give at least two 'undred sacks.

One time a stranger wanted us to contract to sell 'im all the coal we could make. I asked 'im 'ow much 'e was willin' to pay, and 'e said, "Fifty cents a sack."

"Rot me if we do!" I told him. "Not when we can sell it in our uncle's store in Key West for eighty cents a sack!" We told 'im if 'e wanted to pay that much, all right.

"You must wanta make all the profit your ownselves," 'e said.

"Sure," I said, "we the ones 'as to stay out 'ere with all these mosquitoes!"

'E couldn't dispute that! We never did 'ear from 'im no more. By Jimminies, it's a lotta work makin' coal. If you run acrosst anybody wants to buy some for eighty cents a sack, let us know.

Peddling

Street peddlers were long an insitution and way of life in Key West, with roots that went back not only to Cuba and the Bahamas, but to the Old World. Seafood, fruit, vegetables, and dry goods were the principal items purveyed, either by pushcart, wheelbarrow, or hand. In addition, there was the *piruli* all-day-sucker man and the dairyman who walked his milk cows from door to door.

Everyone was pleased with these arrangements —except for several established dry goods merchants, who took exception to competition from Jewish peddlers. They consequently prevailed upon the City Fathers to enact an ordinance aimed at driving these particular vendors off the streets.

"In 1889 the Merchants' Protective Association

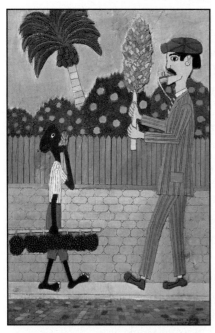

Here is Mario Sanchez's version of a piruli *man. The peddlers sold lollipops to Key West's children. For generations they were an ever-present feature of life in both Key West and Tampa's Ybor City.*

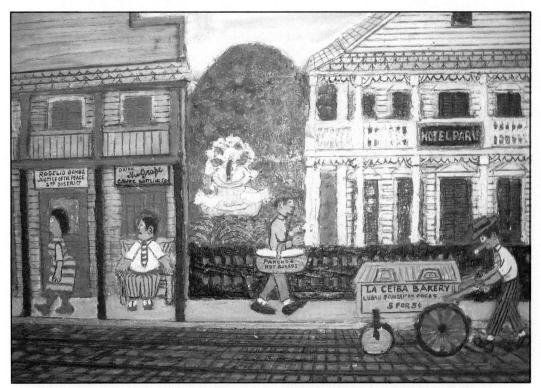

In the good olden days, retailing in Key West was decidedly user-friendly. You could wake up to a yard-long, five-cent hot loaf of Cuban bread on your doorstep. In Mario's depiction above, a shopkeeper is shown seated on the sidewalk, taking in the constant parade of "well-balanced" señoritas walking by.

was organized, largely for the purpose of protecting the old Key West merchants from the competition of the Jew peddlers who had just begun coming to Key West," wrote Judge Jefferson B. Browne in his 1912 book, *Key West: The Old and the New*. He goes on to say: " . . . About the only thing that the Association accomplished was to have the city charter amended to authorize the imposing of a license tax of one thousand dollars on each peddler. This had the effect of making the Jews quit peddling and open stores. Several of them are now among the most prosperous and progressive citizens of Key West. Of the dry goods merchants who were [already] in business at the time the Merchants' Protective Association was organized, not one has a store today, and of the clothing merchants, only one . . ."

By the 1930s street peddling was the source of income for many Key Westers hard hit by the Depression, as well as a significant source of food and goods for households on the island. One venerable Cuban vendor made the rounds calling out in a booming voice the catches of the day, such as *"Lavia rubia!"* (yellow-tail snapper), and *"Guasa! Guasa fresca!"* (fresh jewfish).

The vegetable man made music out of his rhymed chants,

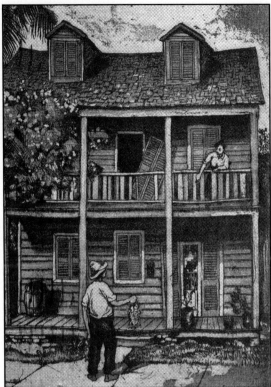

Street vendors selling fish, fruit, and vegetables were an omnipresent institution in old Key West.

The City that Gave Itself Away. Special issue of the Florida Keys Sun, *dated July 6, 1934, relates how the city and county passed joint resolutions giving themselves to the state of Florida. The resolution was sent to Governor Dave Sholtz "on the afternoon train."*

which could be heard a block away.
¡Aguacate maduro tengo.
Naranjas de China yo llevo;
Tambien platano muy bueno!

(Ripe avocado I have.
Oranges from China I carry;
Also very good plantains!)

Dead Giveaway

It was a fine July day in Key West in 1934 when the City Fathers, having their morning coffee in informal session in Pepe's Cafe (as was their custom), resolved that, inasmuch as the city was dead broke and unable to pay its officials, staff, police, firemen, garbage men, or anybody else, Key West should give itself away to the state of Florida. Monroe County joined in the move.

Governor Dave Sholtz promptly passed the city on to the Feds, as represented by the Federal Emergency Relief Administration (FERA, precursor to the WPA).

The FERA sent in an "administrator" in the person of Julius F. Stone, who took over. The city and county councils continued to meet, but in an advisory capacity. Julius F. Stone, attired in Bermuda shorts and a safari sun helmet, was the absolute dictator of Key West.

Stone decided that Key West's only hope for a future was to transform itself into an attractive tourist resort. This was sooner said than done, but Key Westers got very busy in a crash program to try to make the dream come true.

A voluntary work corps was organized, four thousand people signed up, and over a million and a half hours of voluntary labor for public improvements were pledged. As a first step, tons of rubbish were carted away. Crews were hired to rake up the seaweed that every high tide deposited on the beaches. (This looked like a job with a future, so yours truly joined in.) Parks, tennis courts, baseball diamonds, and playgrounds were built.

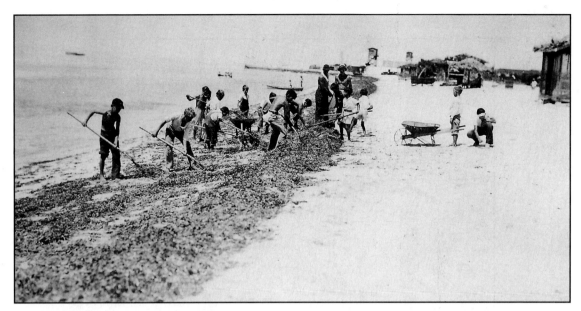

Every high tide deposited smelly seaweed on Key West's beaches. With nothing but shovels and wheelbarrows to work with, hauling it off every day provided steady jobs for many of the FERA workers and volunteers. (This is where the "Sea Breeze Sandwich" was born. See page 150.)

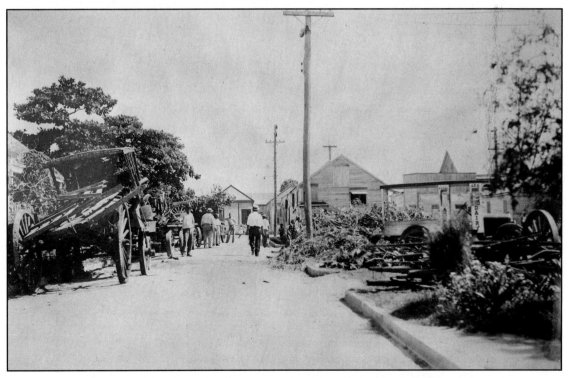

When in 1934 Uncle Sam agreed to bail Key West out of hock, and rehab it as a tourist resort, the first step was a clean-up campaign. Everybody pitched in and cleared their own backyards, with results like this. There weren't enough trucks, so horse carts hauled it off.

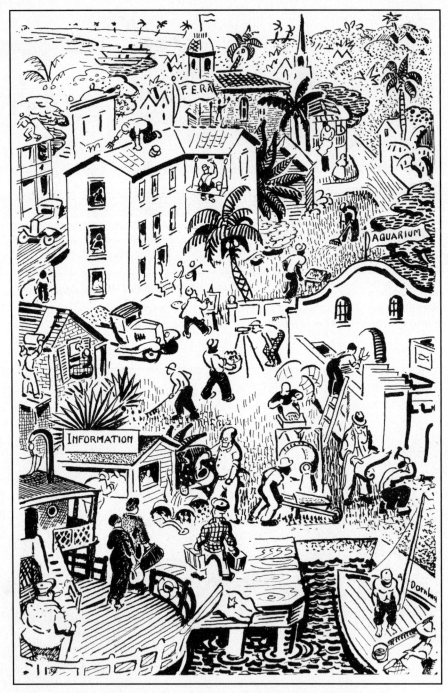

"Key West in Transition," a sketch by Adrian J. Dornbush, one of seven nationally known artists flown in by the FERA in 1935 to embellish the town (everything from bar rooms to brothels) with free murals. If everyone would pitch in, patch up, and paint up, tourist dollars would begin to flow, and everyone would live happily ever after, the hype went.

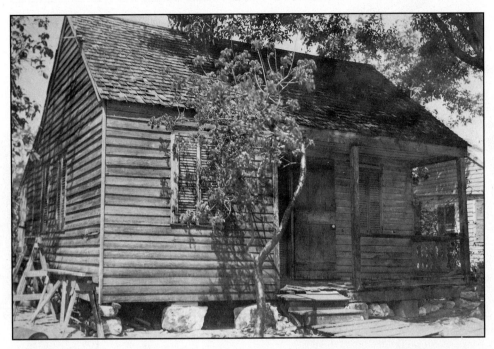

"Before" photograph of a retired school teacher's home, prior to being rehabbed by FERA.

"After" photo of the same dwelling, showing painters putting finishing touches on picket fence.

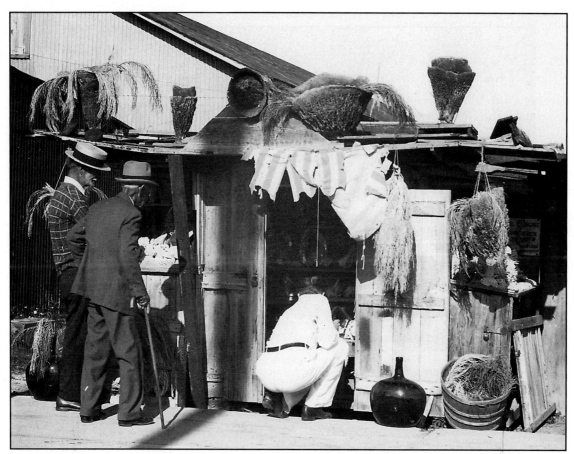

This curio shop was about all the island had to offer in the way of tourist attractions. The owner was in the habit of running up a flag and firing a few salvos from a wooden cannon whenever he felt like it. Note the green glass demijohn, a leftover from the rum-smuggling days of Prohibition.

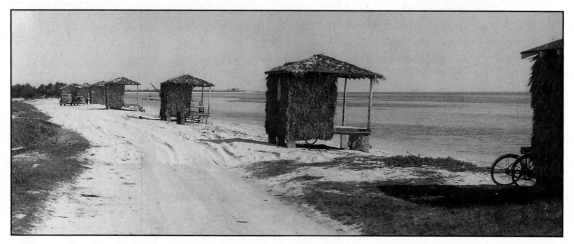

These palm thatched cabanas, thrown together on Rest Beach, were just what was needed to attract tourists, some thought.

Shrubs and trees were planted. A thousand benches were made and placed in shady or sunny resting spots. Every possible "point of interest" to visitors was refurbished.

Stone brought in a coterie of artists, some of national prominence, to paint what they saw. Their works were soon to be seen on the walls of public buildings, hotels, restaurants, bars, jook joints, brothels, and postcards. (The line drawings you find throughout this book are the work of these artists.)

A major question was where tourists would sleep—if any showed up. The Casa Marina Hotel, which had been closed ever since the collapse of the Florida real estate boom in 1928, was refurbished with FERA (public) money, under an arrangement whereby FERA would control the price of rooms and the hotel owners would be protected against loss. In addition, many a private home was given a new roof, paint job, and plumbing, all with public funds. (In due course, both the hotel and homeowners paid back the government for the monies spent.)

To get rid of that totally unpainted look, the slogan was raised "Help to Those Who Help Themselves," and Key West householders were given countless gallons of paint on the condition that they apply it to their domiciles. It is not known what kind of paint it was, but the tropical sun transformed it into an amazing rainbow of pink, yellow, green, blue, and lavender pastels.

Finally, to gild the lily, a few crude thatched cabanas were built on Rest Beach. Coconuts were planted along Roosevelt Boulevard, and Key West's grand dames were recruited to train some maids in all the niceties.

"Why on earth would anybody in their right mind want to leave a place like Miami, which has everything, to come to a place like Key West, which has nothing?" locals asked one another.

But the very first season proved how wrong they were. In their right minds or not, forty thousand came, liked what they saw—and their successors have been gobbling up Key West ever since.

On Relief

During the Great Depression, referred to at the time as the "root-hog-or-die" days, "welfare" was called "relief." In Key West ninety percent of the population was "on relief"—a far higher percentage than in any other community in the nation.

The WPA provided a wide variety of jobs, from pick-and-shovel work on the streets to sewing rooms and food canning. To get on relief, or a WPA job, one had to take a pauper's oath, affirming that they had no job, no money, no property, and no prospect of getting any of those things.

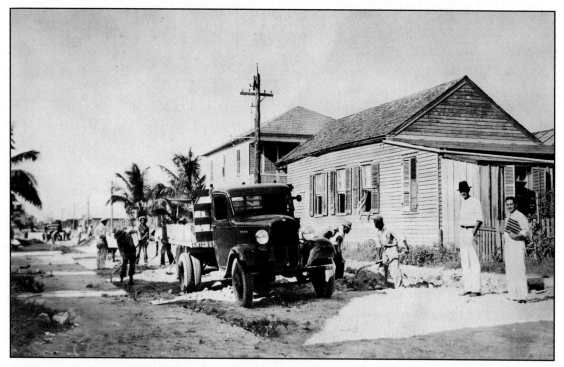

Many streets looked like Catherine Street did then—unpaved, no curbs, full of potholes. Key West patched them up as best it could—with shovels.

Charles Foster, a member of the WPA Florida Art Project, contributed a number of the photographs in this book. He is the author of Conchtown, USA *(Riviera), which incorporates material collected by WPA Writers Veronica Huss and Stetson Kennedy.*

The sewing projects (in Key West some sewed outdoors) provided sewing machines and fabrics, and paid women something like $14 per week to make clothing for their families. In accordance with the law, WPA workers were strictly segregated according to race. One of the Florida program's directors sent out a letter admonishing supervisors to keep a sharp eye out for Afro-Cubans seeking to be assigned to a "white" project.

There were also so-called white-collar projects, including Writers, Art, Music, Theater, and Recreation. (The author joined the Federal Writers Project and penned a Key West Historical Pageant that was produced in 1935, by a combination of all the cultural projects and a cast of five hundred volunteers.)

One day the local newspaper published a brief notice, indicative of the times, as follows:

Key West Girl, 14, In Suicide Effort, Takes Slight Dose of Poison While at Home

Crying that she wanted to die, Grace Hall, 14, 906 Angela Street, one of 13 children of whom Charles Hall, who is serving one year in the county jail, is the father, took a slight dose of poison early Sunday morning. Attendants at the Marine Hospital pumped the poison from the young girl's system. She will recover. Bernard Waite, deputy sheriff, said that the girl mashed up camphor mothballs and rat poison and was drinking the mixture when found by a brother, who notified the police.

I decided to investigate. Excerpts from my notes include the following:

Family of 13 lives in dilapidated shack on edge of cemetery. Father was employed as carpenter on the WPA, earning $15 per week. Stole cigarettes and given year in prison. One of the daughters is 17 years old. She lives in Miami with her three children. Her husband also in jail. County paying mother $3 per week as a pauper. She and five of her children sleep on pile of rags, with clothes on. Baby, 5 months old, in filthy crib, covered by mosquitoes. Has severe chest cold, mother rubbed it with Vaseline. One kid named Peek-a-boo, another Niggerboy. School principal sent one boy home without lunch for being "too dirty to eat." Mother said, "I feed them once in a while."

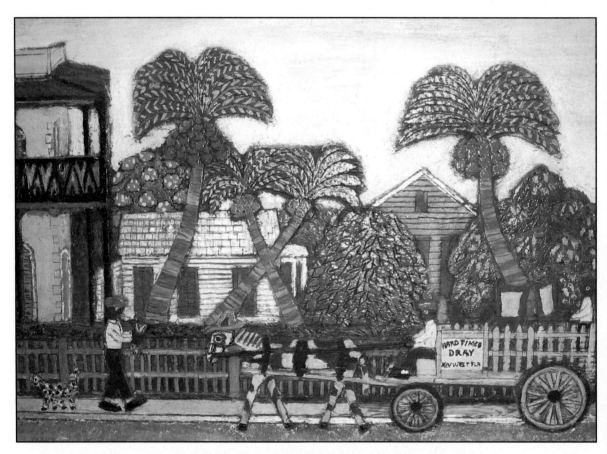

Drays like this would take anything anywhere on the island for fifty cents.

Key West Characters

Ever since the takeover of Key West from its native inhabitants, Key West has been a Mecca for nonconformists of every description. Just why this is so is not known. Nor does anyone seem to know whether the original Native American inhabitants were given to unorthodox or eccentric behavior. In any case, the coming of "civilization" brought with it a long procession of individuals whose deeds and deportment would be questionable almost anywhere—except in Key West. (Some of these tales are in Key West lingo and were told to me during the 1930s. Some were recorded for the WPA Florida Writers Project, and may be accessed at the Library of Congress website.)

Black Caesar

The exploits of Black Caesar have never been reliably recorded, and many different and conflicting tales are told of his depredations. It is generally agreed, however, that Caesar was an African who escaped from a wrecked slave ship. It is said that for a time he engaged in single-handed piracy, and later captured his first prize in the same fashion; pretending to be adrift in a small open boat, he was picked up by a sloop and soon disposed of its captain and those of the crew who would not join him.

At Black Caesar's Rock there is imbedded a huge iron ring, which he is said to have been used for careening the masts of his ship from the sight of passing vessels. When they came close, he

Key West has had more than its share of characters. In the 1940s Mario Sanchez painted this man who lived out of the cigarbox on which he was sitting. He's drinking his favorite: sourbelly wine.

would release the rope holding down the mast and sail after them in hot pursuit.

Black Caesar became a trusted lieutenant of the pirate Teach, otherwise known as Blackbeard. Their ship, the *Queen Anne's Revenge*, was captured by U.S. Naval Lt. Robert Maynard.

Tales of Black Caesar's cruelty, his Babylonian love of luxury, his passion for jewels, and his ambition to rule the Southern seas, have filtered down through the years, distorted no doubt, but indicative of his character. His harem is said to have once contained a hundred women.

Records in the Library of Congress give some basis to stories that Caesar maintained a camp of stone huts, probably in the vicinity of Elliott Key. In the end the camp was deserted, and his crew and prisoners left to starve. His children and theirs did not all die, but wandered about the Keys like wild animals, eating what berries and seafood they could get. Too young to know more than the bare rudiments of a language, they developed in time a language of their own. Perhaps these creatures were the basis of Indian legends, which speak of the region as being haunted.

Key West's First President

In January of 1828, the Legislative Council of the Territory of Florida adopted an act to incorporate the "Island of Key West." This document has been lost to history, but no matter, as it was superseded in November of that same year by a measure to incorporate as the "Town of Key West." This ordinance provided for a president for the city in 1832. He was assisted by a half-dozen councilmen. These noteworthies were empowered to enforce the laws of the territory and those of their own making, but they were limited in their powers to levy taxes or regulate any "hawkers, peddlers and transient traders." The City Fathers had asked for this authority with a view to running Jewish street peddlers out of town. Instead, the peddlers parked their carts and opened up shops, soon taking a place among Key West's leading citizens.

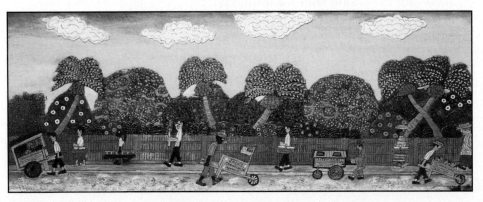

Everyone in this Sanchez art is a peddler, including the man to the far right, who is Macara, the bolita *numbers seller.*

Norman Sherwood: First to Be Hanged

The distinction of being the first man to be hanged in Key West goes to Norman Sherwood, strung up in accordance with the law on December 10, 1830. The charge was murder in the first degree. According to accounts, Sherwood had a run-in with a man named Jones on July 5 of that year. Sherwood went on his way, but returned soon afterward with a pistol, avowing his intention to kill Jones. John Wilson, who was Sherwood's partner, stepped up and asked him to give him the pistol, but Sherwood refused to do so, and further vowed that he would shoot any man who attempted to take it from him. Wilson attempted, and Sherwood shot him dead. He would admit no remorse, insisting that he had given his partner fair warning.

During the five months between the shooting and the hanging, Sherwood was kept in a makeshift jail from which he could have easily escaped. Asked why he had made no attempt to do so, he replied, "They want to hang someone to set an example, so I guess I'll gratify them."

Jacob Housman's Wrecking Empire

While the wrecking masters as a whole were a colorful lot, none among them was nearly so variegated as Captain Jacob Housman, who carved out a wrecking empire for himself, encompassing the Upper Keys and tip of the Florida peninsula, which he ruled as a veritable czar from the capital he built on tiny Indian Key off Lower Matecumbe.

Constantly embroiled with the salvage court and commission in Key West over his share of the spoils, in 1825 he resolved to move his base of operations to eleven-acre Indian Key, which had a deep harbor and was situated in the very heart of wrecking territory. Paying the few fisherfolk he found encamped there to move elsewhere, Housman proceeded to build a mansion for himself (and install a beautiful bride therein), a fabulous "Tropical Hotel," capacious wharfs, warehouses to accommodate the salvaged ships and goods, homes for his administrative assistants, cottages for his employees and slaves, and landscaping for all.

Wrecking masters up and down the Keys welcomed the opportunity to bring their prizes to Indian Key, far from the watchful eyes of the U.S. salvage commissioners in Key West. Housman himself, rather than let the salvage court in Key West pass judgment on his share of the spoils, would tow his prize all the way to St. Augustine, where he felt the salvage court would give him a better deal.

Indian Key not only became a focal point for salvage

operations, but for turtling and fishing as well. In 1832 the U.S. government established a customs house on the isle, with Charles Howe as inspector. At the same time, a post office was installed, with H. S. Waterhouse as postmaster.

In 1835, Customs Inspector Howe was able to report that 703 ships put into Indian Key that year. That this amount of traffic made Indian Key a rival of Key West as a port of entry is indicated by the fact that, although in a county named Dade (as Dade County extended down into the Keys at this time), it was really Housman's county. He built a courthouse on Indian Key at his own expense, installed in it county commissioners and employees of his own choosing, and made arrangements for a superior court session to be held there once each year.

Indian Key came to rival Key West not only as a port of call, but for its nightlife as well, despite its mere eleven acres. Pioneering the "tourist" industry in Florida, Housman's Tropical Hotel began to attract visitors of note, among them the distinguished ornithologist John James Audubon, who set up a base in the hotel for the study of bird life on the adjoining Keys. But in short order he complained that the all-night dancing and carousing of the inhabitants, from which there was no escape, interfered with his sketching, so he packed his brushes and specimens and moved on to the relative quiet of Key West.

All of Housman's successes were brought to naught, however, by one fatal mistake. In 1840 he prevailed upon the Florida territorial legislature to enact what was, in effect, a license for him to stage an Indian hunt. What's more, the enactment went on to provide for a bounty upon Indians—men, women, and children. When the Seminoles got wind of it, they decided to make a preemptive strike. A band of Seminole Indians attacked Indian Key on August 7, 1840, and put the torch to almost the entire settlement.

Refugees poured into Key West and the entire island panicked in fear that Key West would be next. Makeshift fortifications were thrown up, and U.S. naval vessels on maneuvers in Cuban waters were asked to come to the rescue. But nothing more happened.

One survivor of the massacre, James Williams, walked the streets of Key West for years, periodically shouting, "The Indians are coming!"

Housman put what few small boats and slaves he could salvage up for auction in Key West. Several times convicted of embezzling cargo from vessels he had salvaged, and finally stripped of his wrecking master's license, Housman took a job as mate on the ship of one of his former rivals. Less than a year after the fall of

his empire, Housman was crushed to death between two hulls in a rolling sea as he was trying to board a stranded vessel.

Today motorists on the Overseas Highway can see Indian Key to the east, but if they were to go there by boat, all they would find left of Housman's empire would be the cisterns he blasted out of the coral rock. Perhaps the name of this tiny killing-ground should never have been changed from Matanzas.

Squire Egan: "Wreck Ashore!"

The most-oft-told tale about Key West is likely the one about "the good Squire Egan," who, in addition to being master of the wrecking vessel *Godspeed*, preached the Gospel on Sunday evenings in the upstairs auditorium of the county courthouse. (Apparently, Key Westers were not inclined to take the constitutional insistence upon separation of church and state all that seriously.)

The rostrum that served as pulpit afforded an excellent view of the harbor, and on one occasion, the story goes, Squire Egan, looking over the heads of his congregation, saw a merchant ship go hard aground upon a reef. Knowing that a number of other wrecking masters were seated among his flock, he walked down the aisle giving no hint of his discovery, but waxing more vehement as he went.

Upon reaching the door Squire Egan cited the scripture, "Know ye not that they who run in the race run all, but one receiveth the prize? So run that ye may obtain!" Then with a loud cry of "Wreck ashore!" he raced for the waterfront, with the other wrecking masters hot on his heels.

According to the story, the prize on this occasion went to the *Godspeed*, captained by none other than the good Squire Egan.

When Audubon Came to Town

It was May 4, 1832, when John James Audubon, the distinguished ornithologist whose illustrated classic *Birds of America* had already appeared (in a limited edition at $1,000 per copy), arrived in Key West on the cutter *Marion* out of Charleston. A Key West newspaper of the time reported his visit:

> It affords us great pleasure to state that this expedition has given him much satisfaction and added largely to his collection of specimens, etc. Mr. Audubon is a most extraordinary man, possessed of an ardent and enthusiastic mind and entirely devoted to his pursuits; danger cannot daunt him and difficulties vanish before him.

During his stay here his hour of rising was three o'clock in the morning; from that time until noon and sometimes even until night, he was engaged in hunting among the mangrove keys, despite heat, sand-flies and mosquitoes.

On his return from these expeditions his time was principally employed in making sketches of such plants and birds as he may have procured. . . . The favorable impression which he produced upon our minds will not soon be effaced.

In the course of his Key West sojourn Audubon discovered the white-headed pigeon and another species, which he named the "Key West pigeon," both native to Cuba and previously unreported anywhere in the United States. Both varieties had once been plentiful on the Keys, but as of 1922 not more than ninety-nine of the latter variety had been seen in the previous thirty years.

Audubon painted the white-headed pigeon perched upon a "Geiger flower," otherwise known as the rough-leaved cordia, only two specimens of which were to be found in Key West at that time, both in the yard of Dr. Benjamin B. Strobel. It subsequently became widespread over the island.

Provost Filor: Locked 'Em in the Markethouse

Miami Beach and Palm Beach still had ordinances in the 1940s to keep African Americans off the streets after a certain hour at night unless they could prove they were there on business in the employ of some white person.

There used to be such a law in Key West. In 1840 the records show that there were "76 free Negroes and 96 slaves" in the city. At that time there was an ordinance that forbade any black to be on the streets after 9:30 at night. The curfew bell rang at 9:00 as a warning for blacks to head for home, and it rang again at 9:30 to signal that their time for getting there was up. To be on the streets after the curfew, a free black had to have written permission from the mayor or an alderman; a slave had to have written permission from his owner.

Free or not, blacks were not permitted to play the fiddle, beat a drum, or make any other kind of noise after the bell rang, again without written permission from the mayor or an alderman. Every white citizen was empowered to apprehend any black violating this ordinance, and take him before the mayor or an alderman and obtain an order committing him to jail. The penalty was being whipped or put to work on the streets for three days. Offenders were placed in the markethouse—a sweat box twelve by twelve by

seven feet, with one door at the front and a twenty-one-by-twenty-one-inch grille window at the rear, which they say afforded a splendid view of the ocean.

By 1850 the ordinance was being enforced by James Filor, then provost marshal. He started ringing the curfew bell at 9:25 every night, and kept ringing it until 9:30. This of course prompted the blacks to run for home, trying to get there before the bell stopped ringing. When Key Westers would see one running, they used to sing out:

> Run, nigger, run!
> Filor will get you!
> Wish I was in Filor's place,
> I'd give them niggers
> A longer race!
>
> Oh, Filor's sly as a mouse,
> Locked the niggers in the markethouse;
> Kept them there till half past nine,
> Five dollars was their fine.

Somebody dug up an old letter published in the *Key West Citizen*. It was from William C. Maloney, and was dated December 11, 1854. Maloney, who had served a term as mayor of Key West, was writing to Filor, who had been elected state representative, protesting a new state law that let blacks and mulattoes buy one quart of liquor if they had a written order from a white person. So the legislature amended the law to forbid blacks to buy liquor under any circumstances, leaving only mulattoes free to buy a quart on behalf of some white person.

It is perhaps worthy of note that when the U.S. Army started to build Forts Taylor and Jefferson in 1845, it rented slaves from their Key West owners to do the work. (Uncle Sam a slave-driver? Right!) By 1888, nearly a quarter-century after the Civil War, times had changed to such an extent that the *New York Age*, an African-American paper, described Key West as "the freest town in the South, not even Washington, D.C. excepted. There are no attempts at bulldozing and intimidation during campaigns and at elections here. No Negroes are murdered here in cold blood, and there are no gross miscarriages of justice against them as is so frequently seen throughout the South." At that point in time there were 5,654 African-Americans on The Rock, representing thirty-one percent of the population.

This is not to say that Key West was not a Jim Crow town. As

late as the late 1930s, the *Key West Citizen* was printing a first-page editorial "To strictly remind our colored citizens that they are to do their Saturday evening promenading on Whitehead Street, not Duval."

Sandy Cornish: Before He'd Be a Slave

In 1865, when the Civil War came to an end, U.S. Supreme Court Justice Salmon P. Chase decided to make a tour of the South in order to assess its postwar needs and prospects. With him went journalist Whitelaw Reid, who not only wrote frequent dispatches, but also in the following year published a book on things seen and heard during the tour. In telling of the justice's visit in Key West, Reid recounted the story of Sandy Cornish. A black man with a physique like a prizefighter, Cornish was born a slave in Maryland about 1803. He managed to purchase his own freedom and that of his wife Lillah for $3,200. For a time they lived in New Orleans. His home was mysteriously burned and his manumission papers establishing his freedom were destroyed in the fire. Soon thereafter a gang of white men set upon him with a view to selling him on the slave market; but he seized one by the heels, and whirling around, knocked down all the others. Later, he got word that they were going to try again. With his wife and a wheelbarrow he went to Jackson Square. After mounting the barrow and attracting a crowd, he proceeded to stab himself in the hip, sever the tendons in both ankles, and chop off several fingers, which he proceeded to smoke like cigars.

"How much do you suppose I would bring in the slave market now?" he shouted to the crowd.

His wife trundled him, bleeding profusely, in the wheelbarrow to their home. There were no further attempts to kidnap him.

Cornish and Lillah came

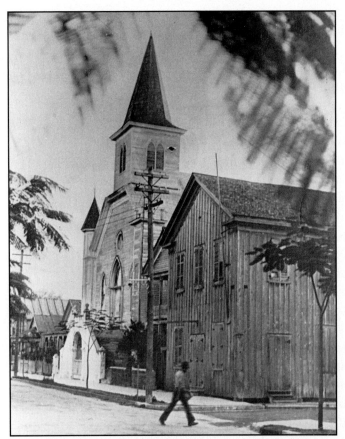

Cornish Memorial AME Zion Church, dedicated to Sandy Cornish, who chopped off some of his own fingers to avoid being sold into slavery.

to Key West in the late 1840s and established a highly successful fruit and vegetable farm near what is now Truman Avenue and Simonton Street. It was there that Justice Chase and journalist Reid interviewed him in 1865, listened to his story, and sampled his fruit.

During the Civil War, Union soldiers were frequent customers, and in time Cornish became one of the richest men in Key West. In 1864 Cornish established the African Methodist Episcopal Church at 702 Whitehead Street, which has served ever since as a memorial to this man who chose to mutilate himself rather than be sold back into slavery. He passed away in Key West about 1869, and in 1987, when the Key West Historic Memorial Sculpture Garden was dedicated to the island's thirty-six "most influential people," the bust of Sandy Cornish was among them.

Colonel Joseph Morgan: "Deport All Rebels!"

The year was 1863, when Federal forces were in possession of Key West, and using it as a base of operations to intercept ships carrying cargo bound for the Confederacy. Some Key Westers professed Unionist sentiments, but most were ardent though silent believers in the Confederate Cause.

In February of that year, the military commander of Key West, Colonel Joseph Morgan, issued an evacuation order that all persons, male and female, and regardless of any professions of loyalty to the Union, who had any near relatives living anywhere in the Confederacy, would be deported within the month to the Federal base at Hilton Head, South Carolina, where they would be turned over to Confederate authorities.

"The town," a loyal citizen wrote at the time (as quoted in Maloney, *Sketch of the History of Key West, Florida*, 1876), "has been in the utmost state of excitement. Men sacrificing their property, selling off their alls, getting ready to be shipped off; women and children crying at the thought of being sent among the Rebels."

Protests from U.S. civil officials and the local Naval officers were unavailing. A transport was set to leave February 27. The evacuees' baggage was on the dock when Colonel J. H. Good arrived from Hilton Head, replaced Colonel Morgan, and rescinded the deportation order.

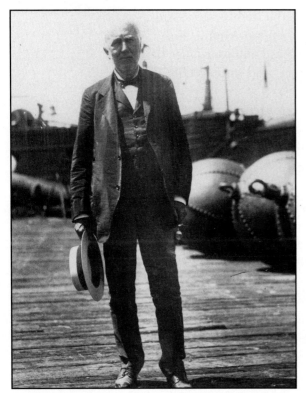

Thomas A. Edison, who gave the world electric lights, standing on dock at Key West Naval Station, 1914. According to local legend, Uncle Sam hired him to come up with a "death ray" to use on the Germans in World War I.

Thomas A. Edison: Tested His Death Ray on Goats

This story was told to the author on April 25, 1939, by Louis Avalo, a Key Wester who said he had been all over the United States. Avalo was forty-five years old at the time, and worked variously as a fisherman, fishing guide, and on WPA construction projects. He had chaired a strike committee of WPA workers in 1935 in their bid for an increase in their weekly wage of $6.65. The tale he told was to the effect that, according to historical sources, the inventor Thomas Edison was working in the Florida Keys for the U.S. government during World War I, conducting experiments with anti-submarine depth bombs. As a teller of tales, Avalo was less emphatic than most.

"Understand now," he began this one, "I'm not telling this as if I knew it to be the truth, because I don't. But a lot of other people in Key West will swear that it is true.

"During World War I, Edison came here to do some experiments for the government. They built him a laboratory out on Indian Key where nobody could bother him or see what it was he was doing. They wouldn't allow no boats to go anywhere near there; fishing boats and yachts had to stay away.

"The story people tell is that Edison was not only working on depth bombs, but also on some kind of Death

A mama and baby goat make themselves at home on the porch of a Key West cottage.

Ray that would kill anybody or anything, and stop any machine just by shining its light on them. They say he made one, too, and to check it out put a herd of goats on one of the Marquees [Marquesa Islands], eighteen miles away from Man Key. They say Edison burnt 'em all up with that Death Ray of his, but nobody never heard no more about it."

Sylvanus Johnson: Said He Was Innocent

It was the year before the Spanish-American War when a black man named Sylvanus Johnson was rumored to have "insulted" a Cuban woman.

Then one day when Johnson and some other blacks were passing a grocery store on Whitehead Street that was run by a man named Gardner, Gardner said something to him, and Johnson allegedly shot him.

They locked Johnson in the jail and there was talk of lynching him.

Crowds of white men began to gather at different bars all over town. When blacks heard about it a big crowd of them went down to the jail to save Johnson from being lynched. The two crowds, one white and one black, met at the jail and it looked like there might be a riot.

Frank Knight was sheriff of Monroe County then. He was the only sheriff in the county ever had any guts. He stood up in the door of the jailhouse, and dared 'em.

"No man," he said, "black or white, is going to take my prisoner out of jail! When I took office I give my oath to protect my prisoners with my life. Wait until the law gets through with Johnson. If the law turns him loose, I don't care what you do with him."

Sylvanus Johnson always did say he was innocent, but the jury said he was guilty, so the jailor hanged him.

Captain Charlie Coker, Brute

I gad, Charlie Coker was one whale of a man. 'E was a hellova man! That yellow-headed, trench-mouthed sonofagun weighed all of 225 pounds and stood six feet two. I mean 'e was solid muscle, too. 'E didn't 'ave no belly to 'im. 'E was all man. 'E was there.

'Is bloody fingers was big aroun' as my wrist. I shook 'ands with 'im once and 'e liked to 'ave ruint me. I should've knew better—rot me if nobody could 'ave turned me to do it again. Oh, 'e was a powerful monster, a brute!

Coker was captain of the *Heron*, one of the old-time sailin' spongers in the days when spongin' was a big thing in Key West.

'E was the best in the trade. There are lots of stories told about 'im, and I know one to be a fact. 'E was caught in a heavy storm up at Bay Hundy [Bahia Honda], and the *Heron* couldn't live into it. Coker luffed 'er into the wind and lowered 'er sails to keep 'em from bein' torn to shreds. The wind was drivin' the *Heron* straight toward the reef, so 'e bellowed to the crew to 'eave over the anchor.

The anchor weighed five hundred pounds, and the whole crew of three mens was up there on the bow a-strainin' their guts tryin' to get it over the side. They was all three good men, and was putting out everything they 'ad, but they couldn't manage to get it over. The wind and current was drivin' the *Heron* a-hellin' for the reef, and old Charlie was a-cussin' the men for all 'e was woith! Finally he seen she was goin' on the rocks for true if the anchor wasn't got over in a hurry. So 'e jumped up on the bow and nearbout knocked them other men overboard. Then 'e stooped over, picked up the anchor, and 'eaved it way out over the side, proper, without so much as a grunt!

There's something else told on 'im I wouldn't swear to be true. It may just be Conch talk, but I'm heard people say it so much I'm kinda' believe it's so. They say one time Coker 'ad a big black man workin' on the *Heron*, and the man said somethin' that didn't suit Coker's humor, after Coker 'ad done told 'im to close 'is trap. So Coker 'auled off and 'it the man on the jaw and killed 'im perfectly dead with one punch! By Jimminies, 'e could've done it, too! People say if 'e'd started out to be a prize fighter 'e woulda been famous that way.

My God, could Coker drink! 'E would kill one quart right after another. It didn't make no matteration what it was—rum, gin, whiskey, awgydent [*Aguadiente*]—any blamed thing 'e could get 'old of. One night 'e was whoopin' up a jimboree in No Name Bar up on No Name Key. 'E 'ad done drunk a coupla' quarts and 'is money was run out. So Coker picked up one of them bottles of red-hot Tabasco sauce and swore up and down 'e'd drink the whole damn thing if anybody'd buy 'im a drink! There was some stranger at the bar, and 'e said, "'Ell man, if you can drink that bottle of sauce I'll do better than buy you a drink—I'll buy you a quart of whatever you want, and give you two bucks besides!"

"Open a quart of awgydent," says Coker. Then 'e took a full bottle of Tabasco sauce, knocked the top off on the edge of the counter, and poured it all out in a glass. 'E drank that Tabasco in one swallow, and chased it with the quart of awgydent!

You can bet your ass Charlie Coker was a brute! Nobody can dispute that.

"Fried Egg": The Roaring Twenties

(From an oral history of Edward Freyberg, taken by Stetson Kennedy at Beluthahatchee, October 19, 1988.)

When I was growing up in Key West back in the 1920s, everybody called me "Fried Egg," or *"Huevo Frito"* in Spanish. My real name being Ed Freyberg. I guess they came up with Fried Egg because it rhymed.

My dad worked down at the ship dock—in the purser's office. Part of his job was to confiscate the liquor the passengers tried to smuggle in from Havana and charge them five dollars per bottle for breaking the bottle (and the law).

They used to keep someone on duty at the Customs House all night, to keep liquor from being smuggled in off the ships. But the way that worked, one of the smuggler's friends would take the customs agent around the corner to a restaurant, and the smugglers would bring the stuff off the ship and hide it under the dock. Then a cab driver would drive up in his Model-T Ford and haul it off.

Did you ever hear about the Whiskey War in Key West? It must have been about 1930. Some of the rumrunners were hiding their stuff in a big concrete-block building out there on Flagler. They got into a fight—accusing each other of stealing their stuff— and somebody set fire to the building. It burned for days and days—all that alcohol going up in smoke.

All those ships were operated by the Peninsular & Occidental Steamship Company—the P&O. They were big oceangoing ferryboats—carried tourists and their automobiles to Havana, Tampa, and places like that. I still remember their names: *Dolphin, Thunderbird, Cuba,* and *Miami.*

Me and my friends used to go down to Jesus Carmona's ice cream parlor, El Anon—that means "sugar apple," a tropical fruit, nothing to do with apples. Jesus wasn't supposed to be selling liquor, but we would go out in back and drink *compuesta,* which was nothing but *aguadiente* with a stick of cinnamon in it. *Aguadiente* means something like "fiery water." It's the first stuff that comes off when you're distilling rum—180 proof. You

Ed Freyburg, known as "Fried Egg". He tells that his grandfather was an officer in Emperor Franz Josef's Imperial Guard, who, according to Fried Egg, "got his wine and women mixed, and had to skedaddle."

drink one glass and you felt like flying. Cost ten cents.

I started drinking when I was twelve. I remember my dad came home one day with a five-gallon demijohn of rum. Paid five dollars for it. He put it in the closet, and told me he didn't want me sneaking any. But every day when I came home from school, feeling tired, I'd help myself to a little nip.

My great-grandfather was named Philip Fontaine. He was a front man for that famous horse race gambler from Idlewilde Farms, Colonel Leon Bradley. He was a colonel in the Empress Guard, but he got his wine, women, and song mixed up and had to come to this country.

When he married my grandmother without his dad's permission, and outside the Jewish faith, his father disinherited him. He had a casino across from the Ponce de Leon Hotel called the Bacchus Club, and my grandmother, who was a very strait-laced Christian lady, was not at all happy about the people he associated with.

The house I lived in in Key West had fourteen rooms, and was the first on the island to have electricity. You could turn off every light in the house and the meter would still keep going around.

Key West Cubans had a fraternity they called *Caballeros de la Luz* [Gentlemen of the Light]. It was supposed to be strictly for Cubans, but they invited me to join. Every Halloween we put on uniforms and paraded through the streets.

The Klan used to parade down Duval Street a lot—once a month, if not every two weeks, about two hundred strong, and some of them on horseback. They were mostly against Catholics and Jews. The Catholic Church in those days was on Duval Street, right across from the Episcopal. I'd still like to know why it burned down. I do remember driving down Flagler Avenue and seeing somebody with tar and feathers on them.

I was just a kid when the Klan killed Isleño. One of the Klansmen who took part in it—I'm not going to name his name, but he was a very prominent man—hid out at our house, slept there, with a gun, because Isleño had recognized him and some of the other ones who flogged him and swore he would kill them all.

There was a time when a bunch of gangsters from up-country decided they would come down and take over Key West. But when they got here our Key West gamblers met them at the train and advised them strongly to go on back where they came from. They took the advice.

During the WPA days I went to Key West on my honeymoon, and was walking along Duval Street when a man who was digging a ditch looked up and said, "Fried Egg! What are you doing here?"

That night my bride and I went out to Raul's Club and this dude from the ditch came up to our table, dressed like a millionaire! Key West was like that.

We used to go to the Monroe Theater—that was before the Strand was built—for ten cents. Whenever there was a Western playing—Tom Mix, Hoot Gibson, or Ken Maynard—us boys would be there. Sometimes there would be a group of women there—Miss Alice with her girls from the Gold Chalice out on Division Street, and Big Annie with hers. You could tell what they were, because they were all so pale.

I had a cousin named John Denim—lived right next door to me. His dad used to love to drink. I saw him get so drunk one night he climbed up the vines that were growing all over the house, like an ape man, and kept hollering "Whoopee!" Folks walking home from church didn't know what to make of it.

Did you ever hear about the time they thought they had struck oil in Key West? It must have been in the late twenties. Right down there across from the synagogue, next to the Key West Drug Store. They pumped and pumped for weeks and months, but nothing ever came of it.

Hemingway? That place was previously owned by the Pattersons, and I used to play in the yard. I remember one time Hemingway caught a great big sailfish or swordfish, and hung it down in Norberg Thompson's ice house. People came from all over to look at it.

Way back before the Spanish-American War my grandfather Wolf was walking along the beach and saw a big barrel floating in. When it got closer, a man stepped out and waded ashore. His name was Carlos Hernandez, and he was my mother's godfather. So we took him in. This was when Cuba was fighting for independence from Spain. He was a big man in that fight. The Spaniards were after him, so somebody brought him over and dropped him off in that barrel. When Cuba won her freedom, he was named the first Minister of the Interior.

I remember when I was just eight or nine years old, my great uncle John Baldwin was a fireman, and the fire truck turned over on him. It was horse-drawn. He went back to work in a few days, but then as he was coming out of the Strand Theater a friend hit him and broke his leg and his knee. The doctor said he'd never walk again. But he went very religious and kept going to this little shrine, and finally one day he came walking home with his crutches under his arm.

There were a lot of funny things about Uncle John. He could pet the most vicious dog. And he could go to birds. The birds would

jump on his hand. There was this enormous blackbird, flew down
the street with him wherever he went. When he went to the butcher
shop, that bird would sit on the roof and wait for him to come out.

My cousin Angela Baldwin was a nurse, and after the big 1935
hurricane that killed so many people, she went up on the Keys to
try to help out. She told me one time she was sitting on a beach up
there, eating her lunch, when all of a sudden right next to her there
was a terrible explosion. It was the body of one of the hurricane
victims that had been washed up and buried under the sand by the
waves. She told me about another guy who had tied his child to the
top of a mangrove tree, and after the storm when he came looking
for his child, its body was still there, but its head was gone.

When they built the post office, the one they built in 1930,
one of the men digging the foundation found a keg full of gold. He
was a Key Wester, but after he found all that gold he disappeared
overnight, and nobody has ever heard from him since.

There was a Captain Bill Gomez, and I always thought he had
been a pirate. They found gold at a Key West house while trying to
sound the depth of a well. It was about three years ago [1985]—the

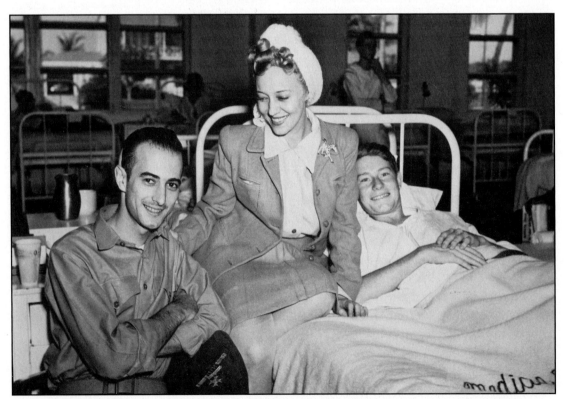

*Celebrated fan dancer Sally Rand, who lived in a dilapidated house near the Key West
cemetery, is shown here cheering up patients at the Naval Hospital.*

story was in all the papers. On Whitehead Street, right across from Hemingway's house. Everybody figured Gomez had put it there.

Sally Rand—the famous fan-dancer—when she was living in Key West she and my cousin Angela were great friends. Sally lived there close to the park, the park where the statue of José Martí is, in one of those old two-story houses with the paint coming off.

I remember there used to be a shoeshine boy with his box on the corner where the Kress five-and-dime was. He could purely make music, snapping that polishing cloth. They said that for a dollar, he would even crack his nuts.

Big Henry: "He's Got One Hooked!"

Big Henry wasn't really all that big—he was barrel-chested, and powerful, worked as a roustabout, or whatever you call them, down at Porter Dock.

FERA artist's portrayal of Big Henry with Big Fish.

Most of the time he would keep a line out for jewfish, *guasa*, we call them in Spanish. Don't know why that comes out jewfish in English. Anyway, it's a giant grouper; get to be five hundred pounds or more. And that's a lot of good eatin'.

Well, Henry didn't get paid all that much money on the job, so keeping a line out for jewfish made a lot of sense. He would take a good rope, with a short link of chain at the end and a shark hook, baited with a whole mullet or something.

So once he had his line out, Henry would go on about his work, but keeping one eye cocked on that rope. Whenever the rope started to move, Big Henry made his move. From then on, it was Big Fish versus Big Henry. Sometimes the tug-of-war would go on four or five hours. The very moment it started, the word went out all over Key West, "Big Henry's got one hooked!" So a whole lot of housewives stayed tuned to the Key West Express rumor mill, until the word finally came, "Big Henry's got him on the dock!"

As soon as they heard that, they would grab a pan and head for the fish dock, or send one of the kids, to get their share. I'm telling you, it hadn't been for Big Henry and his jewfish line, Key Westers would have been a whole lot worse off during the Depression. We may not have been eating "high off the hog," as the saying goes, but we was eatin' high off of jewfish, thanks to Big Henry.

And that's not all Big Henry is remembered for.

He was the only man on the island—and maybe in the world—who could get the husk off of a coconut with his bare hands. Whenever he was of a mind to, he would get himself a coconut, and

sit down on the curb with it, and start jabbing the stem-end on the curb until he got enough of the husk loosened up to where he could take hold of it with his two hands.

He would hold that coconut up to his chest, and pull and heave and grunt until finally that husk gave up and came on off. Big Henry wrestling a coconut was a sight to see.

Big Henry liked to drink, sometimes more than his share, and when that happened he most generally got into fights. I don't know whether he would start them, or the other fellow, but Big Henry always finished it.

There wasn't no 9-1-1 to call back in those days, but whenever word reached the police station that Big Henry was on a tear again—at Sloppy Joe's, the Bucket of Blood, or wherever—they sort of drew straws to see which ones would have to go bring him in, because more often than not the cops would get pretty roughed up in the process.

Big Henry was really a nice guy, and didn't mean nobody no harm. But when he was drinkin', and somebody started messin' with him, that somebody had better look out!

Jack Gage: Drank It All Up

Jack was a British seaman who, every time he was in port, never stopped drinking until he had spent his last cent. He made no apologies to anyone, including himself. "This way," he explained, "if I got drowned on my way back to the ship, I won't be losing anything."

Dr. Whitehurst: No Businessman

A veteran of the Spanish-American War, Dr. Whitehurst liked to put on his uniform and march in all the parades. But he failed so many times in business, he complained, "If I were to open a shoe shop, people would be born without feet."

Monkey Man: The First Help-Yourself Grocery

We called him "Monkey Man" because when he first came to Key West he was an organ grinder with a monkey that collected coins in his cap. His real name was Frank Mastragani—he was an Italian fellow. Some said he weighed close to seven hundred pounds, but that may have been an exaggeration. He ran a little grocery store right there on Duval Street at the corner of Greene. It was really just a shack with wooden shutters, which he would prop up over the sidewalk by day and let down on the windows at night.

I guess you might say Monkey Man invented the first self-service grocery store, way back there in the 1930s, long before

anybody had ever even thought of supermarkets. He was much too big to stand around and wait on customers, so he just sat in a chair out on Duval Street in front of his store, his shirt open, flies all over his chest, and sleep the day away.

Anytime anybody wanted anything, they would just walk right in and get it, and wake him up and pay him on their way out. Of course, those were hard times, and some folks didn't always wake him up or pay him. He kept a bunch of fruit and stuff on racks out on the sidewalk, and us boys would just walk by and help ourselves to whatever we wanted.

I remember one time we walked by with a fishing line with a hook on it, stuck that hook in a watermelon, and went on around the corner and started pulling that string. The watermelon would just slide on down Duval Street and around the corner, and we would run off with it.

There was a time when I was a kid when Monkey Man hired me to help out around the store. He used to sell chickens live, and whenever one got the least bit sick he would tell me to throw it out before all the rest got sick.

Before he ran his grocery store (see page 142), the Monkey Man was a street organ grinder with a capuchin monkey.

In those days my family couldn't afford to eat chicken or any other kind of meat except fish very often. So one day when I was wishing for some *arroz con pollo*, I took a needle and stuck one of those nice fat chickens in the head. It began to look sick right away, so I took it outside, woke Monkey Man up, and said, "This one don't look so good."

"Throw it out quick!" he said, and went back to sleep.

I had already told my kid brother to be waiting outside the back window, so when I threw it out he caught it, and that night my family had the best *arroz con pollo* you ever tasted.

Yeah, Monkey Man was a Duval Street fixture for many a year. I remember the *Septeto Encanto* street players made up a little *punto* (song) about him:

En la playa de Cayo Hueso	On the beach at Key West
Sacaron un tiburon,	They pulled out a shark,
Y del busque le sacaron	And from its stomach they took
Un Monkey Man en camison.	A Monkey Man in a nightshirt.

Coo-Coo Bobo: Crazy Like a Fox

Recorded by the author on Duval Street, 1937; available on CD from Library of Congress and Florida State Archive.

Coo-Coo Bobo? He thought he was Joe Louis, the heavyweight boxing champion of the world. He thought he was Franklin D. Roosevelt, President of the United States of America. He thought he was everybody.

He even thought he was a choo-choo train. And if you could hear, but not see, him imitate one, starting up and coming to a halt at the end of the line, you would think he was a train too.

I guess everybody knows what coo-coo means. And in Spanish *bobo* means fool. With a nickname like that, you might expect the worst. But the man we called Coo-Coo Bobo was neither crazy nor a fool. His real name was Fernandez, and he was an absolute genius of an impersonator.

I remember one time when the American Legion was holding its reunion in Miami, my father was in the Key West drum and bugle corps. When they went up to the convention, Coo-Coo went with them.

When they got there, Coo-Coo put on his crazy uniform that he had bought from some costume shop—nobody could tell whether it was for a colonel or an admiral—and drew his sword and directed traffic at the corner of Miami Avenue and First Street, in front of Burdines. The real traffic cops never said anything to him, thinking it was just like the Legion to pull a stunt like that.

But then after that Coo-Coo spotted a large vacant lot near the convention hall, so he put on a cap and painted himself a sign saying "Park All Day for $5." So while all the Legionnaires were carousing and spending their money, Coo-Coo was stuffing his pockets with $5 bills. When it came time to head back to Key West, everybody else was broke, but Coo-Coo Bobo was loaded. Call that crazy if you want to.

Another time when a battleship made a stop in Key West—its name was *Constitution*, and I think it was Italian—Coo-Coo put on his uniform and strode up to the gangplank.

When they saw him coming in that uniform, they started saluting him, ringing the ship's bells and piping him on board, taking him to be no less than an admiral. Coo-Coo got away with it for some days, being wined and dined at the captain's table.

Captain Joe Lester: Knocked Out Florida

Once upon a time, Captain Joe Lester, ship's pilot, got into a hassle with Sheriff Jim Jones.

"Hit me, and you hit the state of Florida!" Sheriff Jones warned him.

"Then down with the state of Florida!" bellowed Captain Lester, and floored Sheriff Jones with a single blow.

Happy Jack: Must Have Mutinied

People still talk about Happy Jack, who lived all by himself on Sugarloaf Key, way back in the nineteenth century. Nobody knew anything about him, except that he was English. Whenever a fishing or sponging boat came anywhere near, Happy Jack would dash out into the surf and try to buy whatever supplies he could from them. He always paid in gold, so everybody figured he must have been a pirate who had mutinied and made off with the booty.

Hector Barroso: Heard Chords in the Palm Trees

From an oral history recorded by Stetson Kennedy in Key West, November 20, 1988.

You're asking me about things I'm not sure I want to think about. I'm no good at remembering things—I just let them stay in the past.

I was born in 1918 when the First World War was going on. When I was a kid there was no restaurants, no nightclubs, no hotels, no boarding houses, no place to sleep. Nothing but mosquitoes that would kill you. But even so, the people in Miami were always jealous of Key West, because they knew that Key West was better in a lot of ways.

The Barroso family has been in music all the time. Both of my parents came from Cuba. My father conducted the Key West Hospitality Band all during the FERA and WPA years.

The big idea back then was to get culture to the people. So they painted murals all over post office and jook joint walls, and we took our band out of the music halls and played in parks and down on the beach, both daytime and nighttime. There was a big vacant lot right by the La Concha Hotel, and people would just sit there and listen.

When I was about nine years old I started making Cuban sandwiches—sat on a box on Duval Street and sold them to tourists for thirty-five cents. After a while I rented a little sidewalk stand for $1.50 a month. But by the time I was seventeen or eighteen I was playing the clarinet in my father's band. I wasn't thinking about much of anything but music. I even heard chords in the trees.

In addition to conducting the band, my father was working at a cigar factory. Sixteen dollars a week. My mother used to send me

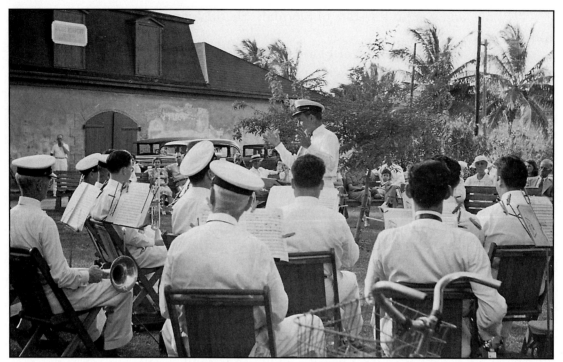

Key West Hospitality Band brought music to the people—outdoors in public parks and on the beaches.

there every Friday payday, before he could get to a bar. They paid off in script instead of money, and you could use it like money all over town, for liquor as well as food.

Duval Street was nothing but rocks, potholes, and white limestone dust. No matter what color cars were painted, in Key West they were all chalk-colored. Every once in a while the chief of police would say, "Our patrol cars are past due for a washing. Go round up Old Black Joe—he's almost always drunk—and we'll let him work out his fine."

By the time I was fifteen I had a band with my brother. Some of the ones who played with me were Ray Godana, Julio Lopez, George Curry, Drew Curry, Gussie Miller, John Pritchett, Delia Diaz, and Tony Thompson—we called him "Bumbaleah." We would play at Pena's Garden of Roses at the Naval Station, where I met a lot of big shots, including presidents. We also played at Sloppy Joe's, the original one.

Hemingway spent quite a lot of time there, and of course there was Skinner, the big black bartender. I remember one night, there was this guy sitting on a stool, talking, and all of a sudden he fell off, dead. His wife was there too, dancing. She said he had told her he wasn't feeling well and didn't want to go to Sloppy Joe's, but she made him.

At the corner of Angela and Whitehead Streets there used to be a Knights of Pythias hall. My band would play for dances upstairs. Some nights we would clear as little as forty cents, and split it between us five musicians. There was a grocery store across the street that had a slot machine, and every time I would clear as much as thirty cents, I would take a break, run across the street, and blow it all on that slot machine. They started to have jitney dances, the girls sitting around the wall, and sailors would come in and buy ten tickets for a dollar.

I started playing at the La Concha about 1940, and played there until about 1946, when I moved to the Havana Madrid Club. That was run by the Carbonells—Ignacio and Freddie. Our band used to play regularly until this new breed came down here and took over everything. They decided they didn't want local talent. They sent to New York for bands, paid $2,500, when they could have got us for $500, or maybe $400.

They don't want to have nothing to do with us Conchs. They're trying to alienate all of us Conchs off the island. I even read that in the paper—some newcomer said Key West would be a better place if they could get rid of all the Conchs.

When I was a kid sometimes the word would go around "the Feds are in town!"—meaning the revenuers—and everybody would gather up all their bottles of rum and stuff and take them out and smash them. Sometimes they would pay us kids to do it for them. Sometimes we broke them, sometimes we didn't—at least not until

The Havana Madrid Club, together with Pena's Garden of Roses in the Navy Yard and Raul's out on Roosevelt Boulevard, were no match for Miami's nightspots, but Key Westers weren't complaining.

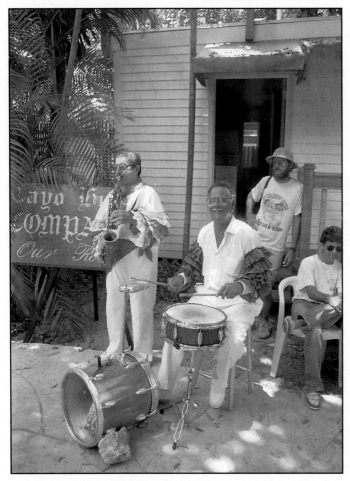

Hector Barroso (left) and Buddy Chavez in a 1991 backyard jam session.

they were empty.

We hardly ever called anybody by their right names—practically everybody on the island had a nickname. There was one guy we called *Caballo de Palo*—Horse of Wood—because he had such spindly legs. He used to tend bar. Now he is living somewhere in North Carolina. There was another guy we called Ache-in-Bungie. *Bungie* is Spanish slang for "ass"—and he really was a pain in the ass. And then there was "Hidey Bulldog Face." He used to stand there on Duval Street, with bricks stuck in his back pockets, and pretend to be a prizefighter. He'd offer to take on anybody who came along, but nobody ever took him up on it, because we all knew he wasn't really a fighter.

There was this place called Mom's Tea Room. Mom was from Georgia. Her husband used to go up to Georgia and steal young girls and bring them down here—white slavery. He brought them down full-grown, most of them about seventeen years old. We never knew whether they had been kidnapped, run away, or just plain liked the idea. When I was eleven years old, Joe Perlman's Dry Goods Store hired me to go around collecting on accounts and making deliveries. Sometimes he would send me to deliver shoes and things to Mom's Tea Room. Those girls would let me put their shoes on them, and when they did they opened up their legs and gave me a good shot of their girlishness.

There was another house on Petronia Street that was mostly black women. The Square Roof was the one with white women. When the sailors were in town they kept both houses busy. It didn't cost much in those days—two dollars.

Then there was Big Annie's out on Stock Island. Pete Nebo, he was a Key West boxer who got to be world welterweight champion.

Bought a place out there, him and his brother, which I believe was called the Red Door, but everybody called it the Bucket of Blood, I guess because every Saturday night the Conchs—the troublemakers—would go out there and have a big brawl.

Back in the WPA days they hired a lot of men with shovels filling up the holes in the streets. Many a time the shovels would be lying on the ground and them men sitting in the shade jabbering. Whenever anybody spotted a supervisor coming the cry would go up, "Find a hole!" And they would all jump up, grab a shovel, and start filling in some hole. It was sort of like musical chairs.

Don't you think you've heard enough? You're making me homesick for the days when Key West was Key West.

Killy-the-Horse: Cussed 'Em Back

As told to the author by Warren Gates.

I can tell you all about "Killy-the-Horse," because he was my uncle's brother. His real name was Felton—Leslie Felton was his name. He used to live over there on Nassau Lane, and had two sons, one named Leland, and I forget the other one.

Key West band leader Hector Barroso, photographed at his home in 1996. Note the five-gallon dark green demijohn in his lap, a relic from Prohibition days when rumrunners smuggled them in from Cuba. On today's antique market, the bottle would cost twenty times more than the rum.

Back before World War II there wasn't but two horse-drawn drays on the island. Killy-the-Horse owned one and a Sweden fellow owned the other. It was a four-wheel dray, with only one horse to pull it, and when it was heavy-loaded Killy-the-Horse would have to use his switch to make the horse go. He couldn't afford a good, strong, young horse—it was always one that already had one foot in the grave. They say he killed lots of horses that way, but I don't know if it's true or not. Anyway, that's why the kids all called him "Killy-the-Horse." Every time they would see him coming down the street they would jump on their bikes and circle his cart like Apaches circling a covered wagon, all the time yelling "Killy-the-Horse! Killy-the-Horse!" He would grab his whip and try to knock them off of their bikes, cussin' for all he was worth!

He was a heavy drinker—used to drink heavy. There was

WATER-FRONT PASS.

Port of ..

Pass *Leslie Felton*

Residence *Key West Fla*

Nationality *American*

Occupation *Driver*

Employed by *Am. Ry. Ex Co*

Date Pass good at *F E C Ry.*

No. **886671** *Nathan H Boswell*

92—1104 *United States Marshal.*

The real "Killy-the-Horse," Leslie Felton, as pictured on his waterfront pass.

another drayman, a Sweden fellow, and the boys gave him a hard time too. He had some sort of spastic problem, and when the boys started calling him "mayaya, mayaya," it made him more spastic than ever. Killy-the-Horse and Mayaya met all of the ships when they came in down at the Mallory Docks. They'd go down there, and anybody who needed anything hauled, Killy-the-Horse would put it on his dray and take it anywhere they wanted on the island for fifty cents. That was money back in them days.

Copper Lips

Oh, yeah, Copper Lips was a fisherman. I don't know why they called him that, unless it was because some of his front teeth was gold. His real name was Willard Baker and his skin was so tough from being out in the sun people said you couldn't cut it with a knife..

Besides being a regular fisherman, Copper Lips was the one who supplied tropical fishes for all the New York aquariums. He had half the kids in Key West catching tropical fish for him, and he'd pay them so much per fish, depending upon what kind it was. He kept those in cages hung overboard beside the wharf, and ever so often a ship would come in from New York and haul 'em off.

Copper Lips used to hang out on the corner there across from the La Concha Hotel. Him and another fisherman named Peter Roberts used to go out in their little sailboats and catch a well-full of grunts and bring 'em in alive right there in front of where the A&B Lobster House is now, and people would be there waitin' for him, to buy some of those fish. He had kraals, like cages, hung down in the water, and he'd keep those fish alive in there. You could come along, and point out the ones you wanted, and he would take 'em out, hit 'em on the head, and clean 'em and gut 'em for you. You could buy five or six grunts for $1.50. It was catch of the day every day.

Rickshaw: First with a Chauffeur

You never heard tell of "Rickshaw"? He was a man had one of those Model-T Fords, and everywhere he went on the island he had a chauffeur to drive him. I guess that's why we called him "Rickshaw." He was the onliest man in Key West with a chauffeur. Lived right there on Grinnell Street, in the 600 block. Rickshaw had plenty money. I don't know where he got it, but he had plenty. And that's all I do know about Rickshaw.

Don Pancracio and Timoteo

Cuba was ruled by the dictator Fulgencio Batista, aided and abetted by the King Ranch, British Electric Company, and Cosa Nostra.

Even so, each day on the Havana radio station CMCR, which reached the Cuban colonies in Key West, Miami, and Tampa loud and clear, a program known as "Don Pancracio y Timoteo" broadcast caustic satire and commentary on the Batista dictatorship and the hardships of the Cuban people.

Don Pancracio and Timoteo were in the best tradition of that long line of folk heroes who—like Chaplin in America, Cantinflas in Mexico, the Itching Parrot in Argentina, Quevedo in Spain, and Karagöz in the Ottoman Empire—have poked fun at the high-and-mighty at the risk of their own life and liberty.

The format for the Don Pancracio and Timoteo show was simplicity itself. An elegant, cultured *caballero* (gentleman), Don Pancracio was in the habit of taking his morning coffee in an unpretentious cafe. Invariably seated on the stool beside him would be Timoteo, a folksy, slow-spoken illiterate *guajiro* (peasant). Don Pancracio would read aloud from the morning newspaper, and Timoteo would offer pithy comments. At times Don Pancracio would expostulate, but nothing could stop Timoteo once he set out to speak his mind on the news of the day.

I still remember Timoteo saying, "All I've got to say is, if they don't stop shipping a major portion of Cuba's beef to the United States, a major portion of the Cuban people are going to have a major hunger."

The program was off and on the air as the censorship cracked down, and on at least one occasion, Timoteo was severely beaten by Batista thugs. Both Don Pancracio and Timoteo were eventually obliged to emigrate.

Horse of Wood: Blew It

His real name was Delfin Fernandez, but his friends called him
Caballo de Palo because of his spindly legs. When I recorded the
Septeto Encanto musical group on Duval Street in 1937, one of the
original songs they sang was:

El Caballo de Palo se casó	The Horse-of-Wood got married
Con una millionaria,	To a millionaire,
Y se arrancó.	And they went broke.
Pregunten por las once	They put it all on number eleven,
Por Chacho,	At Chacho's
Y este punto de Cayo Hueso	And this ditty of Key West
se acabó!	Is ended.

Toña la Negra: Wouldn't Keep Her Mouth Shut

Another unforgettable folk hero among Key West Cubans was
"Toña la Negra," a contemporary of Don Pancracio and Timoteo at
Havana radio station CMCQ, who put on a daily backyard gossip
column in rapid-fire black Spanish talk and song, all aimed at the
incumbent dictatorship of Fulgencio Batista.

Toña's *modus operandi* was to whisper, as if in your ear, the
latest dirt on the regime, and then, after the punch line, to break
into song:

Es mejor que me calle,	It's better if I shut up,
Y no diga nada.	And not say anything.
¿Quién sabe	Who knows
Quién están eschuchando?	Who might be listening?

Lalo Lopez: The Real Harry Morgan

(Author's note: Lalo was not his real name. His daughter says she
will kill me if I publish his real name.)

It was me and the boys gave Hemingway all that stuff he used in
writin' that book—what did he call it? Oh, yeah—*To Have and
Have Not.*

We spent a lot of time in Sloppy Joe's and was always askin'
him when was he going to write a book about Key West. Finally
there come a time when he said he needed money real bad, and had

to write something, quick.

We was all into rumrunning back in those days—wasn't much else anybody could do. We supplied all the bars and nightclubs in Key West, and shipped a lot too. We told Ernesto like it really was, but he put a lot of bunk in that book—all that stuff about Chinks. There was some Chinks smuggled in from Havana, but they were landed up the Keys—never at Key West. Most of the people smuggled in were Cubans, Spaniards, Slovaks, and such stuff. I brought my wife and her sister in from Cuba.

Once, when I was makin' a run I seen a monk [Chinese] clinging to a light buoy. Most of the boys runnin' aliens tied 'em up as soon as they got on board, so they could throw 'em overboard without no trouble. I was sittin' around this bar one time and a boatful of monks came in and tied up at the dock. The smuggler had tried to toss them overboard, but one had pulled a gun and shot him dead. So the monks just piloted the boat on into Key West. They was put on the next boat and headed back to Cuba.

I seen a funny damn thing up at Big Pine Key. A bunch of monks walkin' down the road. Looked like they had been walkin' for days. Wanted to know, "Which way to New York City?"

Not many Key West rumrunners were willing to pose to have their photos taken, but these were an exception. Evidently, a good time was had by all.

I mean them aliens caught hell. I heard guys in Cuba tell about takin' on a load of aliens, collecting their pay in advance, and then landing them on the other side of Cuba!

See that white launch out there? That used to be one of the best in the trade. I sold it to Garcia. Raul rents it out to fishin' parties now. He and Garcia used to run regular loads of rye, gin, rum, champagne, and wine. Key West was one of the only towns in the country where you could get the stuff delivered, and Garcia had a good reputation—he could practically guarantee delivery.

Sometimes we'd get as many as fifty orders and collect in advance before we made the trip. It wasn't but ninety miles over to Cuba, but that Gulf Stream gets mighty rough for small boats. I've crossed the channel in a storm with only a coupla' inches of freeboard above the water's edge. Used to hate to have the boys throw stuff over in deep water. A good friend of mine got drownded all because he was trying to save a few bottles too many.

We moved at night. Sometimes the customs pushed us so close we had to drop the load overboard. Then all they could hold us for was runnin' at night without lights. When they would get on our tail we'd make a run for shoal water where we could lose 'em, or at least drop our load in shallow water where we could pick it up later.

Cockeye Billy

Nobody never tell you about Cockeye Billy? He was a rumrunner with a reputation. We all called him Cockeye. He could swim like a fish, and that's how he made lots of his getaways. Any time he spotted a Customs boat on the horizon, he'd high-ball for shallow water—the nearest island that had mangrove thickets around it. You know, they call mangroves "the tree that walks on stilts," right out into the water. We kept a lot of tunnels cut into those thickets, with a supply of ready-cut branches lying around. All you had to do was snake your boat up into one of those tunnels and pull down the branches behind, and those Customs men never could find you, didn't make no matteration whether it was day or night.

There were times though when Customs caught up with Cockeye when he was still a couple of miles offshore. When they did, he just dove overboard—and that would be the last they would see of him—until the next time out.

Eventually they overtook him way, way out, and there was a shootout. Cockeye was hit—they know he was because there was blood all over the boat—and tumbled overboard. The Coast Guard, Border Patrol, and everybody joined in the search for his body, but they never did find it, and reported that the sharks had got him for sure.

Some Key Westers say they know better. They say Cockeye made it to shore and has been living happily ever after in Miami.

Pancho Macaro: Brought Us Bolita

It is not too much to say that gambling—along with cockfighting, meeting the boat, and promenading along Duval Street—was long the lifeblood of the peoples on The Rock.

The principal form of gambling was *bolita* (Spanish for "little ball"), although for generations playing "Cuba" (the national lottery of that island republic) was also an obsession, so that one day each week it was impossible to conduct a conversation on the streets or alleys of Key West, as every radio in every shop and domicile was blaring the singsong chant of Havana orphans who were employed to call out the winning numbers and their corresponding winnings.

Unrecorded history has it that *bolita* was introduced to Key West (and thence to mainland America) in 1885 by a Cuban named Francisco Gonzales, better known by his nickname, Pancho Macaro.

Bolita is said to be an adaptation of the age-old Chinese game of charada, which had a complement of thirty-six numbers, each of which was associated with some object, so that upon encountering one of these particular objects, or dreaming of it, a player would thereby be tipped off as to what number to play.

There were also such fixed associations between objects and numbers in *bolita*, and Hispanic children in Key West, Miami, and Tampa were apt to learn these even before the alphabet. Lest one forget, almost every household had its calendar or chart for ready reference.

Bolita was so called because the game was played with a hundred small balls the size of marbles, numbered from one to one hundred. These were placed on a tray for public display in the various *bolita* houses at the appointed hour for the "throwing," so that players could make certain that all numbers were there. The balls were then tied into a small cloth sack that is tossed repeatedly into the air, and finally out into the group of spectators, one catching it and isolating a winning ball inside by pinching the bag. The ball is then cut out as he holds onto it, and behold—the winning number!

Bolita *bag with winning ball.*

A five-cent ticket paid $4.00, a $1.00 ticket $80.00, etc. Tickets could be purchased at the *bolita* houses, or from one of the many well-known "*bolita* men" who roamed the streets and made regular rounds.

Popular knowledge had it that cheating sometimes took

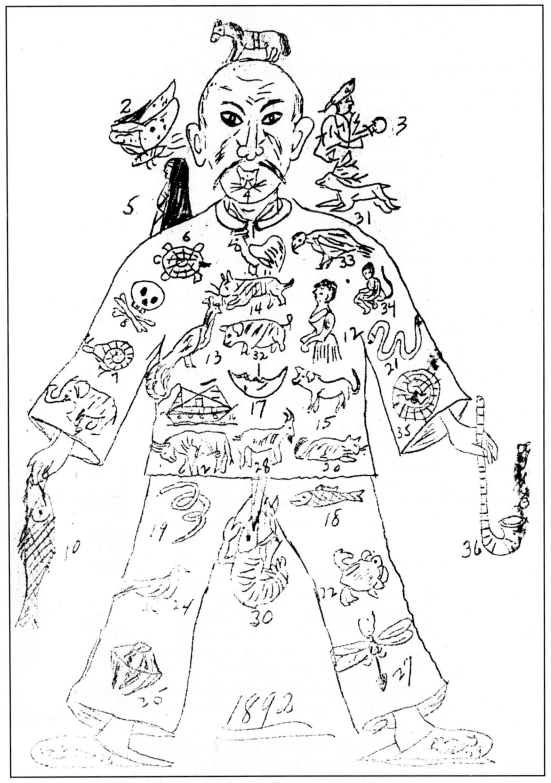

Legend has it that bolita is a descendant of the Chinese game of charada. This handbill, dated 1892, was disseminated in both Cuba and Key West. The association of certain "winning" numbers with certain symbols, whether seen or dreamt about, is still embedded.

place. One way of accomplishing this was for the *bolita* house
to secretly come up with a set of a hundred balls all bearing the
same number. These were then coated with clay, which was then
engraved with numbers from one to a hundred. The house was at
pains to see to it that the bag of balls was thrown into the hands
of one of its agents (incognito in the crowd of players), who when
he pinched one of the balls in the bag, did so vigorously enough
to remove the clay coating, exposing the "winning" number
underneath.

All across America, wherever *bolita* took root, mayors, sheriffs,
and police chiefs were accused—and sometimes convicted—of
exacting rakeoff for "protection."

At the beginning of World War II, a survey of Key West's *bolita*
houses identified thirteen as follows: Curro, Orange Inn, Trumbo,
Two Friends, Nancy, Broadway, Sunlight, Red House, Rocky Road,
Duval, The Club, Cuba, and 8 O'clock House. As a public service,
each house posted a list of all the other houses on its blackboard,
together with their winning number. A notice on the wall read:

> We Pay What the Ticket Calls For
> Examine Your Ticket Before You Leave

Key West's Last Pirate

When I first arrived in Key West as a lad of eighteen in 1935, the
driver of one of the island's fleet of three rickety cabs barely made
it from the bus station to 525 United Street, a two-story rooming
house (which still stands unchanged, except that its silver suede
unpainted patina has given way to glistening white).

Miss Mamie, the operator, was well into her nineties, and spent
her days on the front porch, rocking gently back and forth and
moaning softly, "I'm dying, I'm dying. . . ." From time to time
Undertaker Pritchard would stop by and ask, "Miss Mamie, you
ain't dead yet?" Miss Mamie would moan a little louder and shoo
him off her porch.

Among the other roomers, occupying one and the same room,
was one Raoul, who said he was the son of Key West's last pirate,
and Betty, who said she had followed the fleet from Hampton
Yards to San Diego, ministering to the sexual needs of Uncle Sam's
sailor boys. Sensing a lucrative story for *True Romances* magazine,
I bought her a nickel notepad and a penny pencil. She wrote two
versions of her life and times: "Can An Outcast Come Back?" and
"Was My Love a Sin or a Blessing?"

The fellow named Raoul always said his father had been the
last pirate in Key West. According to Raoul, his father was walking
along Duval Street one day, and some man walking behind him

gave him a Bronx cheer. Raoul's father spun around and spattered the man's brains with his diamond-studded walking stick. After that, he just kept on walking down Duval Street. Nobody never said nothing to him about it.

Manungo: Last of the Ñañigos

The Afro-Cubano known as Manungo had a *bodega* (grocery) on the southeast corner of Whitehead and Catherine. On *Noche Buena*

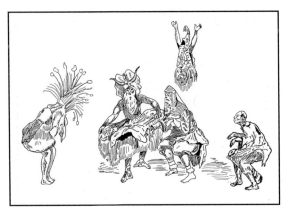

(Christmas Eve), after everybody had finished feasting on the traditional *puerco comino* (pork roasted with cumin seed), black beans, yellow rice, and sweets, Manungo would come out in the street in front of his shop and start tuning his goatskin drum by burning a wad of newspaper or can of Sterno under it. This dried out the moisture, which had made the skin slack while stowed away.

Soon he would be joined by others, dressed in African-style costumes and carrying bongo, timba, or tumbo drums. When everybody had finished tuning they would form a line and start dancing their

Diablito costumes from the National Museum of Cuba, Havana.

way down the streets, all over the island. Everybody else would come out to watch the procession, but you had to be ready to jump, because every now and then the *diablito* (Manungo) would take a

Mario Sanchez placed these ñañigo *dancers in front of Manungo's* bodega *on the corner of Catherine and Whitehead Streets.*

whack at somebody with his stick.

Manungo was the last of the ñañigos in Key West, and the last dance took place in 1923. As late as 1990 there was said to still be a surviving ñañigo in Tampa's Latin Quarter, named Orlando Rosales.

In Cuba the ñañigo clan was a secret society, started by slaves, something like the crocodile clan back in Africa. They even had their own language, *las palabras de ñañigo.* The clan got to be a big thing in Cuba, until the government had to stop it because people were turning up dead after the dances.

FDR Takes on Booze

I [Lalo Lopez] remember one time I had landed three hundred cases of booze up at Long Boat Key, and a conservation officer, a fellow by the name of Joe Knight, came up to me and said, "I hear you're a bootlegger."

"No, bootleggers make moonshine," I told him. "I'm a rumrunner. I don't bring in anything but the best there is—you name it, and I've got it. From Cuba, Spain, Scotland, Ireland, France, Canada."

Knight explained that he was serving as fishing guide for Governor Franklin D. Roosevelt of New York, who was anchored there in his yacht, and was interested in buying a lot of stuff.

"Okay," I told him, "I'll bring it around."

"Oh, no, you won't," Knight said. "We'll drop anchor on the far side of that key over there, and you bring it around as soon as it gets good and dark."

"Damnation!" I told him. "After I've gone to all the trouble of smuggling it in, now I got to smuggle it back out!"

We sweated getting a bunch of it back on board, and met offshore as we had agreed.

Roosevelt told us to put it a case at a time on the diving board he had at the waterline on the stern of his yacht, and open it up. He would then lean over and select a bottle, hand it to his secretary Missy, and tell her to open it and take a sip. He checked out every case that way, and Missy was getting plenty high.

"Look," I finally said to him. "I'd like a few samples myself. How about cracking a bottle of this French champagne?"

"Oh, no!" Roosevelt said. "I'll trust you on the champagne— just hand it up!"

He took on a lot of everything. The year must have been 1931, because I remember him saying, "I guess you realize that if the Democratic Convention nominates me for the presidency, and I win, the first thing I'm going to do is put you fellows out of

business!" In other words, he had already made up his mind to repeal Prohibition.

I saw him when he boarded a Pullman car of the Overseas Railroad in Key West to head back north. He had a stream of porters bringing heavy valises full of that booze from his boat to the train.

(Historical note: It was in 1924 that Roosevelt, together with Boston banker John Lewis, purchased a seventy-one-foot houseboat, powered by two thirty-five-horsepower inboard engines, for $3,750. The asking price had been $8,000. Originally named *Roamer*, the craft was recommissioned at Jacksonville in February, flying FDR's New York Yacht Club flag and a personal blue emblem designed by him. For her maiden voyage he hired Robert Morris as captain, at $100 per month, and his wife Dora as cook. With them went Missy, FDR's secretary. The *Roamer*'s log goes on to report that "J.L." roamed the ship naked, much to the disgust of the two ladies.)

Kill'em Grey: Last of the Chicken Thieves

This veritable folk character reputedly made his living entirely by stealing chickens. His biggest haul, the story goes, was made in 1927, when he emptied the hen house owned by the Cuban consul. Kill'em got every fowl in it, except for one rooster, which somehow eluded him.

Following the big hen-house heist, someone hung a sign around the surviving rooster's neck. It read (in Spanish): "Ever since June 5, I have lived all alone."

Here Hung Isleño, for Living with a Brown

As told to Stetson Kennedy by Norberto Diaz in 1938.

Every time I pass in front of the Cuban Club I think of Isleño. He was a good friend to me, a good friend to everybody.

The other day I was down to the beach and seen the palm tree where the Ku Klux hung him. It's a funny thing, but that was the first coconut palm to die from the blight that's killing all the coconuts on the island. People say the whole island's cursed, and that's why there is so much bad luck and people do not have enough to eat.

Isleño's curse has already killed five of the Ku Klux who beat him. There were about twenty of them, but he put up a terrible fight, tore off their masks, called them by name, and cursed them for horrible deaths in revenge. He shot one of them himself, another got caught in the 1935 Matecumbe hurricane, one was

blown up by dynamite while working up on the bridges, one was ground to pieces under his boat when it went on a reef, and another went fishing and never came back. Isleño's curse killed them all. It's killing another one of them with tuberculosis right now. . . .

I guess I can tell the story as good as anybody.

Isleño's real name was Manuel Cabeza; he was a Spaniard from the Canary Islands, and that's why we called him "Islander" in Spanish. He owned a little coffee shop and had a good business. He was one of them kinda' men what likes to spend their money for a good time. But he never caused nobody no trouble; all he did was be happy and enjoy life.

Isleño began living with a *morena*—a brown girl. I mean, she was a pretty thing, too! We called her Rosita Negra. They lived together in a little room in back of the coffee shop. People talked about his living with a brown, but nobody didn't really think much about it. I think a man's got a right to live with any kinda' woman he wants to. If he wants to live with a brown, that ain't nobody's business but his own. If a man has anything against another man he oughta' go up to his face and tell him about it, not get a whole crowd of men together and hide their faces in pillowcases.

Almost anybody in Key West can tell you who the Klan members are. I know all of them fellers. Some of the very ones that hung Isleño, I've seen 'em in the jungle houses [brothels] over in Colored Town myself. When they see me they try to hide their faces, but I go right up to 'em and say, "Whacha' say, ol' boy? What're you doing here?" They all "jump the fence" and put horns on their wives every chance they get. That's what makes me so mad—them men killed Isleño for doing the same thing they do. Only difference was that Isleño didn't try to hide it.

Well, the Klan sent Isleño word to get Rosita out of his house. But Isleño wasn't afraid of nobody; he had plenty *cojones* all right!

Isleño's World War I medals did not save him from hanging. According to legend, Isleño's hanging triggered the blight that started in Key West in 1950 and eventually killed a good many of the coconut palms in Florida. Quite a time lag, but sometimes curses take their time. Of course, the Florida Department of Agriculture had other ideas as to the cause of the blight. (And, fortunately, the coconut palms have mostly recovered since the '80s.)

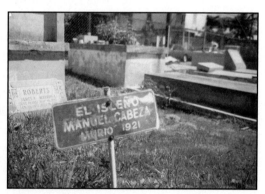

He was laid to rest in the Key West cemetery.

During World War I Isleño had volunteered to fight for Uncle Sam, and had won all sortsa' medals for bravery. When he got that warning from the Klan he just started keeping his gun under the counter of his shop.

Then one night—it was just a few days before Christmas, December 21, 1921—the Klan come marching down Duval Street, all dressed in white robes with hoods over their faces and carrying guns and torches. They marched straight for Isleño's shop. Isleño was in bed with Rosita when somebody came to warn him. He ran for his gun, but it was gone. . . .

By that time the Klansmen had hold of him. Isleño was strong as an ox and put up an awful fight, but they tied him and dragged him to South Beach, stripped him, and beat him till his kidneys burst and the blood ran out. He managed to tear off the masks of a half dozen of them, and swore they would all die horrible deaths. They beat him some more until he was unconscious, and then strung him up in that palm tree.

He was left for dead, but he came to his senses and got loose from the rope somehow, and walked all the way back to his coffee shop.

The next morning when I heard Isleño was to his shop I went to see him. Man, his back was a pitiful sight! It looked just like one of those cubed steaks that has been all diced up to make it tender. He was in bed and suffering something terrible from the pain of his busted kidneys. There was a lot of his friends there to see him, but I couldn't stand it and left.

A couple of days later—the day before Christmas— Isleño got out of bed, stuck a pistol in his pocket, got into a cab and went looking for those men. The first stop was the railroad station, where one of the Klansmen he'd recognized worked in the baggage department. But the man wasn't there.

Then, as they were driving along Duval Street past the Cuban Club, Isleño saw William Decker, who was a big man in the Klan and manager of one of the cigar factories, driving toward them. When their cars passed, Isleño fired, blowing away Decker's jaw and killing him with that one shot. Decker's car ran into a light pole, and in the back seat they found a turkey and everything for Christmas dinner.

Isleño climbed up into the loft of the Solano Building on the corner of Whitehead and Petronia. In no time at all, Klansmen, policemen, deputies, and National Guardsmen surrounded the place, and started shooting it up, and Isleño shot back. After a couple of hours of this, Isleño ran out of ammunition. War hero that he was, he shouted that he would surrender to a U.S. armed

forces officer, and nobody else.

A Naval officer came and gave Isleño his word that if he surrendered he would protect him so he could have a fair trial. Isleño took him at his word, and sheriff's deputy A. H. McInnis and Constable Leroy Torres went in and brought him out. The Naval officer let them march him off to jail, just a couple of blocks away.

After he had been in there about an hour, with the Klan outside hollering for his blood, Sheriff Roland Curry sent for a squad of U.S. Marines to stand guard. I wouldn't know whether it was a put-up job or not, but the Klan called off its men, and around midnight Sheriff Curry told the Marines they weren't needed any longer, and for them to go on back to their quarters.

In about an hour five carloads of robed Klansmen drove up, pointed their guns at the jailer, and ordered him to open up. They beat Isleño in his cell on the second floor until he was unconscious, and then dragged him down those iron stairs by the heels, his head cracking like an egg on every step.

They tied a rope around his neck and the other end to the rear bumper of one of their cars, and dragged him through the streets and on out Flagler Avenue to just above the dam. Isleño was already plenty dead, but they hung his body up on a light pole and shot it full of holes. It stayed there I don't know how long, till the buzzards and smell got so bad, they had to cut it down.

Somebody decided that Isleño's body should be publicly displayed, as an object lesson for white people not to live with brown. It was placed in a small shoe repair store behind the Southernmost Pharmacy, and people came to "view the remains." Some tried to count the number of purple bullet holes. Some attendant, perhaps a Klansman, admonished the viewers, "Remember Isleño!" in much the same manner as they used to say, "Remember the Alamo!"

Love Beyond the Grave

In 1940 I read in the *Florida Times-Union* an AP dispatch datelined Key West, relating that the corpse of Elena Hoyos Mesa had been discovered in Karl von Cosel's bed, and that he had been sleeping with it for the past seven years. The article went on to say that journalists and film crews were converging on Key West from all over the world. As I knew the Hoyos family, I thought that I might be of assistance in dealing with the press. Right away I headed for the Keys.

Friends of Elena Milagro Hoyos described her as a person of rare and fragile beauty and a gay personality. Like many in her family, she suffered from tuberculosis. She married young but

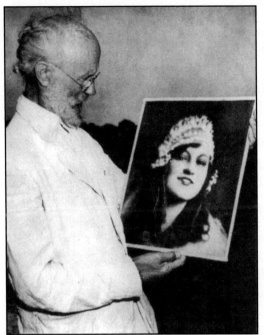

After being discovered, Karl looks fondly at a portrait of Elena, for the benefit of photographers who came from many parts of the world.

had become estranged from her husband. Sometime during 1928 Elena went to the Marine Hospital for treatment. A technician named Karl von Cosel was called in to make X-rays of her chest.

"Count" Karl Tanzler von Cosel was considered an eccentric old scientist of tall, erect bearing and sporting a white, neatly trimmed van Dyke. He had been in Key West seven years, five of them employed by the Public Health Service as an X-ray technician.

Von Cosel's account to newsmen of his many strange adventures centered around his life-long search for a soul mate whose vision he had seen, as a youth, in a marble figure in an Italian cemetery. No one knows whether every word—or not a single word—of his saga was true.

He reported that he was born in Dresden, Germany, where he lived in his family's ancestral castle, "Coselschloss." He claimed that his grandmother had been a German princess and he inherited the title "Count von Cosel." As a boy he aspired to become a great artist, and spent much of his youth studying painting and sculpture.

Although he alleged that he had graduated from the University of Leipzig at the age of twenty-four with nine degrees in medicine, biochemistry, and electrical engineering, he settled down to the more prosaic life of operating a machine shop in Dresden. There he left two small daughters and his wife, whom he accused of "being warlike," to roam the world in search of his ideal mate. His wife soon divorced him. He never again saw his children.

He told of traveling in Africa, where he almost succumbed to tropical fever. In India, he came down with influenza and was nearly buried alive. He described a lavish life—complete with a pipe organ and yacht—in Australia, where he lived for fifteen years. During World War I the Australian military confined him for five years. He lost everything to looters during that time.

After the war he came to America. When he arrived in Key West in 1928, no one questioned von Cosel's credentials as a scientist. He had no difficulty getting a job as an X-ray technician.

The minute von Cosel saw Elena, the count said he recognized in the girl the soul mate whose likeness had been revealed to him in a vision. He claimed that after she left the hospital she invited him to call.

Von Cosel's visits were merely professional at first. Because he was believed to be a specialist in bacteriology, the family was glad to turn Elena over to his care. Twice he claimed to have saved her life by means of electrodes applied to nerve centers connecting the brain with the heart. Von Cosel paid Elena constant attention for two years, during which she grew steadily worse. When Elena expressed the desire for a large double bed, the count bought her one. He lavished expensive gifts upon her. Von Cosel asked Elena's father for permission to marry her, but was refused because she was still married to her estranged husband.

Then on the night of October 25, 1931, after returning from an open-air automobile ride, Elena was seized by an attack of coughing and died. Von Cosel was not present at the time, but arrived shortly afterward and tried vainly to revive her with electrodes as he claimed to have done on previous occasions. Von Cosel claimed to have married Elena the day before she died, which could hardly have been the case unless he referred to some sort of spiritual pact between them.

Elena received the sacrament and was duly buried in the Catholic plot of the Key West Cemetery. Von Cosel kept her grave covered with a tarpaulin to keep the casket dry in the ground, until he could get permission to disinter the body. After a lapse of six months, he begged Elena's father to let him build her a vault, to which the father hesitantly consented. It looked like a miniature cathedral when Elena's body was finally placed within it.

Von Cosel finished the interior of the tomb himself. In the space before the vault there was a chair where he might sit and commune with the spirit of his dead sweetheart. A gilded dome and spire were placed over the crypt. An inscription at the base of pillars supporting the dome read *Accersitus Ab Angelis.* Resorting to a dictionary, I found that the inscription may mean "Summoned by the Angels," but it may also mean "Summoned *from* the Angels."

When Elena's body was exhumed from the grave, her head was found to be in a state of almost perfect preservation. Von Cosel said he had poured some kind of chemical down her throat before burial to preserve Elena's features.

Von Cosel went each day to the crypt to carry flowers and take care of the place. One heard tales that he had been seen in the crypt at night, playing soft music for his beloved. He claimed that he had installed a telephone between the tomb and his home, so he could talk with Elena on rainy days.

Von Cosel moved to a warehouse in a deserted area and brought with him an old airplane he had bought and with which he planned to revolutionize flying. He dreamed of flying around the

During their seven years together, von Cosel built this hydroplane, and christened it the Countess Elaine. *His intentions were to fly Elena on an around-the-world honeymoon, just as soon as he finished reviving her.*

world and taking Elena with him. The plane had been christened *Countess Elaine.*

During the seven years that von Cosel resided in the abandoned warehouse, most of Elena's family, except her sister Nana, died of tuberculosis.

On October 1, 1940, someone discovered that Elena's tomb had been violated.

For a long time Nana had suspected that her sister's body was no longer in the crypt. She went to the cemetery and found that the tomb indeed had been disturbed, so she went to von Cosel's warehouse home.

Von Cosel admitted her to the dimly lit interior. The boxlike front room in which she found herself contained a makeshift X-ray machine, a table, and all sorts of odds and ends. Masks of Elena's face, worked from wax and plaster of Paris, hung upon the walls amidst piles of magazines and untold knickknacks in great disorder. A book on embalming lay on top of the magazines on a cluttered table. Elena's picture, draped with her own black tresses, hung over von Cosel's bed.

Nana recognized a large double bed as the one that von Cosel had given Elena. The bed was covered with a low canvas canopy and draped with heavy folds of blue and white netting, Elena's favorite colors. Finally von Cosel admitted having Elena's body, promising to return it to the tomb and make Nana his heir if she would say nothing about the matter.

Van Cosel pulled back the curtains. There lay Elena, nine years dead. Her eyes were wide open and staring; her lips and cheeks were rouged.

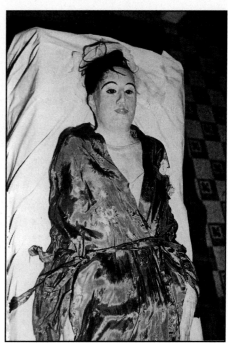

Nana ran from the room, but von Cosel stood in the outer door. Despite his pleadings that the corpse would go to pieces if he didn't care for it, Nana insisted that he put the body back in the crypt. When von Cosel did not return the corpse to the crypt as promised, the family swore out a warrant, charging him with "wantonly and maliciously disturbing the contents of a grave." When deputies went to von Cosel's house to arrest him, they found Elena's body in his bed just as Nana had reported. He confessed that he had slept beside the corpse for seven years. The corpse was clothed in a blue rayon kimono. The legs were still well formed and encased in silk stockings, but the body appeared flat under the kimono except for the usual protuberance around the hips. (A coroner who later conducted an autopsy sawed Elena in half and found that nothing remained but skeleton, paper mâché, and beeswax.)

What Nana saw when von Cosel pulled back the netting.

There was an artificial rose in her hair. Her cheeks and lips were rouged; eyebrows and lashes, artificially drawn. Her glass eyes were open and staring as though she was alive. There were plugs of cotton in her nose and mouth. The hair was short and tousled, most of it having fallen out during her last illness. On her hands, covered with white gloves, hung the gold bracelets that von Cosel had given her. Pink bedroom slippers covered her feet.

The story so fired the imagination of Key Westers that, during the first four days that the corpse was displayed at the Lopez Funeral Home, thousands of men, women, and children filed past the bier to look at her body.

At the time of his arrest von Cosel was wearing a soiled shirt and white duck trousers. Skinny, rawboned, brown as an Indian, he resembled Gandhi, except for his features and height. At his hearing he was attired in a formal dark suit, his white van Dyke

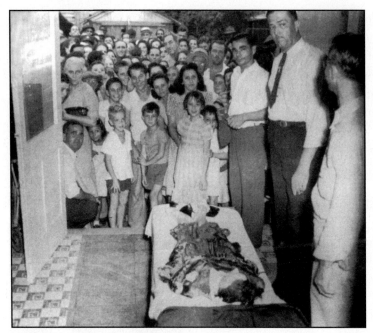

Public viewing of Elena's corpse.

beard neatly trimmed. Dignified and erect, he made a regal, scholarly appearance. In a calm, modulated voice von Cosel described how he had preserved Elena's body.

Describing the method by which he hoped to restore life as "simple," von Cosel explained, "I rebuilt the lost parts, bandaged the broken ones, and put in enough absorbent packing to soak her in the solution with which I planned to feed and develop the tissues. As soon as they had been restored, I hoped to stimulate cavities in the body with a powerful X-ray machine and revive her."

In his final plea at the hearing von Cosel asked that the remains of Elena not be disturbed. Later, however, Nana voiced her determination to have Elena buried in the Protestant part of the cemetery beside her mother and father. When this news was conveyed to von Cosel, he was visibly shaken, vowing to fight to retain her.

Though public sentiment in Key West was divided in the controversy between Nana and von Cosel, no one seemed to feel he should be punished. To local townspeople the old man was no corpse-chaser. "There isn't a jury in the world that would convict him," many said.

Von Cosel's trial was never held, for on November 9 a grand jury ruled that the statute of limitations, requiring that a crime such as he was accused of committing must be prosecuted within seven years, had expired. And so von Cosel was free. The New York Busy Bee restaurant gave him a "victory banquet" the night he got out of jail.

When I arrived in Key West as the events of the hearing were unfolding, Elena's distraught sister gladly handed over to me the family album, and gave me a contract authorizing me to deal with the media in whatever might ensue. As a starter, I arranged for an assistant to copy everything in the album.

I visited the crypt, and finding it unlocked, entered it. Elena's tomb was on the left, and on the right there was a companion one,

Stetson Kennedy, right, visits the crypt that von Cosel built for Elena and himself, shortly after it was discovered that for seven years the count kept her remains in his home with him. Soon after this picture was taken, someone blew up the crypt.

which the count intended to occupy upon his demise.

The very next day, however, another friend of the Hoyos family came with an urgent request from Nana that I return the album and tear up the contract. I learned through the grapevine that it was probably the Catholic Church that had advised her. The Church was urging that Elena's remains be reinterred as soon as possible. In any case, I did as requested.

I went to von Cosel's shed and photographed the bed with its mosquito netting and the surroundings. We discovered that the plane's wheels were constructed of ordinary wooden lathes (such as those once used for making plaster walls), which had been covered by canvas, hardly strong enough to withstand the impact of landing.

I wrote an exhaustive account of the affair, which was published by *Bohemia*, the foremost magazine in Cuba. My agent in Havana, by way of payment, sent me a case of Bacardi rum, claiming dollars could not be transferred.

A *cantante callejero* (street minstrel) named Orlando Esquinaldo, the brother of the judge, composed a song, "El Amor de von Cosel," which I recorded for the Library of Congress.

Elena was reinterred in a nocturnal ceremony in a secret location of the cemetery "so von Cosel could not dig her up again."

Quite some time after the affair had drawn to a close, I

was awakened one night by a loud explosion. It turned out that someone had blown up the Elena/von Cosel mausoleum.

When von Cosel made his final exit from the island, towing the *Countess Elaine* behind him, a small boy ran out and attached a chamber pot beneath the tail of the plane. It was still dangling as they disappeared from view over the bridge to Boca Chica.

In 1952 a deputy sheriff in north Florida found von Cosel's decomposing body, dead for several weeks. In his living room were photographs and newspaper articles about the trial and a life-size replica of Elena Hoyos.

Mario Sanchez: Key West in Bas Relief

No spot on earth has had its folklife so lovingly and brilliantly immortalized as Key West, thanks to native son Mario Sanchez, whose bas relief carved and painted pictures of the island's street scenes during the decade leading up to World War II won him world renown.

Mario began his career as sculptor/painter by carving replicas of the colorful fishes that abound in Key West's tropical waters. They sold for as little as $1.50; nowadays, his carved and painted wooden street scenes, when available, start at prices around $50,000.

Mario Sanchez was born in 1908 in the upstairs of his family's little frame *bodega* (grocery) at the corner of Duval and Louisa Streets. This was in the heart of the Cuban quarter, Gato's Village, and almost directly across from the Sociedad Cuba and Jesus Carmona's El Anon ice cream parlor.

This "strawberry grouper" was one of Mario's early fish carvings.

In 1929 Mario married another Key West native, Rosa de Armas. Theirs was a lifelong storybook romance.

It was in the mid-1930s that he acted upon an urge to carve and paint Key West fish. He did so entirely from memory, with impeccable accuracy, and sold them through Charlie Thompson's Hardware Store, at prices ranging up to $3.00.

I was living across the street, at 1210 Duval Street, and made a deal with Mario to seek customers for large-scale models among Florida's seafood restaurants and lounges. I went so far as to write

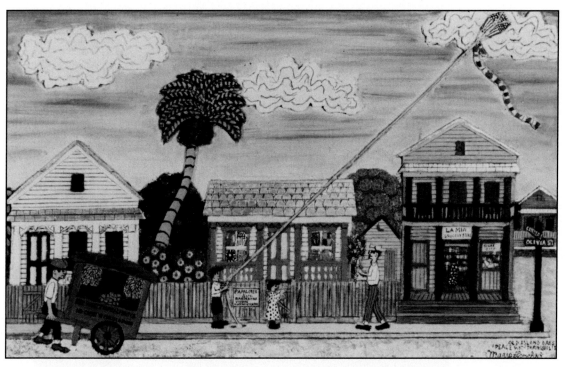

Kite fights were one of the most pervasive aspects of growing up in Key West. Great skill was needed to maneuver one's kite into crossing tails with one's opponent's kite, cutting his string with one of the double-edged razor blades tied to the kite tails. Victory came with one's opponent's kite sailing off into oblivion, leaving the crestfallen loser winding in his empty string. Each boy made his own kites, with consummate skill and artistry.

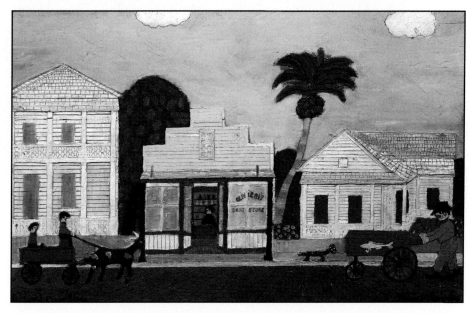

Street peddlers of "almost alive" fish were routinely followed by a retinue of hungry cats. The cats would patiently wait for the peddler to make the next sale and toss them the heads and innards.

*Mario Sanchez did much of his sculpting and painting
in his outdoor studio behind his home on Louisa Street.
(Similarly, the author did as much of his writing as possible
under the open sky.)*

a one-page advertising handout titled "He Carves Fish by the Seashore," but that was as far as our enterprise got, due entirely to my antipathy to salesmanship. (If you could snag one of those Mario fishes today, it would fetch a tidy sum in the marketplace.)

It was Mario's mother-in-law who suggested that he switch from fish to painting on carved wood, depicting Key West street scenes. His first creation was "Manungo's Diablito Street Dancers." (See page 84.) The proprietor of a clothing store on Duval Street spotted Mario walking along the sidewalk with it under his arm, and paid him $250 for it.

And so began Mario's career as a sculptor/painter of Key West folklife. He painted from memory, with the same accuracy and artistry that had distinguished his carved fishes. After first sketching the scene with a pencil on an opened-up brown paper grocery bag, Mario traced it onto a wooden panel, usually three-quarters to an inch thick and about a foot and a half high and three feet long. His tools consisted of ordinary chisels, a mallet, razorblade, and pieces of glass for scraping. His wood of choice was Pennsylvania white pine, but when that was not available he turned to cedar or cypress.

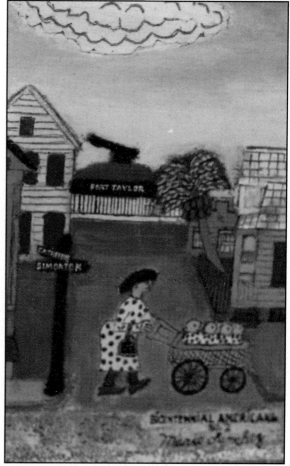

This polka dot mother with a whole wagon of polka dot babies is from Mario's Bicentennial America series.

And what makes Mario's art so great?

His choice of subject matter, for one thing: the halcyon "root-hog-or-die" days of the Great Depression of the 1930s, when almost no one on The Rock had anything but each other. Those were truly hard times, but even so, every scene that Mario painted—even the funeral processions—was a celebration of life. It is plain to see that Key Westers, though Have-Nots, were having a ball!

As in the art of Whitman, Sandburg, Chaplin, and Cantinflas, the integrity and dignity of the "common man" stand out in Mario's murals, with added elements of whimsy and fantasy. Even the dogs, cats, and clouds are bursting with *joie de vivre*.

What's more, the characters—whether two-legged or four-

legged—were no mere fictional figurines, but real life features of the Key West landscape, readily recognizable by name to every inhabitant.

A full-color book reproducing many of his works was compiled by Kathryn Hall Proby and published under the title *Mario Sanchez: Painter of Key West Memories.* And Nance Frank has also published books of his art (see bibliography).

When, after an absence of decades, I returned to Key West during the 1980s and went looking for Mario, I found him in his patio-studio on Louisa Street, hard at work in the shade of a banyan tree. I pulled out a frayed and faded one-page sheet I had written in 1937, advertising his carved wooden fishes, which he had authorized me to sell to seafood restaurants and lounges.

"You should have stuck around," Mario said. "We could have done some things together."

"You still married to that same little girl?" I asked.

"He'd better be!" came Rosa's voice from inside the house, loud and clear.

Rosa's mother was living in Tampa, and for years Mario and Rosa also had a home on Tampa Street. He created many a picture of street life in Tampa's Ybor City—with the same fidelity to reality as in Key West.

Ernesto Hemingway

In Spanish, "Ernest" comes out "Ernesto," and that is what Hemingway is fondly called throughout the Spanish-speaking world, including the Key West Cuban colony that was.

Many, if not all, of the stories told here are not to be found in the mountainous literature about the man—a fact which adds rather than detracts from their significance.

For the most part they are folktales, which is to say they mainly consist of the whole truth, some truth, or no truth at all. In the latter event, while they shed no light upon their subject, they tell us a good deal about the tale-tellers and the culture in which they lived.

Since time immemorial, folks have fantasized about what goes on inside the castle. The Hemingway manse was a hangout for celebrities from all over, and Key West folks got a lot of kicks out of swapping tales like these. Each one had a different source, including the author.

With each telling, the fine art of storytelling often gave rise to exaggeration and even fabrication, and the tale grew and grew through incremental repetition.

Sloppy Joe's Bar has looked as it does today ever since its proprietor (and Hemingway's fishing buddy) moved it to Duval Street. In the thirties, when Hemingway was there, it was on Greene Street. A regular feature back then was a hula dance by Manteca ("Lard"), who had a black snake for a partner.

His Reserved Bar Stool. I guess the most widely told tale about Ernest Hemingway's life in Key West is about his reserved bar stool in Sloppy Joe's. Mind you, that was in the original Sloppy Joe's, when it was on Greene Street.

Painted on the seat of the stool, in bold block letters, were the words, "Reserved for Ernest Hemingway." His stool was right near the door, so "look customers" strolling along Greene Street could look in and see whether he was in there or not.

One time I had the nerve to sit down on Hemingway's stool, but Skinner, the big black bartender, gave me a dirty look, and I got off in a hurry.

"I was just hoping that some of his genius would rub off onto me," I said, trying to be funny.

The deal between Sloppy Joe's owner and Hemingway was that The Author would come in every day and spend quite some time

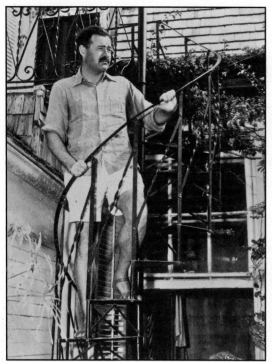

Hemingway on the stairs to the coach-house studio behind his house on Whitehead Street.

drinking and scribbling on a notepad, so tourists could get an eyeful. No exact time was set for his appearances, which meant that tourists would come in just as soon as the bar opened, and drink all day, not wanting to miss him. It was very good for business.

Hemingway collected on the barrelhead, backing his little open jeep up to the rear door and driving off with free cases of all sorts of stuff.

Nowadays, when tourists come into Sloppy Joe's looking for a stool with Hemingway's name on it, they are told that someone stole it quite a while back.

His Whorehouse Gym. Ernesto didn't just referee a lot of boxing matches in Key West. He also trained local Cuban boxers and promoted matches with teams he brought over from Havana.

For a time as a makeshift gym he used a modest little whorehouse located on the corner of Whitehead and Southard Streets. The charming two-story cottage had a small bar at the top of the stair, and a bedroom with a peephole in the door. It was almost big enough to stick your head through, and had a sliding shutter. At hours when the bedroom was not occupied, Ernesto and his boys used it as a dressing room, and did their boxing in the patio down below.

When I visited it in 1939 the onetime brothel/gym was the private residence of an artist and his family. The only vestige from its bygone days was the peephole in the door, which reminded me of that venerable folksong, "Keyhole in the Door," whose most memorable snatch was:

> Keyhole in the door,
> Keyhole in the door;
> And when she let her shimmy fall
> I thought I'd jump right through
> That keyhole in the door!

Sparring Partners Galore. It was said that Hemingway frequently brought six or eight black sparring partners into his backyard—and took them on all at the same time. One of these boxers, Kermit "Shine" Forbes, knocked him out "accidentally."

His Naked Lawn Parties. A lot of Hollywood movie stars used to come to Key West, and Hemingway would either already know them, or pick them up at Sloppy Joe's, like he did that famous writer Martha Gellhorn, and invite them to come stay at his house.

Sometimes they stayed on and on, a good time being had by all. The word was all over the island that they were having naked lawn parties behind his garden wall, so naturally me and the boys spent a lot of time at night up in the mimosa trees outside the wall, checking the story out.

We never did see anybody naked, but one night Joe Hernandez got so excited just looking at those movie stars, even in shorts and halters, that he fell out of the tree, sprained his ankle, and almost got us all caught. After that, we gave up on it.

Those Screams in the Night. When the first tourists started trickling into Key West in the mid-1930s, they were scared out of their wits by screams in the night that could be heard all over the island—they were that loud.

We Key Westers, being in the know, would just turn over and go back to sleep; but the tourists would be so alarmed they jammed the telephone line to whatever policeman was working the graveyard shift at the jailhouse. It was his duty to assure them that nobody was being raped or garroted, and that the screams came from a flock of peacocks Hemingway kept on his grounds, along with his six-toed cats.

If it had been anybody but Hemingway, they would have put a stop to it. As it was, they actually thought of putting some sort of notice on the literature the Tourist Bureau was sending out, so the "strangers" (tourists) would be forewarned.

The birds strutted about the grounds by day, but by night the cocks felt they had to make those godawful screams, just in case some stranger peacock might have landed on The Rock. They felt like they had gotten here first, and it was their territory.

They were a long way from India, or wherever it is peacocks come from, but we just took them in stride. Key Westers are used to all sorts of strange birds dropping in and staying on.

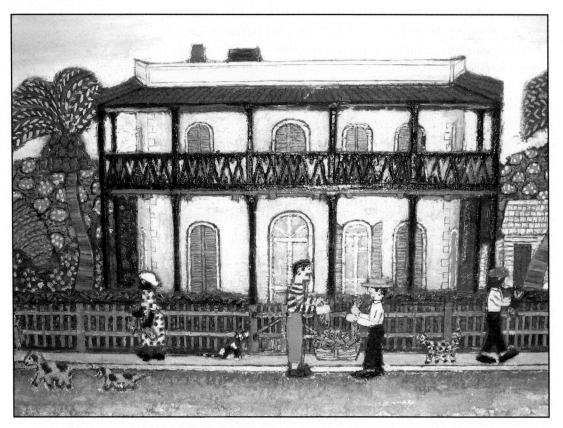

Mario Sanchez has Hemingway himself buying fish in front of his house.

His Lack of Collateral. Hemingway had to have been hard up when he was writing *To Have and Have Not.* He had done told all us boys in Sloppy Joe's he had to come up with a pot-boiler, quick!

After he had finished it and it was scheduled to come out in a couple of weeks, he went to the bank and asked old man William Porter to let him have a coupla' thousand to tide him over till his royalty check came in.

"Well, Mr. Hemingway," Porter said to him, "what can you offer by way of collateral?"

It made Hemingway so mad he got up, closed his account, and walked out. Then, when his royalty checks started pouring in, including movie rights, he put it all in some bank up in Miami.

This story has got to be for true, because it was told by Hemingway's brother, who breezed into Key West about that time in a little sailboat, on his way to do some island-hopping in the Caribbean.

His Collapsible Outhouse. You know, back in those days didn't hardly nobody in Key West have a flush toilet. In fact, I remember going all the way up to Miami to go to the movies, just so I could see and use one.

We all had a *cursado* ("a place frequented" or an outhouse), and Hemingway's house had one in the backyard too. I'm sure he must have had a real toilet inside, but whenever a movie star was staying there, the neighbors say the first thing Hemingway did was to tell her he was very sorry, but that outhouse was all he had in the way of a toilet.

Then, after she had done gone in and closed the door, he and his other houseguests would gather in a window, and he would push a button, and the walls of the outhouse would come tumbling down.

You don't have to believe it. I'm just telling you what was told to me, by people who say they saw it with their own eyes.

All Hail His Urinal! When Hemingway established residence in Key West, it was in a house at the corner of United and Whitehead Streets. He liked the neighborhood, but the neighborhood didn't like him. Then he purchased the Asa Tift house up the street at 907 Whitehead. There he had a salt-water swimming pool, the first in Key West. He also had a urinal. Him being such a heavy drinker led folks to say all his money was going down that urinal.

This urn, and the urinal from Sloppy Joe's, created a fountain in Hemingway's backyard, a favorite drinking trough for the many cats and peacocks there.

His Apprenticeship to a Rumrunner. One day when Lalo Lopez—the real Harry Morgan in Hemingway's *To Have and Have Not*—was having a few drinks with him in Sloppy Joe's, Hemingway was pestering him as usual about inside dope on rumrunning. Lalo decided he had had enough.

"I'm tired of telling you—why don't you come go with me tomorrow? I've got a load hidden under water in sacks up on Boca Chica, and could use some help bringing it up."

Hemingway went.

"He was damned good at it too!" the real Harry Morgan told me.

Boxing in Church. "Fried Egg" (Ed Freyberg) was telling me about the time when he was attending mass there in the Catholic Church.

Everybody was down on their knees praying, when all of a sudden there was this big crashing noise in the rear of the church. Fried Egg jumped up and hurried down the center aisle to see what had happened. What happened was that, while everybody else was taking mass, Ernest Hemingway was back there shadowboxing, and had knocked over some of the furniture.

Judging Them Flowers. When Key West staged its first Flower Show, Hemingway, together with his famous houseguests author John Dos Passos and radio journalist Elmer Davis, was asked to judge the blossoms and award the prizes. A good time was had by all—especially the judges, who had a highly spiked punch bowl hidden in the bushes.

Never Struck Another Lick. There's another story told about Hemingway, which I got from Fried Egg, who got it from his great aunt. Hemingway was out in his backyard, digging a hole for a new cistern, when lo and behold he uncovered a large steel door. It had to have been a cache of gold, because he never struck another lick [of work].

Places

Places have always played integral roles in
communities of every size, and Key West, Florida, USA, has been no
exception.

Considered as a whole, the island of Key West itself is, of
course, a place—surrounded by the Atlantic Ocean on the east and
Gulf of Mexico on the west, with continents looming to both north
and south—which for generations could only be reached by water.
Given the three-by-five-mile dimensions of The Rock, and its oft-
times population of twenty to thirty thousand souls, places on it
were bound to be highly conspicuous and accessible.

Places, of course, may be some geographic feature, such
as South Beach or the Salt Ponds. Then there are man-made
structures, serving the entire gamut of human activity, ranging in
Key West all the way from the Square Roof brothel to the Instituto
de San Carlos and Sociedad Cuba. Beyond that, they can be
classified according to function, such as Pepe's Cafe, where much of
the city and county's official business was transacted, the Butcher
Pens, or Pena's Garden of Roses.

Rather many places qualified as institutions, from Chicho Bolita
to the Naval Station, and even to individuals like snake-dancer
Manteca, Skinner the big black bartender at Sloppy Joe's, or Ernest
Hemingway himself. (Such two-legged institutions are dealt with in
the previous chapter, "Key West Characters.")

That which follows is a roundup of some of the physical and
structural places which played important roles in the lives of Key
Westers during the first half of the twentieth century. Some of these
places are still in place and serving their original functions; others
have either "gone with the wind" or been converted to what realtors
shamelessly call "highest best usage."

Up on the Bridges

"The bridges" have loomed large in the lives of many generations of Key Westers, even before the coming of the Overseas Railroad in 1912 and the "modern" Overseas Highway that was built over its trestles after the Big Blow of 1935. A goodly number of Key Westers were among the many workers who down through the years lost their lives in the building of both the railroad and the highway. Big blows aside, it was dangerous work, especially on the bridges that spanned channels where the current was unswimmable at flood tide. When a worker fell under those circumstances, there wasn't much his buddies could do but wave goodbye.

There were some Key Westers among the victims of the Labor Day Hurricane of 1935, but most of them were veterans of World War I who had staged a hunger march on Washington, only to have their tent city burnt out by General Douglas MacArthur. Somebody thought it would be a patriotic thing to send them to the Keys to work on the bridges. It was a poor reward. Mosquitoes ruled, day and night. Tank cars of drinking water were sent in daily from

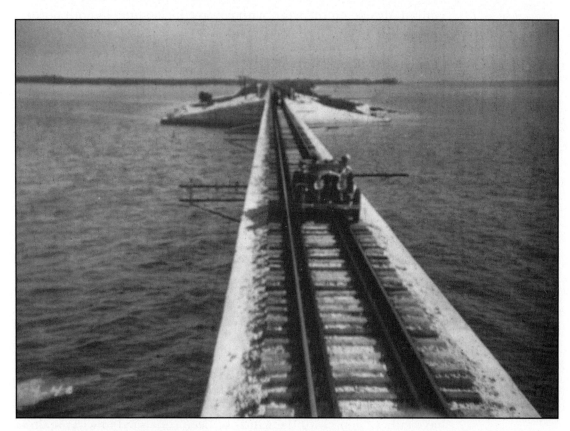

Just couldn't wait. This Key West motorist didn't wait for the Overseas Highway to be completed. He took off over the Overseas Railroad in 1928.

Homestead, and rum and prostitutes from Key West on weekends.

When I first reached the island in the wake of the hurricane, many were gathered in Sloppy Joe's and other bars up and down Duval Street. Drunk or sober, they were in such a state of shock they stared glassy-eyed and could scarcely talk.

The general depression (none would think of calling it a "recession") that afflicted Key West after the outsourcing of the cigar industry to Tampa and the blight that had put an end to the sponge industry was mitigated only somewhat by jobs building an aqueduct from the mainland and converting the railroad into a highway.

The bridges were not only a source of life, but death as well. In addition to all those who fell victim to accidents while working on them, a number of others lost their lives by driving off into the water. Many of the bridges linking the Keys were narrow, two-lane affairs mounted upon wooden pilings, with wooden planking and guardrails. You could drive right through those rails without being hurt in the least and with your car being but slightly damaged; but of course if it happened over deep water, you were a goner. Some,

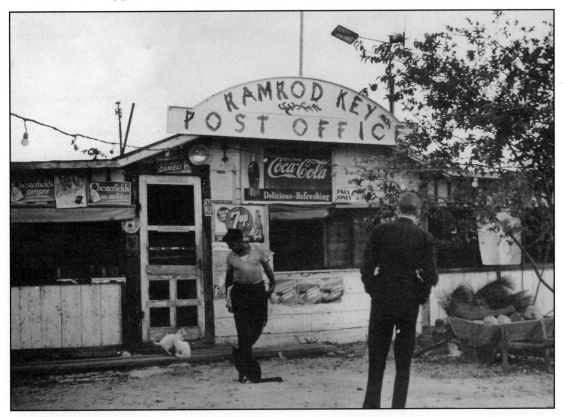

Human habitations were few and far between up on the Keys, and if you wanted to be sure of reaching the mainland, it was wise to start out with a full tank of gas. You could buy an island along the way, just by paying a few hundred dollars in unpaid taxes.

in fact, lost their lives in shoals and canals, where, as a result of shock and/or inebriation, they would drown and their bodies would be found the next morning, still sitting behind the steering wheel.

Generally, everybody on The Rock would know about it long before the *Key West Citizen* got around to printing a notice. The way the local rumor mill would convey the news was likewise rather perfunctory, and went like this:

"Did you hear what happened to So-and-So last night? He ran off a bridge."

"Where?"

"Stock Island. It was in pretty shallow water, but he was still in the car when they found him this morning, drowned. I guess he had one too many last night, at the Bucket of Blood or someplace." (End of obit)

The Bucket of Blood

That was what this joint out on Stock Island was called because, for one thing, it had a red roof. You could get whatever you wanted to drink at the Bucket of Blood—and 'most any kind of woman too. At first it was owned by Martin Key, but later it was taken over by John Nebo, the Key Wester who became world middleweight boxing champion.

The Butcher Pens

Before the coming of the Overseas Railroad in 1912 changed things, the only way Key Westers could get any red meat was to have it shipped in on the hoof. Most of it was brought from Punta Rassa, on the Gulf coast near Fort Myers.

The cattle were unloaded at the Mallory Dock, and Key West's two cowboys, Antonio Rodriguez and a black man named Sheehee, would get on their horses and herd the cattle through the streets and on out to the Butcher Pens at the Atlantic end of White Street. There was hardly any traffic in those days, so about the only things that had to get out of the way of the cattle drive were the dogs sleeping in the streets.

This was before there were any real beef cattle in Florida, so what Key Westers got were so-called "woods cows" that had been rounded up on the open range in cow hunts over on the Gulf coast. These critters, descended from Spanish Andalusian stock, had sharp horns and bad tempers, and were fast on their feet. Whenever one of them would break ranks during the drives out to the Butcher Pens and get into somebody's yard, Rodriguez or Sheehee would just shoot it and drag the carcass the rest of the way.

The hometown butchering stopped with the coming of the

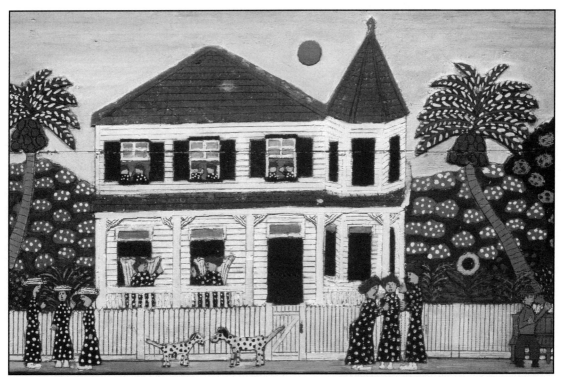

The Key West gossip mill, as depicted by Mario Sanchez. Maybe they are chattering about who ran off a bridge. Even the dogs are at it. Polka dots must have been in vogue.

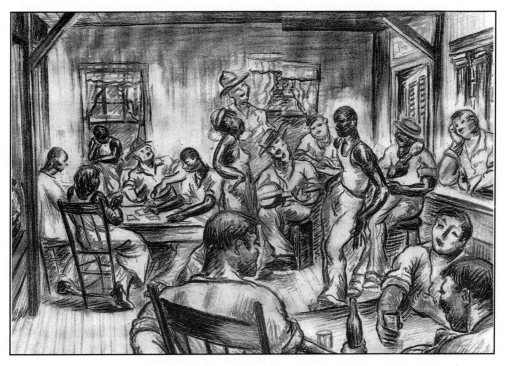

The 3.2 Cafe, located on Petronia Street, was named in honor of the first alcholic beverage to be legalized after Prohibition, namely beer with only 3.2 percent alcohol. The 3.2 Cafe integrated itself some three decades before the civil rights movement of the 1960s came along. The law looked the other way, and a good time was had by all. This is a reproduction of a sketch by the noted FERA artist Albert Crimi, courtesy of the author's son Loren Kennedy, who now owns the original art.

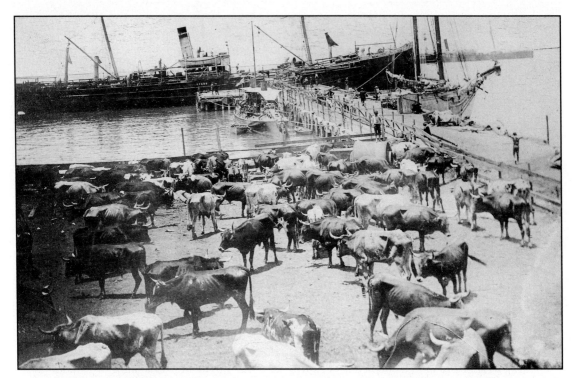

The first stop in Key West for this herd of cattle from Punta Rassa, Florida, was this dockside corral. Cattle were then paraded down Duval Street from the dock out to the Butcher Pens near the West Martello Tower. Whenever a rambunctious steer broke ranks and got into somebody's backyard, the Key West cowboys would shoot it and drag it the rest of the way.

Beef cattle were not the only bovines on the streets of Key West. This old postcard depicts the "walking dairy," the custom of milking cows that were walked from door to door.

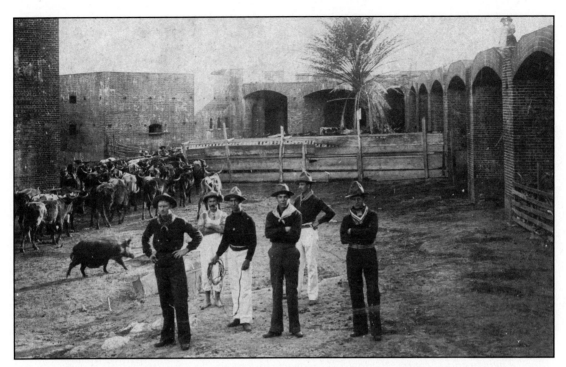

End of the road for cattle after their promenade down Duval Street, where the butcher pens adjacent to the West Martello Tower served as a ready-made holding corral. On slaughter days, the aquamarine and blue waters of the Atlantic turned into a virtual Red Sea. Note the wild razorback hog, also known as a "piney woods rooter," at the left.

Overseas Railroad, as Armour & Company shipped in all kinds of meat and stored it in their facility at Caroline and Grinnell Streets.

In the 1930s Key Westers were still talking, however, about the butcher whose *modus operandi* consisted of stabbing the animal in the throat and then pressing his lips to the wound to drink all the blood he could hold. But there was much too much blood for him, and the waters of the Atlantic Ocean around Rest Beach frequently changed from aquamarine and magenta to pink and crimson, the story goes. Needless to say, this attracted all the sharks for miles around.

On butchering days Key Westers and tourists, if any, did their swimming elsewhere.

Gato's Village

"El Barrio de Gato" was what we used to call the section of Key West that ran from Truman Avenue (formerly Division Street), to Whitehead, to South, to Simonton Streets, all the way down to the ocean.

It was named after Eduardo Hidalgo Gato, who learned the cigarmaking trade in New York City, and in 1871 started his own company and brand, which came in seventy different sizes and

This is the Gato Cigar Factory in Mario Sanchez's "Gato Brothers After." Their brand of cigars, "Gato 1871" was world-famous.

shapes. He moved his factory to Key West, and he soon had hundreds of workers in the two-and-a-half-story frame building on the corner of Simonton and Virginia. When that burned down in 1915, Gato replaced it with a poured-concrete structure, which later served as a U.S. Navy commissary.

The typical cigarmaker cottages sprang up all around the factory,

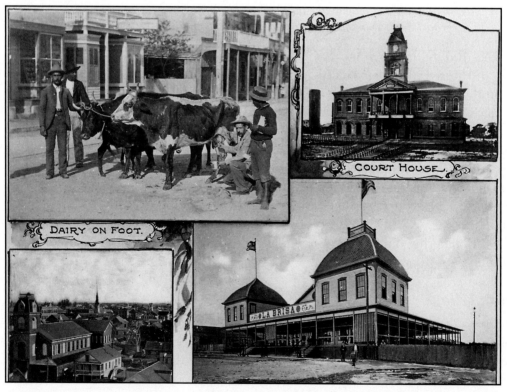

La Brisa, recreation hall on South Beach at the foot of Simonton Street is shown lower right in this collage of Key West scenes around the turn of the twentieth century.

conductors of the Overseas Railroad to wire them a warning any
time revenuers boarded the train headed for Key West. By the time
the train arrived, not a bottle of booze of any description could be
found anywhere on The Rock.

Thinking they would outwit the Key Westers, the U.S. Revenue
Department hired a squad of Puerto Rican agents. Sure enough,
the railroad conductor took them to be local Latinos, and so sent
no warning telegraph. Pena, Raul, and a dozen other vendors were
caught red-handed and locked in the brig at the Navy Yard.

Pena's wife tearfully telephoned the commander at the Navy
Yard, who assured her he had no foreknowledge of the bust.
Interpreting the affair to be an invasion of his authority (after
all, many Navy captains took on refreshments at Pena's), the
commander called in a company of Marines and gave them orders
to let the liquor dealers out of the brig and put the revenue agents
in, which they did.

"The U.S. Navy and U.S. Revenue Department almost went to
war with each other," Key Westers still recall.

Another story Pena liked to tell was about the time he got a call
from a Navy Yard officer who did sentry duty at the dock, advising
that Customs had captured and brought in a frigate loaded with
beer.

"Give me five hundred bucks and I'll let you haul off five
carloads," the officer said.

"You've got a deal," Pena told him.

He then called in his partner, and told him to get in his boat
and go around to the far side of the captured frigate that night and
tie up to it. When Pena got there in his car they loaded the boat
first, and then Pena got his five carloads, the bribed officer carefully
keeping count at the Yard exit.

The next day Pena got a call from the officer.

"I'm missing an awful lot of beer," the man said.

"Don't ask me nothin' about it," Pena replied. "You checked
me out at the gate, personal."

It was common in those days for everybody—Revenue,
Customs, Coast Guard, and even conservation agents—to exact
bribes from the rumrunners.

"I remember on one run my man got stopped three times out
in the Gulf Stream, and paid off all three times, but I still made ten
thousand dollars on the trip," Pena used to boast.

In those days a one-gallon demijohn of Bacardi rum in a wicker
basket sold for $12.50. A popular item was a four-way glass bottle,
made in the Bahamas, which had a different-colored liqueur in
each section.

When World War II came along, the Navy decided it needed the land where Pena's Garden of Roses, some houses, and a parking lot were, so they offered Pena $20,000 for everything. Pena made such a fuss they finally paid him $39,000, but he was still so mad he went to Spain and never came back.

When word went around the island that the Navy was about to bulldoze the Garden of Roses, the whole island turned out to watch, hoping the dozers would uncover wherever it was Pena hid all his liquor.

They never did find it, though, and people are still looking.

Pepe's Cafe

Pepe's Cafe, which was located on Duval Street (where Rick's Bar now is), was where everybody who was anybody, and many who were not, took their morning coffee. It was Cuban *cafe con leche*, of course, and you could choose between the open cans of *leche condensada* and *evaporada*, which were to be found on every table. It came with slabs of Cuban bread, toasted and buttered. It was a good way to start the day.

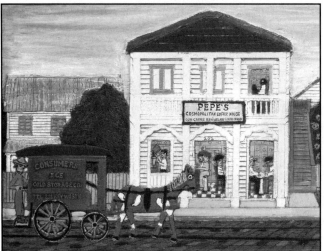

In Mario Sanchez's version of Pepe's the sign says "Pepe's Cosmopolitan Coffee House/Our coffee revives any living dead."

Some say that during the 1930s more of the city's business was transacted in Pepe's Cafe than in the halls of government. Once ensconced in Pepe's, the City Fathers dawdled indefinitely, gossiping, swapping tales, and taking votes on public issues.

It is even said that it was in Pepe's Cafe, in 1934, that the fateful decision was made to abdicate and turn the bankrupt city over to the state government. Governor Dave Sholtz came to town, accepted on behalf of the state of Florida, and promptly proceeded to pass it on to Julius F. Stone, Florida administrator of the FERA (Federal Emergency Relief Administration), whom he had brought with him, and who accepted on behalf of Uncle Sam.

Raul's Club

Long before Marineland or Sea World came into existence, Raul Vasquez and his trained fish were a major attraction at his club out by Rest Beach near the West Martello fort. Raul had impounded

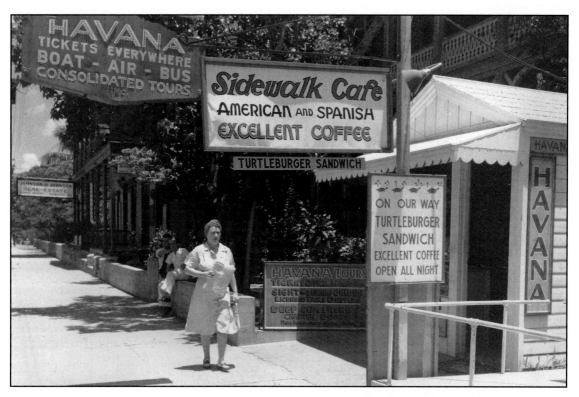

Here is how Duval Street looked in the '30s. This teeny-tiny cafe had no room for the clientele that frequented Pepe's down the street.

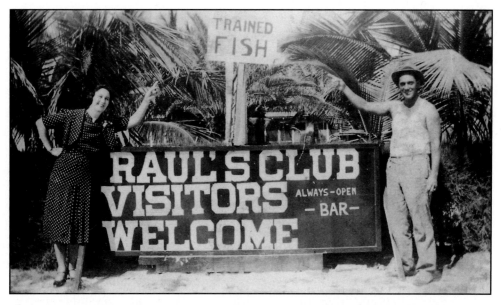

Raul Vasquez fed his "trained fish" behind Raul's Club near the Martello Towers. So who can say that Key West did not provide the prototype for such mainland attractions as Marineland and Sea World?

a tidal lagoon behind his club, and stocked it with all sorts of saltwater fish.

To amuse his customers, he would walk out to this lagoon. The fish would see his shadow coming and rush to meet him. He would stoop down and feed them by hand and they would roll over on their sides so he could rub their tummies. Some would let him lift them out of the water for all to see. It was all very good for business.

Rocky Road

Presidents come and go, but some roads seem to go on forever.

Key West's Truman Avenue is a good example. Just because President Harry S. Truman, like President Franklin D. Roosevelt before him, liked Key West, what had long been known as Division Street underwent a name change in his honor.

It wasn't always called Division, either. It didn't even exist up until the outbreak of the Civil War, at which time (1861) a General John M. Brannan decided he needed a direct route along which he could march his garrison from the Army post which was at one end of the island, to Fort Taylor, which was at the other end. So the road was cut, literally, by simply removing the underbrush and exposing the lumpy surface of the coral rock beneath. For a few years people called it Brannan Road, but generations that followed thought of it and spoke of it as "Rocky Road"— no matter who came along and pinned some other name on it.

The Salt Ponds

During the early decades of settlement, much of the island of Key West was dotted with shallow ponds of water, of varying degrees of freshness and salinity, according to tidal flooding or rainfall. At the northeastern end of the island there were some hundred acres subject to tidal flooding, and in 1830 a South Carolinian named Richard Fitzpatrick, who had moved to Key West, leased the area and proceeded to construct what are still referred to as "The Salt Ponds."

Using the native coral rock, the area was divided into rectangles fifty feet wide and a hundred feet long, separated by dikes of rock two feet high. A system of floodgates let the sea water in at high tide, and then sealed it off to evaporate from the heat of the sun. With luck (no heavy rains and no gale-force winds to cause flooding) the salt water dried into "rock salt" crystals ranging from an eighth to a quarter of an inch in diameter.

A black Bahamian named Hart was brought in to supervise the operation. By 1832, it was employing thirty people and producing

sixty thousand bushels of salt. But heavy rains washed it all away and Fitzpatrick gave up two years later.

The LaFayette Salt Company, whose principal stockholders were in Mobile and New Orleans, was the next to try, but it was unsuccessful.

Charles Howe took over and in 1850 succeeded in harvesting thirty-five thousand bushels. The operation was expanded, and in 1851 Howe sold a half interest to W. C. Dennis, who ran it until his death in 1864. The banner year was 1855, when seventy-five thousand bushels were produced. Much of the salt was sold to the fishing industry at Charlotte Harbor, Florida. Production was halted during the Civil War by the Federal forces at Key West to prevent the salt from making its way from Charlotte Harbor to the Confederates.

After the war, in 1865, Lt. W. R. Livermore of the Army Corps of Engineers acquired the property and invested heavily in restoring its operations, but gave up in 1868, convinced that it could not be operated profitably with "inefficient and irresponsible free negro labor."

It remained for the hurricane of October 19, 1876, to put an end to salt-making in Key West for all time. On that date, fifteen thousand bushels, just as they were about to be harvested, were washed back out to sea.

The Key West Realty Company purchased the area in 1906 and divided it into residential lots. For a long time thereafter, the rectangular stone dikes remained in evidence.

Turkish Baths

The same Doctor Fraga who invented the vermifuge (see page 130), besides operating Fraga's Drug Store, had Fraga's Turkish Baths right next to it.

There was a long row of wooden booths, and to get water he paid a man named Rafael to hand-pump well water up into a high tank, so that gravity would give it pressure. I don't remember now how he heated it, but he did. For $3.00 a week you could take a bath at Fraga's every day. It was popular with cigarmakers, baseball players, and people like that who got into a lot of dust and felt like they needed to take a bath pretty often.

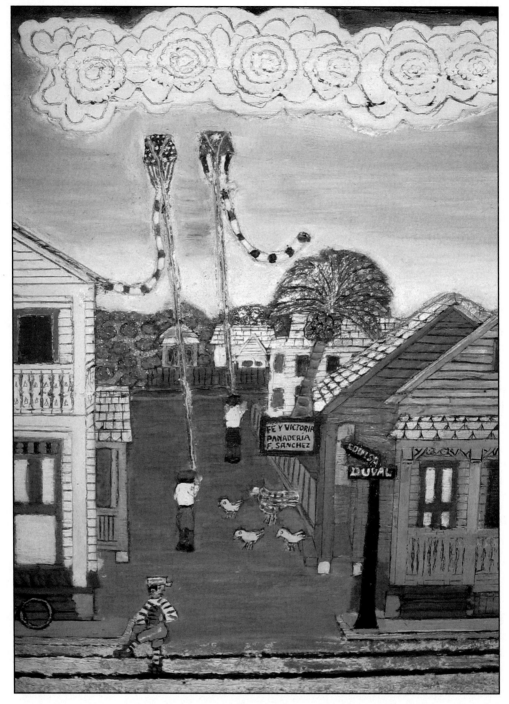

Kite fights, with razorblades tied to the kites' tails, were fought on South Beach and all over Key West. They were a big deal with Mario and the kids on The Rock.

Stuff 'n' Such

Back in the mid-1930s when I was a twenty-year-old field researcher working for the WPA Writers Project, my orders from Dr. Benjamin Botkin, folklore director at the national office, were to collect *everything* folkloric I could find on the island. Key West may be small, but this was still a large order.

As in any new discipline, we were struggling with a need to find names for all the various kinds of folk stuff that buzzed around us like a swarm of bees. To start with, there were the familiar categories like folklore, folksong, folk music, folk dance, folktale, and so on. But then we kept running into such Key West sayings as "when the wind is walking right, the water is crystal as gin."

Not just in Key West, but all over Florida and America we were hearing such one-liners, which say a lot in a few words in a special way. This is what my co-worker, Zora Neal Hurston, who was working up in Eatonville, had in mind when she said, "Folklore is the boiled-down juice, or pot-likker, of human living." Up in Washington, folklore director Botkin was taking note, and in time projected a WPA Writers book to be entitled *Folksay*.

As head of the Florida Folklore Project I sent word to all of our field workers to be on the lookout for such pithy folksy statements, and to take special care to record them exactly as they heard them, without changing a single word, or even letter, comma, or semicolon. Otherwise, the rhythm, literature, and poetry go out the window.

But folksay was far from being the only unclassified folk stuff floating around. Not knowing what label to put upon it, or file to put it in, we just kept calling it "folkstuff," and finally decided that was as good a label as any.

Again, in time, Botkin up in Washington projected a WPA Writers book to be called *Folkstuff*. So from Key West and elsewhere, we kept sending all sorts of stuff in, with or without labels.

Folklife and folk culture are totally holistic by nature, and

not at all concerned with categorization. What folks have to say comes from the heart—which is what makes it so meaningful and colorful. So what follows is a random sample of stuff heard up and down Duval Street, in and around the Fishermen's Cafe, and up under the Square Roof during the 1930s.

Talk about Mosquitoes

Wherever you go in the world where there are mosquitoes, you can hear tall tales about how big and bloodthirsty the locals are. But the mosquitoes on the Florida Keys are in a class by themselves.

For generations, you couldn't keep a cow, goat, dog, cat, or chickens on the Keys because the mosquitoes would eat them alive. They say the only way the Key deer manage to survive is to wade out on the windward side of the islands until only their noses are sticking up above the water. People are still talking about a sailor during World War II who got drunk and passed out on the waterfront. The mosquitoes got so much of his blood he never woke up.

Anytime you started up the Keys for the mainland by auto you had to make sure you had plenty of gas, as gas pumps were very few and very far between after you left the island. This could be a matter of life or death, because if you ran out of gas after dark, sometimes the mosquitoes would be so bad that rolling up the windows would not do you any good—they would come through the same holes in the floorboards your clutch and brake pedals

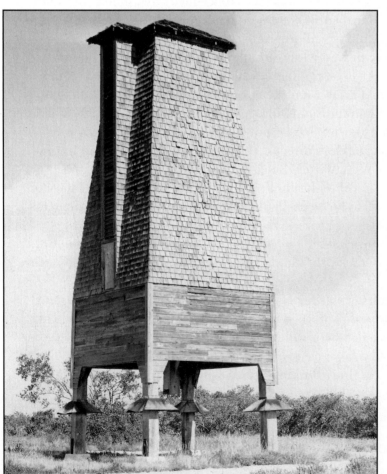

Mosquito Control, Florida Keys–style. This bat tower was built on Sugarloaf Key in 1929 and bats brought in from Texas. Shortly after being released, all the bats disappeared. There is an on-going debate as to whether they went back to Texas or were eaten by mosquitos.

came through, and you would be obliged to wade out and submerge
yourself in the water like the Key deer, and hope and pray that
somebody would come by in a car before the night was over and
rescue you.

If you went to pick tamarind up on one of the outlying Keys,
you had to wear not only a face net, but gloves and two or three
thick shirts. They would come at you in black clouds, not beating
about the bush but taking the shortest route from where they had
been straight to you.

Key Westers who stayed up on the Keys ten days or so at a
time making charcoal to sell said that the only way they could foil
the mosquitoes was to braid their beaks when they stuck them
through the wooden doors.

Back then, Key Westers had to be sure to set their alarm clocks
to get to work on time because sometimes the clouds of mosquitoes
would be so thick you would think it was still nighttime long after
sunup.

Before mosquito spray was invented, folks walked around
waving a leafy twig around the head, arms, and legs.

And if the night was too hot or mosquitoes too thick to sleep in
comfort, people grabbed a blanket and headed for the windswept
county dock on South Beach, where, after a bit of guitar music and
shared wine, one could sleep very well indeed.

Pirate Gold

Probably no place on earth has more tales of buried treasure—true
and false—than Key West and the Florida Keys. All down through
the years, all sorts of people have turned up suddenly rich, and
there couldn't be any other explanation but that they had found
buried treasure.

All the talk about buried treasure in Key West is not just talk.
The beach on the west end of the island was a favorite treasure-
burying ground for pirates, until Uncle Sam drove them off and
built a naval station on top of it. For a long time after that there
were no banks, so a lot of people buried their money, and some
kept it up even after banks came, because they didn't trust them.

It didn't have to be a fortune, either. The story is told of the
Key Wester who moved to the mainland for some years, and then
came back and entered the house where he had lived, went to the
staircase and pulled a wooden dowel from the rail and recovered
two dimes he had hidden there long before.

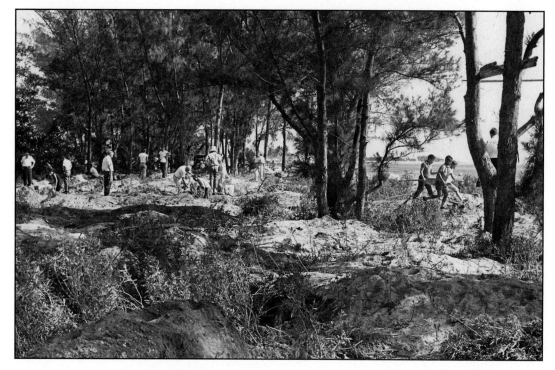

Looking for buried pirate gold has always been a preoccupation in Key West, but searching for vintage bottles was often more fruitful. When a construction crew stumbled upon an ancient garbage dump behind Rest Beach, throngs of bottle-hunters rushed to the scene.

Cats, 10 Cents Apiece

"Boys, we've done everything we could think of to get rid of the rats, but it ain't doin' no good. No use in us spendin' any more money on poison—these rats would rather eat our sugar cane. These few cats we got here on Cape Sable has done the best they could, but they can only eat so many rats. So I say we ought to chip in and make a run down to Key West and buy up a whole bunch of cats and bring 'em here!"

At first the men all laughed, but the more they thought about it the more they began to take the idea seriously. Finally they decided to give it a trial, and Gene set sail for Key West. As soon as he got there he stuck up a sign saying:

Will Pay 10 Cents Apiece for Every Cat Delivered to This Dock

In no time at all there was a steady stream of kids with cats to sell. When Gene had about four hundred of them—all his boat would hold—he cast off for Cape Sable.

"That ninety-mile trip was the worst I ever made!" he said. "Those durn cats fought and yowled the whole way. Many a time I

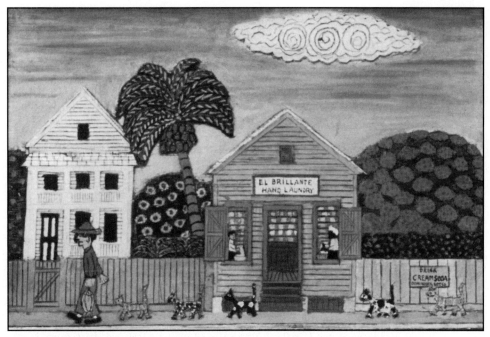

Five Key West cats are following the man with the fish in this Mario Sanchez scene.

thought I would have to jump overboard to keep 'em from eatin' me alive!"

As soon as the cats could jump ashore they did, and took off in all directions. They got to be so wild, folks said they was breeding with the bobcats. But Cape Sable hasn't had a rat problem since, and after a while the mosquitoes killed off all the cats.

Saturday Night Promenade

One of the few things that young people could do in Key West for free, or almost free, was the Saturday Night Promenade.

Young teenage girls would get all dressed up, stick a red hibiscus blossom in their hair, plaster a little *busca novio* ("looking for a sweetheart") curl over their forehead, and they were set to go.

Except, of course, they had to be chaperoned by an aunt or some other relative. Sometimes two aunts would tag along, to keep each other company and get out on the town. If the teenager already had a boyfriend, the couple would walk ahead, with the chaperone(s) bringing up the rear. If the young man treated the girl to a Coke or something, he was obliged to do the same for the chaperone(s). Even though Cokes only cost five cents each, the cost of a date could add up.

When one or more girls promenaded together without a male escort, they would be followed or passed by admiring youths

making such cracks as "*¡Cuba, llama su hijas!*" ("Cuba, call your daughters!")

The line of march was always the same—up one side of Duval Street to the end, cross the street, and walk back on the other side.

There were very few street lights, but, as visiting newscaster Elmer Davis observed, "Everybody knows where everything is, and there isn't much to see anyway."

A very good time was had by all, and many a Key West marriage got started just like that—promenading up and down Duval Street.

Cockfights

For many years the Key West cockfighting pit was located on Amelia Street, not far from the Sociedad Cuba. Fights were staged every Sunday afternoon, from one until six P.M. When you saw men coming from every direction, headed for Amelia, you knew it was about time for the fights to begin.

There were Concos as well as Cubanos there, but very few women. Betting was heavy. Steel needles were affixed to the honed-off stumps of the cock's natural spurs. When a cock stopped fighting and tried to escape, everyone cried, "To the pot!"

When one was badly injured but gamely attempting to fight on, the crowd called upon its *gallero* (handler) to save him to fight

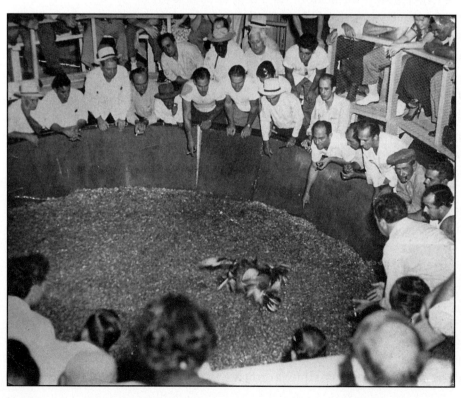

Every Sunday afternoon, menfolk got up from their domino games at the Cuban Club, or dropped whatever else they might be doing, and wended their way to the cock-fighting ring. The man in white hat (center) is the ring-master. Also in the picture are the state legislator and his brother.

another day. Resuscitation was accomplished by shoving a plug of peeled aloe vera pulp down its throat, with immediate results. Some revived cocks wanted to get back in the pit and fight some more.

In recent decades, cockfighting moved out of Key West and up onto Rockland Key. In the old days, cocks were bred in Key West, and also imported from Cuba and Tampa, and brought prices up to $40 for a champion. Later, inflation raised the going purchase price to as much as $500. The trade embargo against Fidel Castro cut off the supply of Cuban gamecocks along with everything else, so then they were imported from Puerto Rico. Aficionados have not forgotten the names of some of the legendary champions of mid-century: El Pinto, El Canelo, Banano, Martí, and Pisa y Corre, among others.

Nowadays the cocks have fared better than the cockfights. While clandestine cockfights may still be going on in the Lower Keys, in Key West they are a past pastime.

But across Key West hundreds of feral roosters and hens scamper along alleys and across parking lots. They awaken slumbering Key Westers at dawn and distract diners in outdoor cafes. But most local folks tolerate them, and visitors chuckle at this local curiosity. The fact that rather many of the older birds have had their natural spurs filed off, to accommodate the needlelike steel spurs attached for fighting, attests that something has been going on somewhere, and not very long ago.

In March 2008, volunteers captured 419 of these game birds for relocation to Eustis, Florida, three hundred miles to the north. The next morning a cacophony of crowing still echoed across the island. The survivors seemed oblivious to the fact that hundreds of their one-time rivals had been deported.

Los Caballitos

Key West had its own circus, which we called *Los Caballitos*, meaning Little Horses, but which kids called the Merry-Go-Round. They pitched their tent once a year in a vacant lot at Simonton and United.

Some of the big sponsors of *Los Caballitos* were some of Key West's Cuban Baseball Club: Alfredo Crespo, José Maria Baeza, Pancho Fleitas, and Felo Rodriguez. They went every year to the Cuban Professional Baseball League in Havana, and when they retired were in the Cuban Baseball Hall of Fame.

Los Caballitos not only kept Key Westers entertained, but traveled all over Florida. Before baseball games would start, *Los Caballitos* used to put on a big show of acrobatic stunts.

Conversation Overheard

A Cuban driver of a horse-drawn carriage in Key West brought a Conch fisherman home, and it seemed as if the fisherman didn't want to pay him, so the Cuban said, *"¡Dame una dinera!"*

"I hain't cot none," said the Conch.

"¡Dame una dinera!" demanded the Cuban again.

"I hain't cot none!" said the Conch angrily. "And look 'ere, mon, if I 'it ye, ye von't valk nor ye vonst roon, but ye'll floi—ye'll floi right hoff the hearth!"

Doctor Fraga

Back in them days it was customary for just about everybody to get wormed once a year at least, usually in the spring, to start the year off right.

There was a Doctor Fraga who had a drug store at Virginia and Duval, where Flamingo Crossing Ice Cream Shop is now. He had his own special prescription for a vermifuge, which he sold under the name of "Doctor Fraga's Cuban Vermifuge." It came in a special bottle, too, aqua-colored, about four inches long and an inch thick, with ribs. If you were to ask around, you could probably find people who still have one of those bottles.

Doctor Fraga's vermifuge was absolutely guaranteed to get rid of at least fifty to a hundred worms with every dose. I don't know what ever happened to all them worms—you never hear of anybody taking vermifuge anymore. Doctor Fraga's Vermifuge must have got rid of 'em, once and for all.

Key West Funerals

Perhaps inspired by funeral traditions in New Orleans, a Key West funeral procession was a resplendent affair, led by a cornet band in colorful uniforms and white gloves. The first of these musical ensembles was the Key West Cornet Band, organized with seventeen pieces in 1874.

Key West followed the Mediterranean custom of shops closing their doors and homes their window shutters as a funeral procession passed by, as a token of respect.

Ménage à Trois

Another continental custom, the *ménage à trois* (three-fold household), was not without its exemplars on The Rock. In this custom an elderly man who desires to take a junior wife into his household may do so, without sanctions imposed by his incumbent spouse.

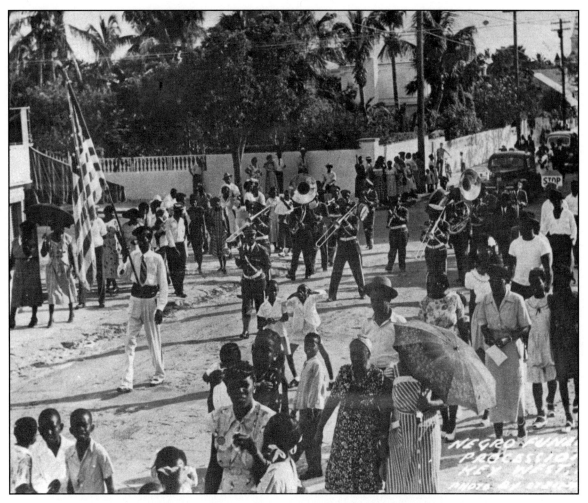

A major African-American contribution to the island's culture was the Welters Cornet Band that led the funeral processions that were staged when someone important passed away. Here the band is passing the corner of Angela and Simonton on its way to the city cemetery.

Far more civilized than putting the elderly wife out, Key Westers agreed.

Graveyard in the Rock

The original Key West cemetery was located near the lighthouse at Whitehead's Point, but a hurricane in 1846 destoyed it and washed most of the cemetery's occupants away. The dimensions of Key West, being what they are, have imposed certain restrictions upon folkdeath as well as folklife.

For one thing, getting put "six feet under" is a little much when the burial ground is solid coral rock. Pickaxes and, in their turn, jackhammers, have been a requisite, making the life of a gravedigger on The Rock an arduous one.

Artist's sketch of the good ship Mascotte, *which for generations was a principal means for transporting Key Westers to Tampa to visit friends and relatives—and vice versa. Whether you were expecting someone on board or not, everyone went down to the dock to "meet the ship" for lack of anything better to do.*

Tourists and coins were few and far between during the Depression, but there was no shortage of boys waiting at the foot of Duval Street to dive for them.

Considerations of both space and labor have resulted in coffins, often as many as three or more, being superimposed on top of one another. Some of the headstones include a photograph of the deceased, protected by a transparent stonelike slip, after the manner common to Mediterranean countries.

In death as in life, Key Westers have insisted upon being characters. One marker bears the laconic inscription, "I told you I was sick!" Another, more recent, is dedicated to "Our Little Hippie."

Meeting the Boat

It was in 1873 that the Mallory Steamship Line began regular service between New York, Key West, and Galveston. In addition, there were many other regular callers at the Trumbo Docks, such as the *Mascotte* and *Olivette*, which did a thriving business transporting Key West and Tampa Cubans back and forth to visit relatives.

"Meeting the boat" was an event that drew large crowds of Key Westers, regardless of whether they were expecting friends or relatives on board or not. The reception included boys diving for coins tossed by passengers, trying to intercept them on the way down before they got lost on the murky bottom.

If the ship was coming in from Havana, crewmembers could be seen hastily making arrangements for a small boat to retrieve contraband liquor that they had dropped overboard, with float attached, at the mouth of the harbor. At the same time, "pirates" and customs boats were trying to beat them to it.

Outhouse

Another well-nigh universal institution dictated by the absence of running water and "inside plumbing" was the *cursado* ("frequented place"), complete with Sears catalog in lieu of toilet tissue, which cost money, which no one could spare for such luxuries.

Flies abounded, but the brilliant sun evidently sterilized them en route from outhouse to kitchen. Many a Key Wester, impatient for progress, made periodic pilgrimages to Miami where they bought a ticket to the movies—not to see the movie, but to see and use a real toilet.

The water shortage also caused pioneer methods of bathing to persist on the Keys long after they had been superseded on the mainland. Bathrooms, in other words, were equipped with pitcher and bowl, and a round tin washtub for ablutions of the whole body. All water for household usage was drawn from the cistern by a

When pollution was "no problem." For generations, cities and towns in Florida and across the United States dumped raw sewage into rivers or oceans. Key West was no exception. This 1929 scene shows barrels of privy contents waiting to be hauled out to sea.

Water from Heaven. Every dwelling had its cistern to gather runoff rainwater from the roof ("with all that bird-shit"). Lids had to be tight to keep rats and cats from falling in (lizards were even more of a problem). A film of kerosene on top of the water deterred mosquitoes from laying their eggs. It took the coming of World War II to provide the motive and money to pipe in water from Homestead.

Many a household lacked the luxury of a pump-with-tub. With a lifetime to practice, a stand-up bath with basin worked quite well. A galvanized round washtub was much better.

Inside plumbing, early Key West style. The hand pump was probably connected to a rainwater cistern, not a well. This bathroom was a cut above those using round galvanized laundry washtubs.

hand pump on the back porch.

Mother Nature not only had a great deal to say about the way of life on the Keys, but, for all those engaged in maritime pursuits, more or less dictated what people did day by day. Everybody on the Keys knew that the only time to go fishing was "when the wind is walking right, and the water is crystal as gin."

What's more, every Key Wester knew that only a damfool stranger (mainlander) would go swimming after a big blow had made the water milky. (If you do, you get a seven-day itch.)

The Post Boy

Key West got its first post office in 1829, and *The Post Boy*, skippered by Captain David Cole, a small sailing vessel of ten tons, brought mail about once a month from Charleston. Or so the contract called for. But according to some contemporaries, those deliveries were more often based upon "fifty-day months."

The Post Boy was required to put in, en route, at Cape Canaveral, which was as noted for its calms as Cape Horn is for its storms. Captain Cole blamed the delays on the fact that he was required to make a stop there.

Persons attending the arrival of the *The Post Boy* generally carried one or more twenty-five-cent coins with them, as that is what it took to claim a letter that had not been "prepaid" by the sender. You could also get a newspaper sent to you COD.

Mail service did not improve rapidly. In 1833 the only regular mail was coming monthly by boat from St. Marks. It was not until 1848 that a "remarkably fast and comfortable steamer" of 1,100 tons, the *Isabel*, took over the Charleston/Key West route, and maintained it until the Civil War broke out in 1861. Ships owned by the Morgan interests of New York brought mail during that same period from such Gulf ports as New Orleans.

A shipping line holding a contract from Cedar Key to Key West operated for twelve years. In 1876, a writer complained that its contract ought to be looked into to see whether it called for "weekly" or "weakly" service. At the same time, he exulted that the young people had "great cause for happiness," because the adoption of affixing prepaid stamps had brought the cost of a letter down to twenty cents, and a newspaper thirty cents, with a probability of still lower rates in the future.

Washing

This word once had a very special meaning in Key West. A description of the practice penned by the Reverend Simon Peter Richardson, assigned to Key West by the Florida conference of the

Methodist Episcopal Church South in 1845, read as follows:

"Brother Graham of California memory, was stationed there [in Key West] the year before, and gave me a very unfavorable account of his ministry on the island. He told me there were thirty-two grog shops there, and that he had encountered many difficulties. The whiskey men had threatened to wash him, which meant to tie a rope around his waist and shoulders and from the wharf to cast him into the water and then haul him in, and then cast him out again. It is a terrible ordeal to put a man through. He eluded their grasp by taking refuge on the boat that brought him over.

"He suffered many other indignities that were heaped upon him during the year. His church building was a small structure twenty by thirty feet. His flock was composed of Wesleyan Methodists from the West India Islands. There was but one American among them, and the more I thought over the treatment he had received, the more indignant I became. The devil made a flank movement on my piety and consecrated my life, until I felt that, if I ever heard of any attempt to 'wash' me, they would smell fire and brimstone. I resolved that I would wipe-up the earth with the first man that insulted me. The devil had got complete control of me.

"I was the only regular preacher on the island. . . . I looked around for trouble but found none. Everybody was polite and kind to me. I soon began to cool down and feel repentance for my sins. In a few days the judge, doctors and prominent citizens called to see me, a reception I never had before, nor have had since. I was invited to the Masonic lodge and chapter, and made chaplain of both. My little chapel was soon filled with women, the men standing around outside."

Who Needs Cops, Anyway?

Anyone who feels that Key Westers nowadays don't pay enough attention to the laws should have been around during the last quarter of the 1800s.

The number of people living on The Rock jumped from three thousand in 1860 to more than five thousand by 1870, largely as a result of the Cuban influx and the development of the cigar industry. A great many of these newcomers settled in homes outside of what were then the city limits. State law required that folks living inside a city, as well as those living outside, had to cast a majority vote for any extension of the city limits.

Some votes were taken, but the folks on the outside elected to stay out, letting it be known that they were enjoying their freedom, and didn't have need of such things as taxes, police, fire, and

garbage services. Things rocked along that way for years.

"Those outside the city limits were as orderly and law-abiding as those within, and were happy and prosperous without the so-called privileges of a city, and in addition were free from molestation by city policemen," a local historian vouchsafed in 1912.

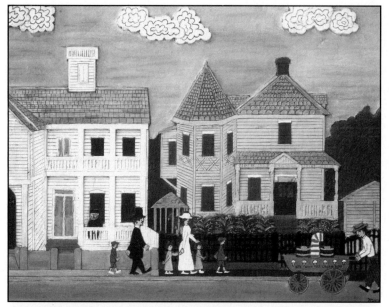

Where the Gingerbread Really Came From

If you want to believe all those Key West tourist guidebooks you would think all that "gingerbread" on Key West houses—balusters, spindles, newel posts, and cornices—were "hand-carved by old ship's carpenters" or "brought in from the Bahamas."

Fact is, most of them were made at the woodworking shop of Francisco Camellon, which was on Simonton between Truman and Virginia. Camellon had a horse-pulled lathe. He had two horses, who took turns turning the lathe. While one was walking around and around in a circle doing the work, the other would be in a field out back, grazing and resting.

When Camellon finally retired, a man named Farragut took over the shop, and he and his sons ran it. As a sideline they made toy tops that children spin.

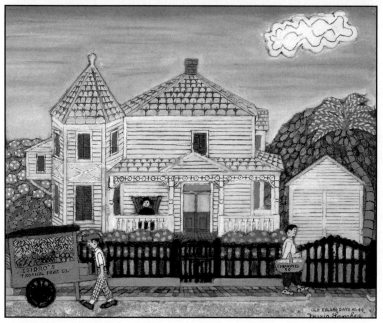

Mario Sanchez drew this house on Simonton Street twice. His earlier version at the top had little "gingerbread." The second, executed years later, has much more—perhaps from Camellon's workshop down the street.

All Deep Water Men

"We're poor ones for scenery, and all deep water men, with small likin' for the lead-line and windlass, Sir. I'll show you what it is to cut across lots [reefs] in a gale o' wind! Why, man, I can smell my way up the coast in the thickest weather, like a bird-dog scents a partridge. . . . You ungodly steamer-man, runnin' through murk like this with curses on your lips! Are you prepared for eternity?"

Suddenly there came that most terrifying of sounds—the jarring grind of the keel thumping over hard bottom.

The captain merely turned his head. "Give her a good full," he said. "It's the Hogback Reef. I thought it was about due."

—Parsons Magazine, 1910, purporting to be the language of a Key West seafaring man back in the days when sail was just beginning to be replaced by steamboats.

The Gods of Yoruba

The variant of voodoo that Afro-Cubans brought to Key West was called *brujeria*, and the men and women who practice it are known as *brujos* and *brujas*. According to Doctor Fernando Ortiz in his book, *Los Negros Brujos*, the word *brujo* (from an African word) was in use in Cuba before the Portuguese word *fetichero*.

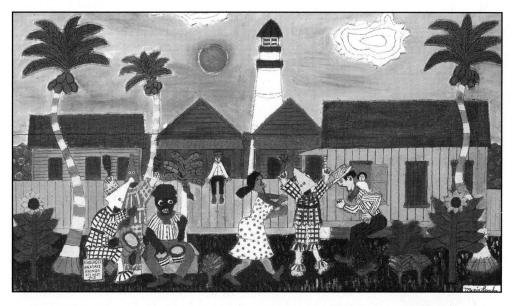

Every Christmas eve (Noche Buena) after everyone had finished eating their roast pork and black beans, Manungo would come out on the sidewalk and fine-tune his drum. Others, in and out of costume, would join him, bringing their instruments. When everyone was ready, Manungo would lead the procession of dancers through the streets. As the diablito (little devil) he carried a stick and periodically would charge a spectator, scattering everyone and making the evening a great success. The Ñañigos were a gang/cult of African origin, and any affront, real or fancied, to one of their members could lead to death.

If you ever find marks like these scratched in the dust around your back door, be careful not to step on or over them. Get yourself a broom like the ones used around fireplaces and, standing to one side, carefully erase them. Good luck.

Top: Three typical brujo *idols. Key West's own Chucker Edwards said his was so tough it ate steel wool for breakfast. Bottom: Shango, African god of lightning, one of the Yoruba pantheon once widely respected in the Western Hemisphere by people of African descent, and well-known to Afro-Cubans in Key West.*

Brujeria is monotheistic to the extent of worshiping a "Jupiter Optimus Maximus" named Olorun, alias other African names meaning the Señor of Heaven, Glorious and Elevated Being, the Ever-Just, King of Glory, and so on. A pre-eminent god without an idol, Olorun is far above communicating with men. He is the common property of a number of African tribes and cults.

One of *brujeria's* most potent spell-casters is prepared by removing the entrails of a black or white chicken and stuffing it with human excrement, roasted corn, fruit peels, buttons, black beans, herbs, the feet and comb of a rooster, coins, nails, tacks, shells, fishhooks, blood, grated coconut, lard, and Guinea pepper. The thing is then secretly deposited as near as possible to the victim, preferably under his house.

Professional *brujos* and *brujas* do a thriving business in Miami, Key West, and Tampa, but greater influence is wielded by the much more numerous and equally adept amateurs. As is generally the case in voodoo, women predominate among the believers, and their spells almost always have to do with marital and other amorous relations, serving to initiate, maintain, improve, or sever them.

Most powerful and elite of the *brujeria* cults is *ñañigo*, an African society imported bodily to Cuba and thence to Key West and Tampa. Besides its religious functions, *ñañigo* is something of a fraternal and mutual-aid society. Each group consists of thirteen members; four big chiefs are elected, and the remaining nine also have titles and particular duties. The four best dancers are selected as *diablos*, or devils. Only the most fearless and virile of men are admitted, though some groups initiate one unmarried woman.

The principal *ñañigo* ceremonies and street dances customarily take place around Epiphany and during the carnival season. Not infrequently, street dances were performed to distract public attention so that a *ñañigo* could murder one of his enemies. Needless to say, the dances created considerable apprehension whenever they occurred. Eventually *ñañigo* was banned in Cuba, but it continues to exist in many of the island's urban and rural slums.

In Cuba the secretiveness

of the society lent itself well to the plotting of
revolutionary activities, and the *ñañigos* contributed
substantially to the overthrow of Spain's control. With
the founding of the Republic, many of the island's
most prominent white citizens joined *ñañigos* in a
vote-getting maneuver.

The *ñañigo* ceremonies and dances are probably
closer to Africa than anything else performed in
Florida. Incantations are intoned in the "words of
ñañigo," a jargon combining African and Spanish
dialects. One of the most primitive aspects of the
rites is the manner in which the ceremonial rooster
is killed. Some *diablos* grasp the cock by the legs
and repeatedly strike its head against the floor as
they perform their contortionist dance. Other *diablos*
prefer to grasp the cock's neck between the first and
second toes of their right foot and decapitate it with
a jerk on its legs. The blood is deposited in a basin
called a *chumba*, and sprinkled over the altar, idols,
and floor.

Depiction based upon ñañigo
*costume in Museum of Natural
History, Havana.*

Another dramatic ceremony is the symbolic
burial held whenever a member is to be expelled or murdered for
revealing the cult's secrets—it is their "death from *ñañigo*."

Ñañigos among the Cuban patriots sought refuge in Key West
and Tampa, and were later joined by other notorious *ñañigos* who
were wanted in connection with *ñañigo* killings in Cuba. Some
became respected citizens in their Florida communities.

A *ñañigo* group was organized in Key West, and enjoyed its
greatest popularity between 1880 and 1890. Street dances were
given from time to time, and dance parties on New Year's. However,
a Cuban resident was mysteriously murdered during one of their
street dances, and although the police could find no evidence, it
was the general belief in Key West that it was an act of the *ñañigos*.
After that the society gradually disbanded. In 1923 the last *ñañigo*
street dance to be held in Key West was performed "for fun" by
Cuban young people attired in makeshift costumes.

The greatest living influence of *ñañigo* in Florida is in Cuban
popular musical compositions that feature characteristic *ñañigo*
bongo drum rhythms, and the "words of *ñañigo*" addressed to the
Gods of Yoruba.

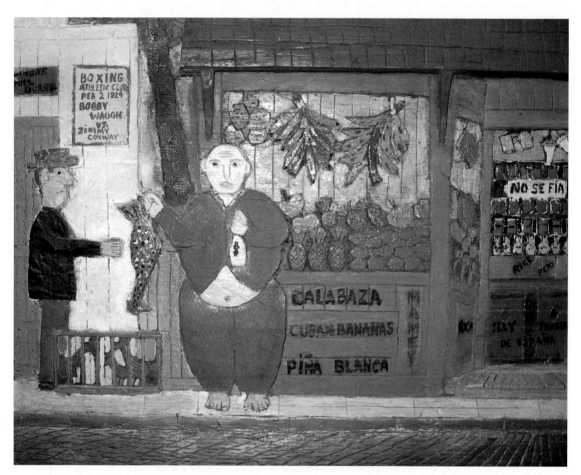

Monkey man is dispensing a live speckled chicken at this streetside produce stand on Duval Street. The "calabaza" in Monkey Man's sign is a tropical squash. "Cuban bananas" are the tiny ultra-sweet variety imported from Cuba. "Piña blanca" refers to the small, sweet, white pineapple grown in Cuba (not the big yellow from Hawaii).

What's to Eat

Three major factors merged to make the island's cuisine
something special: the abundance and variety of seafood, the
availability of "exotic" tropical fruit and tubers, and the influence of
traditional Spanish/Creole cookery.

The results are indeed exceptional. If you are inclined to pursue
the matter beyond the dining table, the abundance of Spanish and
Creole cookbooks make that part easy. Warning: "Key West Cook
Books" are a dime a dozen in shops all over the island. Some are
better than others, so it pays to compare.

Good information on what can be done with tropical fruit
and tubers is not readily come by. Perhaps some elderly señora or
proprietor of one of the surviving *bodega* markets can be found who
is willing to instruct you.

What follows is a small sampling of the distinctive foodstuffs
that Key West has to offer.

Conchs Eat Conch and Grunts

The conch is truly symbolic of the folklife of Key West. No matter
how you spell it or what language you speak, if you want to be
understood in Key West, you should pronounce it "konk." The word
is derived from the Greek *konche*, applied to a variety of spiral-
shaped gastropod marine mollusks. The Romans, who didn't learn
their Greek very well, spelled it *concha* and applied it to the mussel,
a bivalve.

Everybody in Key West and the rest of the Florida Keys, as
well as all the islands of the Caribbean, knows their conchology
well enough to know that the Greeks were right. Even tourists
know the conch for what it is, having seen them stacked in piles
in front of roadside shell shops up and down the Florida coasts. At
mid-century the signs atop those piles read: "5 Cents" or "Free."
This, together with an exploding American taste for conch fritters,
chowder, and salad eventually led to a ban, in 1985, of any further
harvesting of conchs in Keys waters. Since then the demand has

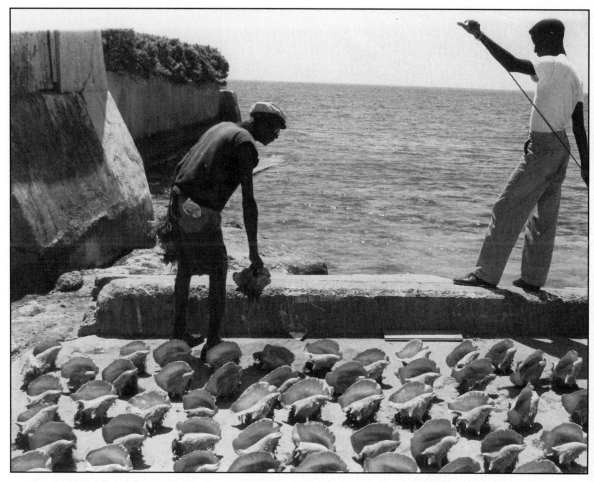

"Conch Shells for Sale, 5¢ apiece." Foot of Simonton Street, Key West. Long before mainstream America acquired a taste for conch fritters, chowder, and salads, their shells were piled high outside of citrus stands and gas stations all along Florida's east coast, for free or five cents. You couldn't give one to a Key Wester. They know that, inside a house, they bring bad luck.

been met largely by import from Caribbean sources. Attempts to "grow" conchs in Keys waters have thus far not proven successful.

Long before white and black men came to the Western Hemisphere the natives were making good use of conch shells as bowls, scrapers, and digging tools. The shells were also used as bugles for blowing signals, and this was something that the people from other continents also found useful.

But it has been as a staple in the diet that the conch endeared itself to the people of Key West and other islands. Both the elongated "king conch" and the more common "queen conch" are relished raw and prepared in a variety of forms not only for their taste but also for the aphrodisiac powers attributed to them. Conch is said to do the most for your sexuality when eaten raw, alive and kicking.

In Miami, in fact, a flourishing chain of lunchrooms during the 1930s were developed under the name of "He-Man Conch Chowder," with signs reading:

It Has What You Lack—
Gives You Vim, Vigor and Viggle!

On days "when the wind is walking right" and Keys waters are "as crystal as gin," Key Westers equipped with glass-bottomed buckets (which also served generations of spongers) and long poles tipped with hooks could bring up conchs from depths as great as sixty feet. Lacking a pole, a Key Wester, spotting a conch on the ocean floor while on a fishing trip, could seldom resist diving for it. Once in the boat, the flesh of the conch was extricated from the shell by piercing the third spiral from the tip with a screwdriver, and then severing the muscle attaching it with a twist of a knife blade inserted into the slot.

That done, you can pare the flesh into strips, dip them into the salty seawater, and enjoy! And if the fish are not biting to your satisfaction, all you have to do is chew up the other portions of the conch and spit them into the water as chum, and all the fish in the area will congregate for a share.

The next step up or down the culinary ladder is conch salad. Prior to the advent of refinements aimed at the tourist palate, the traditional Key West conch salad was simply conch diced and marinated in a dressing of Key lime juice, vinegar, salt and pepper, and perhaps served on a bed of lettuce.

For frying, conch strips are marinated in this same dressing (minus the vinegar) and dipped in a batter of your choice.

The traditional Key West recipe for making conch chowder called for 4 coarsely ground conchs, 4 diced potatoes, 1/2 stick of butter, 1 pound salt bacon, 1 diced onion, 1 diced green pepper, 1 tablespoon Worcestershire sauce, and salt and pepper. In a large pot, you simmer the conch and potatoes in 2 quarts of water. In a skillet, you sauté the onion and green pepper with the bacon and butter. You add the rest of the ingredients to the skillet and stir till soft. Then add the skillet ingredients to the conch and potatoes in the big pot and simmer to desired thickness.

Back in those days when wrecking, sponging, and cigarmaking made Key West the most affluent community per capita in America, a deluxe cream of conch stew was in vogue. It went out of style during the Great Depression, but has enjoyed a bit of a comeback since then. If strangers only knew what they were missing they would demand this version in Key restaurants, at any cost!

Conch Puree Supreme was made with ground conch, 1 onion, 3 stalks of celery, 1 quart of milk, 1 quart of cream, 1 stick of

butter, and salt and pepper to taste. Boil the conch, onion, and celery in 3/4 quart of water for twenty minutes. Heat (but do not boil) the milk, cream, and butter, and then combine this creamy mixture with the liquid containing the other ingredients. Let stand, strain, stir in six crumbled soda crackers, and serve, topping bowls with whipped cream.

Key Westers' appreciation of conch is best summed up by the old Conch jingle which goes:

> In all my mother's children, I loves myself the best;
> And till I gets my stomach full, God help the rest!

Whadaya Mean, "Key Lime Pie"?

Not only in Key West and the other Florida Keys, but all over the country unsuspecting Americans are ordering what the menu calls "Key lime pie." Ignorance may be bliss, but it is no substitute for real Key lime pie. With very, very few exceptions, none of the pies being served by that name have ever seen a real Key lime. By and large they are a concoction of tapioca (or whatever it is that store-bought pies are made of), some sugar, green coloring, and citric acid, or, at best a little juice from a Perrine lime or Persian lime (which is half-lemon, and looks and tastes like it).

Key Lime

A real Key lime is round like a ping-pong ball, and about the same size as one. They are infinitely more tart, flavorful, and aromatic than the hybrid limes that have almost totally replaced them on the market. The easy way to tell one from the other is to scratch the peel with a fingernail. If it's a Key lime your nose will know it, even at arm's length!

Some accounts have it that this lime originated in India and reached Spain in time for Columbus to introduce it to Hispaniola when he landed there in 1492.

Apparently European explorers took them with them wherever they went in the tropical regions of the Americas, and in time they came to be known as "Mexican limes." When the United States "purchased" Florida from Spain for $5,000,000 in 1819, the limes were already flourishing in Key West and were sufficient reason for sailing vessels to make the island a port of call in order to replenish their supply of limes. Pickled in barrels of brine, they were a prime preventive against scurvy aboard ship during long weeks at sea without fresh fruit or vegetables.

For generations, the growing of Key limes was a major industry on the upper and middle Keys. Those were the days when drug stores featured soda fountains where one could sit on a stool

or at a table and a "soda jerk" would concoct whatever drink you wanted. Fresh limes were generally displayed on the counter in a large glass bowl. They were used for not only for limeade, but for "dope with lime" (wherein "dope" was Coca-Cola), the most popular drink of all.

The black Bahamians who settled on Islamorada, Key Largo, Matecumbe, and elsewhere on the Keys, for generations divided their time between picking limes and fishing. The groves did not look like groves, but jungles overgrown with vines. The trees were not planted in rows, but in any little depression in which rainwater could gather, and a hole for planting could be chipped into the coral rock. Consequently, one could drive through a lime grove along the Overseas Highway and never know it, the lime trees being lost in the tropical greenery. Unlike other citrus, the Key lime has a way of bearing year-round. Picking them required a machete to hack through the vines and to protect the workers from the rattlesnakes.

The value of Florida Keys property being what it is today, the Key lime doesn't seem to stand a chance for a comeback, unless it is upon the mainland. Meanwhile, America doesn't know what it's missing.

Real Home of the Cuban Sandwich

You can buy what's called a "Cuban sandwich" almost anywhere in America today, just as you can what's called "Key lime pie." But the real home of the real Cuban sandwich was probably right here in Key West.

Of course, you have to start with real Cuban bread. All the bakeries and supermarkets now will sell you a loaf of "Cuban bread," but if you watch you will see that they have bags reading "Cuban bread," "French bread," and "Italian bread," and they may well be putting the same bread in any one of those bags, according to your request. To be real Cuban bread, it has to be made of a certain kind of flour, and it really ought to have one of those wavy crusty strips running down the middle of the topside.

It's okay to make a Cuban sandwich out of those long loaves, cut up in pieces about ten inches long, but the best is to use one of the oblong buns called *cocas*, which are already the right size, and crusty at both ends.

In those days you could ask for a *sándwich de jamón* (ham), a *sándwich de puerco* (pork), or a *sándwich mixto* (mixed). The mixto had both ham and pork in it, and a slice of American cheese and some sour pickle. Most people wanted mustard on their ham and mixed sandwiches, and mayonnaise with lettuce and tomato on

the pork. If you wanted it *tostada*, all you had to do was say so.

Way back, what was probably the best Cuban sandwich on the island was made by the *hermanos* Alfredo and Zacarias, who had a little *bodega* on the corner of Virginia and Simonton. According to Mario Sanchez, who ate a lot of their sandwiches, these brothers had a special way of baking their ham. He says they boiled it with a "string" of garlic and some cloves, and after it had cooled they sprinkled it with some brown sugar, which they turned into a glaze by pressing it all over with a hot iron.

These same brothers, when the cigar factory across the street from their shop was still open, used to take two big pots of Cuban coffee over there, twice a day, and the cigarmakers would all buy *un buchito* (a little swallow) in a demitasse cup to keep themselves going.

In later days, the Cuban sandwiches made by Jesus Carmona at his El Anon ice cream parlor on Duval Street, next to the Cuban Club, were just as good.

Jesus Carmona's El Anon ice cream parlor was located next door to the Cuban Club. El anon is the name of a tropical fruit known in English as sugar apple. In addition to that, Jesus made ice creams and sherbets from a host of others. including mango, sapodilla, mame, guanabana (soursop), guava, manzanilla, tamarind, and sapote. His recipes were top secret, and, alas, died with him.

Key West's first supermarket, the Gulfstream Food Department Store, opened its doors on February 8, 1949. The islanders were especially fascinated by the refrigerated and frozen foods sections.

Hollerin' Hongry

During the root-hog-or-die days of the Great Depression, various "hard times specials" made their appearance on Key West tables, such as *montadella* (spiced ham luncheon meat), which was fried and then dumped, grease and all, over hot grits. (Very tasty—don't wait for the next depression to try it!)

Generations lived and died on the Keys without benefit of refrigeration. The only ice, cut from freshwater ponds in Maine, arrived at great intervals aboard sailing schooners. The scarcity of ice contributed to the popularity of such dishes as *ropa vieja* (old clothes), actually beef jerky cured by drying on racks beneath the hot Keys sun. Buzzards presented no problem since they seldom venture so far out to sea.

The dearth of fresh water was another fact of life on The Rock. Up until the completion in 1944 of an overseas aqueduct bringing potable water from the mainland, almost everyone had to rely upon rainwater drained from rooftops and collected in cisterns. Tight covers were a must to keep cats, rats, and lizards from falling in.

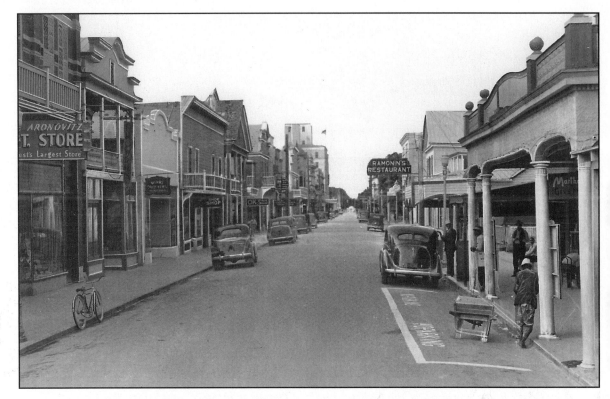

Aronovitz's Department Store, on the left, advertised itself as "Key West's Largest." Ramonin's Restaurant, in the distance on the right, is where the author subsisted on twenty-five-cent garbanzo soup during the Great Depression.

The Sea Breeze Sandwich

Not even the Great Depression of the 1930s was able to put a damper on the Key Westers' sense of humor.

One of the bright ideas that occurred to the federal government during the several years in which it was responsible for all of the island's public services was to hire some of the unemployed (more than eighty percent of the population was thus qualified) to rake up the seaweed that every high tide deposited on the sands of South Beach. (The rationale for this potentially perpetual project, a job with a future, was to keep the beach looking attractive just in case a tourist showed up.)

It was here, under these circumstances, that the sea breeze sandwich was invented. It happened one day when the whistle blew for lunch. An Afro-Cuban worker, whose name has been lost to history, extracted a hunk of Cuban bread from a brown paper bag, sliced it, and then held the two halves up into the sea breeze, which, thanks to all the decomposing fishes and crustaceans in the seaweed, carried with it a flavorful *fruta-del-mar* aroma. That done, the man squeezed a lime onto the bread, put the two halves

together, and proceeded to munch on his sandwich *con mucho gusto*.

"What on earth do you call that?" his colleagues asked.

"*Un sándwich de marisco*," he replied. The fishy-smelling seabreeze that had permeated the bread was a poor substitute for seafood, but they all got the idea.

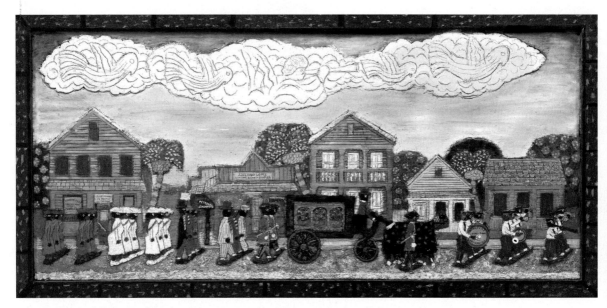

Most occasions in Key West called for music, even funerals. When the family could afford it, black funerals in Key West looked like this, with the Welter's Band leading the way.

The Key West Songbag

Many of these songs and tales, as recorded by Stetson Kennedy and others during the 1930s, may be heard at the American Folklife Center on the Library of Congress website. (Search "Florida Folklife from the WPA Collections.")

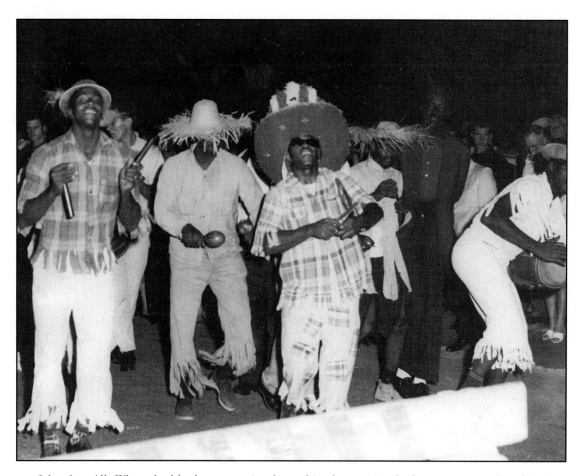

Islanders All. When the black community danced in the streets, the beat was a combo of Latin, Bahamian, and Key West rhythms.

A LA BAHAMA

The Anglo- and Afro-Bahamians who settled in Key West and elsewhere on the archipelago brought an abundance of cultural baggage with them, including an overflowing songbag, some harking all the way back to the British Isles, others to the African mainland, and still more created out of the two groups' shared experiences in the Bahama Islands.

Back home in the Bahamas, both groups had traditionally been occupied in the main with such maritime pursuits as fishing, sponging, turtling, rumrunning, wrecking, and boat-building. It was much the same in the Florida Keys, and their songs reflected the fact. The Bahamian songbag imported to the Florida Keys frequently incorporated both Anglo and Afro elements and were shared by both groups. Here are some of the most popular survivals.

Sponger Money

Although Afro-Bahamians had engaged in sponging in their home islands, when they came to the Florida Keys they found the occupation largely monopolized by the Anglo-Conchs. Consequently, many of them occupied themselves with commercial fishing.

> Sponger money never done, sponger money,
> Look at my hand, my hand look new,
> Cause I don't want no other money
> But sponger money.
>
> Look in my trunk and see what's there, sponger money.
> One hundred dollars was my share, sponger money.
> I'm gonna take away your woes, gal, sponger money.
> I'm gonna buy you fine new clothes, sponger money.
>
> Then when we go out on the street, sponger money,
> You'll be lookin nice and neat, sponger money.
> Then all the boys will envy me, sponger money.
> Then all the girls will fall for me, sponger money.
>
> Money don't make me, you know, sponger money.
> Sponger money ever flow, sponger money.
> Tell ev'rybody in town, sponger money,
> Me and my gal gon' dance em down! Sponger money.

Conchy Joes

Conchy Joes, all they know
Is after supper to the crawls they go;
Talkin' 'bout fish and turtle too,
Mark my word, you'll find it true.

I went a-fishin', fished all night,
My grapple got hooked,
Fish wouldn't bite;
Hard times, nothin' to do,
I lost my grapple and mainsail too!

A Gal Name Pink

Aunt Nannie got a gal
Name Pink, Pink, Pink,
And all her clothes
They stink, stink, stink!

Hoist up the John B Sail

Hoist up the John B Sail.
See how her mainsail set.
Send for the Captain ashore,
And let us go home.

Oh, let us go home,
To see my darlin',
Let us go home.

I feel so break-up
I want to make-up [set sail]
And go home. . . .

Captain and Mate got drunk,
Open the people's trunk,
Stole all the people's junk.

The Captain raise Cain up town.
Up come Policeman Brown,
Who took the Captain down.

ABACO

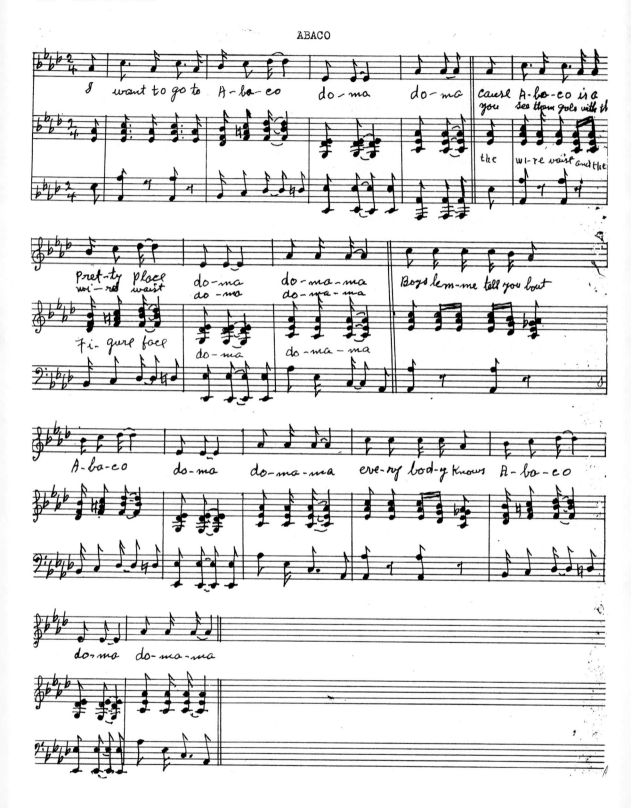

The Judge he was sorta' kind,
Scold him for drinkin' wine.
"Let you off light this time."

The Captain told the Mate,
At nine o'clock to lock the gate;
Run, run before it's too late!

Chorus:
Let us go home, oh, let us go home,
To see my darlin', let us go home. . . .

Abaco Is a Pretty Place

I want to go to Abaco, do-ma, do-ma,
'Cause Abaco is a pretty place, do-ma, do-ma-ma.
Boys, lemme tell you 'bout Abaco, do-ma, do-ma-ma.
Ev'rybody knows Abaco, do-ma, do-ma-ma.
You see them gals with the wire waist, do-ma, do-ma,
The wire waist and the figure face, do-ma, do-ma-ma.

Them Nassau Gals

'Round and 'round the bar-room,
Foolin' round the bar-room,
Runnin' round the bar-room.

Them Nassau gals like tigers,
Tigers, tigers, tigers.
They tear you down like tigers,
Tigers for sponger money!

Grate your potato,
Grate your potato.
Put a piece of pumpkin in it,
To make it yellow. . . .
Sponger mon-ey.

Bay grass was the weddin' bed,
Seaweed was the bolster,
Sandbank was the pillow.

Them Nassau gals like tigers,
Tigers for sponger money!

All you Nassau gals
Take your mind off the Nassau boys;
They all gone to war—all gone to war. . . .

Bellamena

Another classic of the Bahamian waterfront, known wherever
Bahamians have gone in Florida, is "Bellamena." A version
recorded in Key West includes a number of verses not to be found
in the popular Harry Belafonte rendition.

Bellamena, Bellamena,
Bellamena in the harbor.

Mena, Mena, Mena in the harbor,
Gonna' put *Bellamena* on the dock,
Gonna' paint her bottom black-black!

Oh, the *Mystery*, oh, the *Mystery*,
That boat she tote the whiskey;
Gonna' put the *Mystery* on the dock,
Gonna' paint her bottom black-black!

Oh, the *Maisie*, oh, the *Maisie*,
That boat she drive me crazy;
Gonna' put *Maisie* on the dock,
Gonna' paint her bottom black-black!
Now I ain't talkin 'bout her backsides—
Gonna paint her *be-hind* black-black!

Crab Is a Better Man

Pharoah, go 'way from my door!
Crab is a better man than man.
Pharoah, I'm tired with the plague!
Crab is a better man than man.

Crab is a better man than man,
'Cause he got his house and land.
Crab dig deep into the sand,
To build his house and land.

Crab is a better man than man.
Crab don't need no helpin' hand
To build his playhouse in the sand.

Bonefish Is Bitin'

Good morning, Father Fisher,
Good morning, Father Brown;
Have you any sea-crabs?
Please sell me one or two.
Bonefish is bitin',
I got no bait to catch 'em.
Every married man got his own bonefish!

Emma Dee's mad with me,
For what I don't know . . .
Jacob burned the kitchen for bread,
For what I don't know . . .
Peas and rice, loggerhead fin,
For what I don't know . . . Eh yeh, Lallie Lou!

Biddy, Biddy

Biddy, biddy,
Pass my old gold ring,
Till I can go back to London,
To seek out Simon,
Who's got the pawn.

Tearoll: Had an Idea

A stellar performer in the Afro-Bahamian community of Key West toward mid-century was one Theodore Rolle, better known as "Tearoll." A native of the Bahamas, Tearoll was in great demand as a singer after he settled on The Rock.

After his repertoire of Bahamian classics had been exhausted at a WPA recording session conducted by me at the Cornish Memorial AME Church in 1939, I asked Tearoll if he knew any "dirty" songs.

"Plenty!" he replied. "But I won't sing 'em in front of all these ladies."

Realizing that so-called "dirty songs" were a relatively neglected genre in the academic folklore collecting community, I resolved to dispense with the ladies, somehow.

"How about meeting me here at eight o'clock tomorrow morning, for a 'men only' session?" I asked him.

"I'll be here at eight sharp," he said. "But how about you?"

"You can depend on it," I assured him.

"*¿Palabra del hombre?*" (All blacks being lumped together on The Rock, they spoke a little of everything.)

"Word of the man!" I said, and we shook on it.

The next morning we were both there, on the dot, but hordes of women had arrived earlier and were sticking their heads in all the ground-floor windows. When Tearoll and I tried to shoo them away, they just laughed and laughed.

"What the heck?" Tearoll said. So the show went on. . . .

By latter-day standards, the songs he sang were not all that dirty. As a matter of fact, they were not nearly dirty enough to qualify for the primetime, family-hour television, radio, film, and video offerings of the New Millenium.

At this writing, about the only song that comes to mind is one titled "Tearoll's Idea," which included such memorable lines as:

> Baby, you wanna run around with me,
> You gotta wear your drawers half down!

(Rumor has it that all the dirty songs I recorded during the 1930s for the WPA Writers Project may be found in the National Archives in Washington, D.C., in an obscure corner in a cardboard carton labeled "Delta.")

Bill Burroughs: Brought Back Booze

One of Tearoll's songs had to do with "Bill Burroughs," a Bahamian black who during Prohibition had been a rumrunner operating between Bimini and Miami. The song chronicles an aborted delivery when, finding themselves fenced in by a police barricade in Miami, the good delivery men of Burroughs & Company reloaded

and cached their liquor—boat and all—under the waters of Biscayne Bay.

Although the words changed each time Tearoll had another beer, the composite subsequently pieced together went like this:

My name is Bill; my title is Burroughs;
This is old big boy bitch Bill Burroughs,
And I just got back from Bimini Bay.
Now just talkin' 'bout this name of Bill,
We got to see how it's done:
Each and ev'ry muckin' woid begins with B.

Big bad Bill brought boat been Bimini
Brought back big boxes booze,
Buddy-boy Butler—Bill's brother behind
Bringing balance booze [to] Benson [Miami boss].

Brought booze bridge
Big Boss back-back Buick
Broke barricades, beat Brass-Buttons,
Brought back booze boat's boxes
Buried bitch Biscayne Bay!

Bill Boy, Bad Boy, Big Boy, Baseball Boy,
Belted Boy, Baby Boy. Behold: Bill Burroughs!

With that, Tearoll cried "Now!" as a signal to his accompanists to end with a crescendo.

I succeeded in locating the real Bill Buroughs in 1941, at which time he was residing at 1438 Third Street in Miami. When asked whether he would be willing to provide some more of his compositions, he replied in pencil on a sheet of note paper that if payment could be had he might be able to remember some. But alas, I was as broke as he was.

Bimini Gal

Bimini gal is a hellova trouble!

Chorus:
Eh, lemme go down to Bimini!
You never get a lickin', go down to Bimini!

Bimini gal is a rocker and a roller!
East-southeast take you to the lighthouse!
Jim Curry, Joe Curry, bully for Skelton!

The Boy Who Went to the Apothecaire Shop

Doctor, Mar sent me down to the apothecaire shop, quicker'n blazes, 'cause Bob's home sick as the dickens with the pippin-choc. She ain't Pottle got a lardy-tin cup's cot wine bitters in it!

This Is About Sue Getting Her Clothes All Wet-Up

Mar, Sue's out 'ere settin' soppin'-drippin'-dreanin' dry:
She hain't cot a drip on ter if ye die!

Sal and Bill

Bill used to go see Sal every night but he would always sit by the fireplace, so one night Sal got tired, and she said, "Look 'ere, Bill, if ye mean to court me, ye must court me like a vite man! Don't sit off there as if I was pizen, ye longlegged, lantern-jawed, knock-kneed, pigeon-toed owl! Ye hain't cot a tarnel bit of sense!" Then Bill draws his chair close to Sal, puts his arms around her, and says, "No vhere 'longside ye, Sal. Oh, 'ow I loves ye!"

Brownskin Girl

Brownskin girl,
Stay home 'n' mind baby;
Brownskin girl,
Stay home 'n' mind baby;
Papa's goin' away in a sailboat.
If I don't come back,
Throw away the damn baby!

Come See the Crow

 Now, run your mama come see the crow,
 See how he fly;
 The crow fly east, the crow fly west;
 The way he fly, that way is best.
 Run your mama come see the crow,
 See how he fly!

 Fly, fly, fly away,
 See how he fly.
 Fly right up to Hutchin's Bay,
 See how he fly!

Fishy-Fishy, Bite!

If the fishing is slow, Key West Conchs swear that a surefire way to
make them start biting is to recite:

 Fishy-fishy, bite!
 Fishy-fishy, bite!
 Your father said you could,
 Your mother said you might.
 Fishy-fishy, bite!

Melia Mucha Mala

While I was living at 1210 Duval Street in 1939, a Bahamian
black woman named Amelia Devoe would drop by every Monday
morning to do the family washing in the backyard, drawing water
from the cistern by hand pump, which was the only source of water
for the household. For washing and ironing a very large bundle
she charged seventy-five cents, which compared favorably with the
local laundry, which charged a dollar.

"Melia," who was sixty-nine at the time, lived at 408 Deacon
Lane. She had been born in Nassau in 1870, and, after receiving
no schooling, emigrated to Key West in 1895.

When greeted in Spanish (*¿Como está?*) upon her arrival, she
invariably responded with all the Spanish she knew, "*Melia mucha
mala.*"

On one occasion, however, she replied:
Fine, fine, superfine,
The best of kind;
John fine, Henry fine,
Lawn fine, and brown cotton pretty-fine.

This was something she remembered from Nassau, she said, as having been the habitual greeting of a woman who ran a fabric shop. "Lawn," she explained, was an inexpensive type of cotton cloth, popular in the islands.

My Mother Had a Barrow

My mother had a barrow;
She crocked the marrow,
And give a nigger bristle,
And that made the nigger whistle.

Phyllis Stole the Ham

Phyllis stole the ham,
And fried it in a pan.

Oh, if my wife dies,
I'll soon get another one,
Soon get another one,
Soon get another one.

If my wife dies,
I'll soon get another one.
Phyllis stole the ham.

Tillie, Lend Me Your Pigeon

Tillie, lend me your pigeon
To keep company with mine.

Chorus:
My pigeon gone wild in the bush,
My pigeon gone wild . . .

Lil' Bill was steering,
Aunt Sophie was pulling the rope,
Mama Nannie was mixing the dough,
Papa Peter was down below,
Tobie was feeding the crow.

Chorus

Mr. Bethel Dog Bit Me

My mother sent me to town
To see the merry-go-round.
Mister Bethel dog bit me!

I gave the girl a half
But she would not let me laugh.
She say I'm like a beer,
And I could not go nowhere.
Mister Bethel dog bit me!

Betsie Bookie

Louise Hawkes, who was working for the WPA Florida Writers
Project in Key West in 1940, obtained this song from Dalia Sawyer,
a music teacher, at her home at 1017 Fleming Street, where she
was born around the turn of the century. Her grandparents had
immigrated to Key West from the Bahamas. She remembered she
had heard this sung as a game song by black children in Key West
during her childhood.

Go, go, go pray the Masser,
Go long, go lingo, lingo, lingo,
Jackie Wiry, Eichi Ubie,
Joe Funando, sukie, sukie,
Ander am, Betsie Bookie!

When I Was Young

When I was young and in my prime,
The Devil in Hell couldn't beat my time;
Now I'm old and getting gray,
My constitution's wore away.

Woman Sweeter than Man?

Woman sweeter than man?
Not from Cat Island land!
Before I'd let a woman be sweeter than me
I'd throw myself into the sea!

A LA CUBANA

When Cubans began immigrating to Key West, the majority were
bent upon working in the cigar factories that were being outsourced
from Cuba by manufacturers who hoped to leave labor unions
behind. These workers were bound for a new land with a different
language and culture, but, unlike most immigrants headed for
America, they were not all that keen on being Americanized. It
was jobs they were after, and they were determined to bring their
own culture, and above all their own music, with them. (They also
brought their labor unions, much to the vexation of the owners.)

Cuban music had already evolved into a world-class idiom,
embodying not only Hispanic and Afro elements, but some little
Amerindian as well. El Maestro Ernesto Lecuona had established
a global reputation for such classic compositions as "Siboney"
and "Carabali," and the whole of Cuba was dancing to his *sons*,
danzons, and *danzonettes*, which were in vogue in ballrooms
throughout Latin America. (Their popularity gained a new lease on
life with the appearance, toward the end of the twentieth century,
of the film *The Buena Vista Social Club*.)

And so it was that, along with their cloth-bag coffee makers
and other *impedimenta*, the Cubans emigrating to Key West
brought with them not only their heritage of songs, ballads, and
tales from Old Spain, but a preponderance of the Creole musical
idioms that had evolved over centuries on *"La Perla de las
Antilles,"* Cuba.

Nor did they leave behind the instruments which made their music what it was: *maracas* (gourd rattles), *claves* (mahogany sticks), *guajo* (a corrugated piece of wood scraped with a stick), *bongo* and *tumba* drums, and the *marimba* (a wooden box with metal strips for plucking). Some of these were of African origin; others were expropriated from the indigenous Indians, prior to their virtual extermination. Whatever their origins, all of these instruments put down roots and flourished on The Rock.

Thus, the *Cubano* colony in *Cayo Hueso* was never lacking in its own songs and music, and ere long the entire island—including Anglos and Afros from the Bahamas and mainland—were all dancing to Cuban melodies and rhythms. In fact, they were even walking to it. There was no escape. There really was no escape because many Cuban residents were in the habit of keeping their radios tuned to Stations CMCQ and CMQ in Havana, letting them blast Cuban music all day and into the night. One was never out of

Author Stetson Kennedy adjusts a Library of Congress recording machine while his Cuban/ Conch wife Edith sings folksongs at her home at 1210 Duval Street, 1938. WPA photographer Robert Cook took the picture with a delay shutter on a second camera.

earshot of it. To cap it all, in time many an Anglo *Conco* played—and played well—in the Cuban bands.

What follows is a sampling from the Cuban songbag. Some are just songs and some of the songs also serve as games. Some are from Spain, many from Cuba, and a goodly number that are Cuban-American and thus "Made in the USA" (Key West).

Songs

If You Want Me to Love You
Si Quiere Te que Quiera

Si quiere te me quiera
Linda cubana,
Traeme bonbones;
Así es como se endulzan los corazones.

Si quiere te me quiera
Linda Cubana,
Ponte le salla corta
A la Americana.

If you want me to love you,
Pretty Cuban,
Bring me bon-bons;
That is how hearts are sweetened.

If you want me to love you,
Pretty Cuban,
Wear your skirt short,
In the American style.

Desi Arnaz: A Key West Greeting
Desi Arnaz: Un Saludo Cayohuesano

Desi Arnaz ha demostrado
Que hablar en español no es un pecado,
Que la música, el baile y el canto
rompen barreras sin causar espanto.

Desi Arnaz has demonstrated
That speaking Spanish is not a sin,
That the music, the dance and the song
break barriers without causing fright.

Un saludo para este trovador que de Cuba vino,
Y que fué nuestro amigo antes que la fama
Encaminara su destino.
Con su guitarra con nosotros armonizó
Y muchos gratos recuerdos nos dejó.

A greeting for this troubadour who came from Cuba,
And who was our friend before fame
Would direct his destiny.
His guitar harmonized with us
And left us many pleasing memories.

Mucha suerte, Desi, para el future desconocido,
Y muchas gracias for tu, "I Love Lucy"
Que mucho nos ha divertido.

Much luck, Desi, for an unknown future,
And many thanks for your "I Love Lucy"
That has much entertained us.

Mama, I want
Mama, yo quiero

Mama, yo quiero.	Mama, I want.
Mama, yo quiero.	Mama, I want.
Mama, yo quiero, mama!	Mama, I want, mama!
Da la chupeta	Give the nipple
Da la chupeta	Give the nipple
Da la chupeta	Give the nipple
Porque el niño no llore!	So the little boy won't cry!

Calinga

Toma, toma,	Take, take,
Toma Calinga,	Take Calinga,
Para la vieja	For the old woman
Palo y heringa!	Stick and enema!

The Cockroach / *La Cucaracha*

Key West's *Septeto Encanto* (Singing Seven) took the popular Mexican song "La Cucaracha" (The Cockroach) and composed verses of their own about Key West characters and scenes. Some of these, recorded at 1210 Duval Street in 1939, went as follows:

La cucaracha, la cucaracha,	The cockroach, the cockroach,
Ya no puede caminar,	Already cannot walk,
Porque le falta,	Because he has no
Porque no tiene,	Because he lacks
Marijuana que fumar.	Marijuana to smoke.
Las muchachas de Cayo Hueso,	The girls of Key West
Usan mucho colorete;	Use much rouge;
No se lo untan con la mota.	They don't put it on with the puff.
Se los ponen por paquetes.	They put it on by the package.
Las muchachas de Ybor City	The girls of Ybor City
Son bonitas y bailan bien;	Are pretty and dance well;
Pero tienen un defecto:	But they have one defect:
Que no se lavan los pies.	They don't wash their feet.

Las muchachas de West Tampa,
Tienen mucha simpatía;
Usan muchos trajes buenos,
Con las barrigas vacías.

The girls of West Tampa
Have much charm;
They wear many fine clothes,
With their stomachs empty.

The Painted Bird
La Pajara Pinta

Estaba la pajara pinta
Sentada en su verde limón.
Con el pico recoge la rama,
Con la rama recoge la flor.
¿Ay Dios, cuando veré mi amor?

The painted bird was
Perched on her green lemon.
With its beak it gathers the
 branch.
With the branch it gathers the
 flower.
Oh, God, when cometh my
 love?

Pancho Carancho

Pancho Carancho
Mató a su mujer,
Con cinco palitos
Y un alfiler.

Pancho Carancho
Killed his woman,
With five little sticks
And a needle.

Papa, I Want
Papa, yo quiero

Papá, yo quiero
Usted me compre
Un clarinete
Que haga asi:
"¡Fili, fili, fili!"

Papa, I want
You to buy me
A clarinet
Which goes like this:
"Filee, filee, filee!"

The Patio of My House
El patio de mi casa

El patio de mi casa no es particular.
Cuando llueve, se moja como los demas.

The patio of my house is nothing
 special.
When it rains, it gets soaked like
 others.

Señora Santana

"*¿Señora Santana, porque llora el niño?*"
"*Por una manzana, que se le ha perdido.*"
"*Yo le daré una, yo le daré dos;*
Una para el niño, y otra para vos."

"Señora Santana, why cries the boy?"
"Because of an apple that he has lost."
"I will give him one, I will give him two;
One for the boy, and the other for you."

El niño:
"*Yo no quiero una, yo no quiero dos;*
Yo quiero la mia, que se me perdió."

The boy:
"I don't want one, I don't want two;
I want mine that I lost."

Sleep, Piece of My Heart
Arroja, Pedazo de Mi Corazon

Arroja, mi niño, arroja, mi amor;
Arroja, pedazo de mi corazon . . .

Slumber, my son, slumber, my love;
Slumber, piece of my heart . . .

Tin Marin

Tin Marin
De do' pingües.
Cucara macara,
Titiri fue,
Pasó la mula, pasó Miguel.
Mira a ver quien fue!

Tin Marin
of two biggies.
[two nonsense lines]

The mule passed, Miguel passed.
Look who's "it"!

Where Are You Going, Chiqitin?
¿Adonde vas, Chiquitin?

"*¿Adonde vas, Chiquitin?*"
"*A la Café de la Union,*
Para tomar chocolate
Y bailar la rumba, Pantalión."

"Where are you going, Chiquitin?"
"To the Cafe of the Union,
To drink chocolate
And dance the rumba, Pantalion."

Ballads

Ballads tell a story, set to music. Here are three that were popular
in Key West.

Where Are You Going, Alfonso the Twelfth?
¿Donde Vas, Alfonso Doce?

¿Donde vas, Alfonso Doce?
¿Donde vas triste de ti?
"Voy a busca a Mercedes
Que ayer tarde no la vi."

Where are you going, Alfonso the Twelfth?
Where do you go so very sad?
"I am going to see Mercedes
Who late yesterday I did not see."

"Ya Mercedes está muerta,
Muerta está que yo la vi
Quatro duques la llevaban
Por las calles de Madrid,
Por las calles de Madrid."

"Mercedes is now dead,
Dead, for I saw her.
Four dukes were taking her
Through the streets of Madrid,
Through the streets of Madrid."

Al subir las escaleras
Alfonso se desmayo;
Y las tropas le dijeron:
"Alfonso, tened valor,
Alfonso, tened valor."

When climbing the staircase,
Alfonso swooned away,
And the troops said to him,
"Alfonso, have courage,
Alfonso, have courage."

Las luces del palacio
Ya no quieren alumbrar
Porque Mercedes ha muerto,
Y luto quieren guardar.
Y luto quieren guardar.

The lights of the palace,
They do not want to shine,
For Mercedes has died,
And mourning they wish to keep.
And mourning they wish to keep.

Las campanas de la iglesia
Ya no quieren replicar,
Porque Mercedes ha muerto
Y luto quieren guardar
Y luto quieren guardar.

The bells of the church
They do not want to ring
For Mercedes has died,
And mourning they wish to keep.
And mourning they wish to keep.

Mambru

The ballad of Mambru—an Hispanicized rendition of
Marlborough—travelled all the way in time and space to Key West
by way of Cuba from seventeenth-century Spain, where it was sung
to ridicule the military forays of the first Duke of Marlborough,
John Churchhill (1650–1722), on the European continent.

In Florida it has been sung as a children's ring game, in which
all join hands and circle, until they reach the refrain *"que do, re,
mi,"* at which point they stop and clap in time with the refrain.
With each new verse they join hands and resume circling.

English translation, minus refrains after first
verse:

En Francia nació un niño,	In France there was born a boy.
¡Que dolor, que dolor, que pena!	What sorrow, what sorrow, what pain!
En Francia nació un niño	In France there was born a boy,
De padre natural.	Of a natural father [out of wedlock]
Que do, re, mi,	What do, re, mi,
Que do, re, fa,	What do, re, fa,
De padre natural.	Of a natural father.
Por no tener padrino,	For not having a godfather.
¡Que dolor, que dolor, que pena!	What sorrow, what sorrow, what pain!
Por no tener padrino,	For not having a godfather,
Mambrú se ha de llamar.	Mambru had to cry.
Que do, re, mi,	
Que do, re, fa,	
Mambrú se ha de llamar.	
Mambrú se fue a la guerra,	Mambru went off to war,
¡Que dolor, que dolor, que pena!	What sorrow, what sorrow, what pain!
Y no sé quando vendra.	And didn't know when he would return.
Que do, re, mi,	
Que do, re, fa,	
Y no sé quando vendra.	
Por ahí viene un paje,	Here comes a messenger,
¡Que dolor, que dolor, que pena!	What sorrow, what sorrow, what pain!
Por ahí viene un paje.	Here comes a messenger,
"¿Que noticias traerá?"	"What news do you bring?"
Que do, re, mi,	
Que do, re, fa,	
"¿Que noticias traerá?"	

La noticia que trae	The news that he brings
¡Que dolor, que dolor, que pena!	What sorrow, what sorrow, what pain!
La noticia que trae:	The news that he brings:
"¡Mambrú se ha muerto ya!"	"Mambru has already died!"
Que do, re, mi,	
Que do, re. fa,	
"¡Mambrú se ha muerto ya!"	
La caja de terciopelo.	The box of velvet,
¡Que dolor, que dolor, que pena!	What sorrow, what sorrow, what pain!
La caja de terciopelo,	The box of velvet,
Y la tapa de cristal,	And the top [or cover] of crystal.
Que do, re, mi,	
Que do, re, fa,	
Y la tapa de cristal.	
Y encima de la tapa.	And out of the top,
Un pajarito va.	A little bird went.
Que do, re, mi,	
Que do, re, fa,	
Un pajarito va.	
Cantando el "pio pio."	Singing "pio pio"
¡Que dolor, que dolor, que pena!	What sorrow, what sorrow, what pain!
Cantando el "pio pio,"	Singing "pio pio,"
Y el "pio pio pa."	And "pio pio pa."
Que do, re, mi,	
Que do, re, fa,	
Y el "pio pio pa."	

I have no idea whether it originated in Spain centuries ago, or in Key West in modern times, but I distinctly remember hearing on the island another verse which went like this:

Added Key West verse:

Mambrú se fue a la guerra	Mambru went off to war,
Montando a una perra;	Mounted on a bitch;
¡La perra se cayó,	The bitch fell over,
Y Mambrú escocotó!	And Mambru was knocked out!
¡Que dolor, que dolor, que pena!	What sorrow, what sorrow, what pain!

Games

Al Ánimo

In place of "London Bridge"—to which they related not at all—
Key West Cuban children played one of their own. *Ánimo* can
mean thought, mind, spirit, energy. In the song, it merely serves to
provide lyricism, rhythm. The game is similar to "London Bridge."

Al ánimo, al ánimo, la fuente se rompió, The fountain broke,
Al ánimo, al ánimo, manda la a componer. Send it to be fixed.

Al ánimo, al ánimo, no tenemos dinero. We have no money.
Al ánimo, al ánimo, nosotros le daremos. We will give ourselves some.

Al ánimo, al ánimo, ¿con que se hace el dinero? With what can we make money?
Al ánimo, al ánimo, con cascaras de huevo. With egg shells.

Ur-i, ur-i, ur-a, Hurray hurray, hurray,
La reina va a pasar. The queen is passing by.
La de adelante corre mucho, The one in front runs much,
Y la de atras se quedara! The one behind will stay there!

Heal, Heal

Sana, Sana

This is a rhyme that a mother recites to a child who comes to her
with a hurt finger.

Sana, Sana, Heal, heal,
Sana, sana. Heal, heal.
Culito de rana. Little frog's ass.
Si no sana hoy If it doesn't heal today
Sanara mañana. It will heal tomorrow.

The Butcher Shop
La Carniceria
A tickling game, in which the parent begins at the child's wrist, and on up the arm until the armpit is reached, at which point the tickling begins in earnest.

¡Cuando vayas a la carniceria,	When you go to the butcher shop,
No me traigas carne de aquí,	Don't bring me meat from here,
Ni de aquí, ni de aquí, ni de aquí,	Nor from here, or here, or here,
Sino de aquí, de aquí, de aquí!	But from here, here, here!

Pipi the Rooster
Pipi Si Gallo

This is a little game played with children. At the last line, the parent pinches the hand of the infant, in imitation of a pecking rooster.

Pipi si gallo,	Pipi the rooster,
Montando a caballo;	Riding a horse;
Quita la mano	Take away your hand
¡Que te pica el gallo!	Or the rooster will peck!

Little Rooster
Pollito
This little rhyme is recited by the mother in teaching her child to twist his or her hand from side to side.

El pollito de la vecina	The little rooster of the neighbor
Que asadito sabe a gallina.	When broiled tastes like chicken.

Little Girl
Mozita

In the following cradle game, the mother teaches the infant to tap itself on the head.

> *Azotate, la mozita,*　　　　　　Little tap, little girl,
> *Con la mano en la cabecita!*　　With your hand on your little head!

Folktales

The folktales that follow were all being told to the Cuban children in Key West and Tampa in the 1930s, after travelling all the way in time and space from Old Spain to Florida by way of Cuba. Hopefully, many of them are also known to the children of Florida's more recent immigrations from Cuba and Mexico. Just as "Jack and the Bean Stalk" and Mother Goose rhymes have proven to be an enduring part of the British contribution to the mainstream North American heritage, so are the stories here to be found throughout the Spanish-speaking Western Hemisphere.

None of these tales or characters were born in the New World like Paul Bunyan or John Henry; however, the likes of Cantinflas, the Chaplinesque comedian from Mexico; the "Itching Parrot," irrepressible journalist of Argentina; and Che Guevara, the martyred freedom fighter from Cuba, are doubtless headed that way.

Brother Rooster and Brother Rat

Brother Rooster invited Brother Rat to go with him and pick nuts. Upon reaching their destination, they were undecided about which of them would pick the nuts from the trees and which would stay on the ground and pack them into the bag.

Finally Brother Rooster was elected to climb the tree and pick the nuts. Brother Rooster started picking the nuts and throwing them down to Brother Rat. As fast as Brother Rooster threw down the nuts, Brother Rat cracked the nuts, eating the kernel and placing the empty shells into the bag. When he had filled up the bag with empty shells, he called up to Brother Rooster to come down.

When Brother Rooster came down he decided to eat a couple of nuts. However, when he opened the bag and found only empty shells, he became so furious that he pecked Brother Rat's eye out.

Brother Rat was left with only one eye. As he was going down the road he met Mr. Dog and asked him if he would give him some hair to cover the eye which Brother Rooster had pecked out. Mr.

Dog said, "I cannot give you some hair unless you bring me some bread." Brother Rat asked, "Where can I get some bread?" Mr. Dog said, "Go to the bakery."

So Brother Rat went to the bakery and asked the baker to give him some bread to give to Mr. Dog so Mr. Dog would give some hair to cover the eye that Brother Rooster had pecked out.

The baker said, "I cannot give you some bread unless you bring me some wood." Brother Rat asked, "Where can I get some wood?" The baker said, "Go to the forest and the forest will give you some wood."

So Brother Rat went to the forest and asked the forest to give him some wood to give to the baker so the baker would give him some bread to give Mr. Dog so Mr. Dog would give him some hair to cover the eye that Brother Rooster had pecked out.

The forest said, "If you go to the blacksmith and get an axe you can have some wood."

So Brother Rat went to the blacksmith and asked him for an axe to cut some wood from the forest to give to the baker so the baker would give him some bread to give to Mr. Dog so Mr. Dog would give him some hair to cover the eye that Brother Rooster had pecked out.

So the blacksmith gave him the axe. With the axe he went to the forest and chopped some wood. He carried the wood to the baker. The baker gave him some bread. He carried the bread to Mr. Dog. Mr. Dog gave him some hair, and he covered the eye that Brother Rooster had pecked out.

The Fox and the Raccoon

Once upon a time a raccoon was walking in the forest and encountered a fox. The fox had not eaten for a long time, and was very hungry. When he saw the raccoon he thought it would make a good meal.

"I am going to eat you," the fox said to the raccoon.

The raccoon was very upset, and said to the fox, "I know you are going to eat me, but before you do, I want to make you a bet."

"And what is it that you want to bet?" the fox replied.

"We will run a race, and if you win, you eat me; but if I win, you will let me go free."

The fox, knowing that he could run much faster than any raccoon, agreed.

The raccoon was married and said he wanted to go see his wife one last time before being eaten. In this way he got the permission of the fox, and went to see her. He told her everything that had happened. He was very sad, because he knew he was going to be

eaten, and he wanted to go on living with his wife. She started
to think and came up with a plan. She told her husband to run
the race in a cornfield, which was tall, and to hide along the way
and she would be hiding at the other side, and just before the fox
arrived at the end she would stand up, and he would think he had
lost the race.

And so the race began. The fox was far ahead, but just before
he reached the end, the raccoon's wife raised her head. The fox
could not believe he had lost. So he insisted on racing again. The
very same thing happened again. The fox went crazy. He insisted
on racing five more times. But each time there was always the
same result. The fox was so sick to his stomach that he spit up the
entrails of an animal he had eaten earlier.

When the raccoon came along and saw the bloody entrails, he
picked them up and wrapped them around his waist, making it
look like they were his own. When the fox saw him he felt so sorry
for him he decided not to eat him after all. In fact, he was so sorry
for him he offered to carry him home. So the raccoon climbed on
the fox's back, and sang to himself all the way home, *"Por este
camino tan plano, un cojo llevaba un sano."* (Along this road so
flat, a sick carries a healthy.)

The Evil King

Once upon a time there was a king who was very evil and mean.
One day he woke up in a bad mood and decided to get rid of all old
people in his kingdom. So he sent out his soldiers to cut off their
heads. The soldiers carried out his orders, and all of the old folks
were exterminated—except for one, who escaped to the mountains
and took refuge in his son's house.

When the king heard that there had been a survivor, he sent
his soldiers to the mountains to investigate and verify the rumor,
and if they found it to be true, to kill the man like all the rest. The
soldiers went to the house of the son, and searched and searched,
but in vain, because the old man had been hidden by his son in a
nearby cave. So the soldiers went back and told the king of their
fruitless searching. The king was furious, and ordered that the old
man's son be brought before him. When brought to the palace and
questioned as to his father's whereabouts, the son insisted that he
knew nothing.

The king did not believe him. He ordered him to go out into
the world and find the King of Flowers and bring him to him, or
he would be beheaded. He returned to his house and told his wife
what had happened. The son was very sad, and decided to go to his
father's hiding place and tell him what had happened. When he did

so, his father told him not to worry, for he knew where the King of Flowers could be found.

Following his father's instructions, the youth searched and found the King of Flowers, and took it to the king. The king was very surprised. He was in fact furious, and did not believe that the young man could have done it on his own, but must have had the help of a wise old man. The young man insisted that he had done it all by himself, but the king was certain that he was lying. And so the king ordered him to go out and find the King of Birds and bring him to him within a certain time, or be executed.

The young man went back to his father and told him what had happened. As before, the old man was able to tell his son where to find the King of Birds. He did so, and took him to the king within the allotted time. Again the king was furious and unwilling to believe that the youth had performed the task alone. So he gave him a third assignment: to report to the palace on the following day, and to be inside and outside of it at the same time.

This was difficult, but the young man trusted his father's wisdom and went to his side explaining the king's desires. The old man told him how to do it. The young man went in the morning and attached himself to the roof of the palace with a rope. He started to swing in and out of the main entrance. The king marveled to see him go in and out at the same time. Not being satisfied with this, the king told him to return the next day with his wife and dog. When they arrived at the palace, the king gave the young man a whip and told him to whip the dog until the dog would tell the king where the old man was. But the dog was as trustworthy as always. Then the king told him to hit his wife. After a while she confessed where the old man was.

Once the old man faced the king, the king placed his hand over the old man's shoulders, convinced that the old man was intelligent since he had raised a young man to such perfection. The king felt bad about what had happened, forgave the old man, then let him go back with his son, daughter-in-law, and dog to the farm, where they lived happily ever after.

The Little Rabbit

Once upon a time there was a little rabbit that would not obey his mother. One day she said to him, "I have to go out today, but I want you to stay in the house." Disregarding his mother's words, the moment his mother left, the little rabbit ran off down the street to the woods he had decided to explore.

"Plin, plon, plin, plan, plan, plin," his little feet sounded on the ground. At last he decided to go home, but he was lost. "Plin,

plon, plin, plan, plan, plin," the little rabbit hopped from one place to another, but could not find his way home.

Very soon night came, and the poor little rabbit did not know what to do. Suddenly he saw a light in the distance. How happy he was! He thought it was his house, so he went toward it. But how disappointed he was when he discovered that the house was not his. The door was open, so he went through it into a room. He was so tired he immediately fell asleep on the floor.

Some time later, a witch came in. Her hair hung down over part of her horrible face. Her nose looked like the beak of an owl. Her eyes were like those of a crab.

"Hah, hah!" laughed the witch when she saw the pretty little rabbit asleep on the floor. At the sound of her laughter, the little rabbit awoke.

"What are you doing in my house?" the witch cried out.

"Noth-noth-nothing!" the poor little rabbit said.

"Well! I must punish you for daring to come into my house," said the witch. "I would eat you with pleasure, if I hadn't already had a big meal."

Then she picked up a stick and touched him with it, turning him into a piglet.

Rooting in the dirt with his snout, and his feet going "pla, pla, pla," he ran off through the woods. This time he came upon the road leading to his house. Arriving there, he knocked on the door. His mother opened it, but when she saw the little piglet going "cru, cru, cru," she grabbed a stick and chased it away. Sad and tired, the piglet went back into the woods.

A hunter came upon him, tied him up and took him to his house where he showed him to his wife, saying, "Look, beloved, what a nice little pig I found for us to eat."

"Very good," she replied, "but it would be best if you took him out to the patio to cut off his head."

And so the hunter took him out, tied him to a tree, and then began to sharpen his axe. All this time the little piglet did not stop trembling. He began to cry for his mama, but the only sound he could make was "cru, cru, cru." Nobody came. When the hunter swung his axe, cutting off the piglet's head, out jumped the little rabbit! Gathering all his strength, the little rabbit ran without stopping, his feet going "plin, plon, plin, plan, plan, plin." When his mother saw him she jumped for joy. The little rabbit, after telling her all that had happened to him, promised to never go out on the street alone again, or disobey her in any way.

The Old Man and the Penny

Once there was an old man cleaning the front steps of a church
and he found a penny. He did not know what to buy with it. He
thought, if I buy an apple, I would have to throw the skin away. If
I buy a peach, I will have to throw the seed away. If I buy a pear, I
will have to throw away the stem. So he decided to buy peas.

He bought a bag of peas for half a cent and laid it against the
fence while finishing his work, but along came a rooster and ate the
peas. When he noticed that the rooster had finished with his peas,
he went to the owner of the rooster and told him that the rooster
had eaten his peas and he would either have to give him back the
money or the rooster. But as the owner of the rooster was a poor
man and could not give him money, he had to give him the rooster.

When he got the rooster, he went to his home and there he
started dressing the rooster to eat it. As he was setting the table
a dog came into the kitchen and ate the rooster. So he went to
the owner of the dog and told him what the dog had done and
demanded either the money for the rooster or the dog, so the
owner, not being able to pay for the rooster, decided to give him the
dog.

This time he wanted vengeance so he put the dog in a sack and
walked towards the river where he dumped the dog, but the dog
got out and ran back to his master. Not being satisfied, as he had
not been able to drown the dog, he went to the owner again and
demanded that he must have the dog; that it had run away from
him. This time, the son of the owner of the dog, loving the dog as
he did, put himself inside the sack and when the man had walked
to the river he thought he would take the dog out of the sack and
tie him so that he could not swim out. But to his surprise, when
he opened the sack, he found the little kid inside. Of course he
could not do this to the kid, so he let him go and, seeing that every
attempt was impossible, decided to buy another bag of peas with
the other half of the penny he had left.

Master Giuseppe's Prize Pig

Master Giuseppe had a prize pig. One day he found he was short
of funds, so he decided to take his pig and sell it at the fair. On
the way to the fair he stopped at a convent where he met a priest.
The priest admired the pig very much, and asked, "Where are you
going with that fine donkey?" Master Giuseppe replied that it was
not a donkey, but a pig. The priest, however, insisted that it was a
donkey. Master Giuseppe told the priest that, if he could prove it
was a donkey, he would give it to him. So the priest called several
other priests to decide and they all agreed that it was a donkey, so

Master Giuseppe lost his prize pig.

When he returned home and told his wife what had happened she was very angry. But together they thought up a scheme. Master Giuseppe disguised himself as a doctor, and went to the convent and asked for shelter. It happened that the priest who had deprived him of his pig was very ill, so Master Giuseppe was asked to attend him. He agreed, and told the other priests that if they heard the patient shouting during the treatment they should pray for him, as he would be healing. So he locked himself in a room with the sick priest and began beating him with a stick. The priest began to shout and his brethren began to pray. As Master Giuseppe wielded the stick, he kept asking, "Was it a pig or a donkey?" At last he opened the door so the other priests could hear the sick priest reverse his decision. Then Master Giuseppe took his pig back home and decided to eat it instead of selling it.

Miss Martinez Cockroach and Mr. Perez Mouse

Once upon a time Miss Martinez Cockroach was sweeping the floor of her house when she found a nickel. "What can I do with this nickel?" she said. "If I buy candy, I will soon eat it and then I will have no more. If I buy bread, I will soon eat it. If I buy a cake, I will soon it eat it. Oh my, what will I do? I know. I will buy me some flour!"

So she went to the grocery store and bought herself some flour. Then she dug herself into the flour and came out white all over. Then she seated herself on the porch. Pretty soon Mr. Goat came along. "How beautiful you are Miss Martinez Cockroach!" said Mr. Goat. "Do you want to marry me?"

"Yes," said Miss Martinez Cockroach, "but how do you do?"

"Baa-baa," said Mr. Goat.

"Oh no! You frighten me," said Miss Martinez Cockroach. So Mr. Goat went away.

Pretty soon Mr. Cow passed by. "How beautiful you are, Miss Martinez Cockroach! Do you want to marry me?"

"Yes," said Miss Martinez Cockroach, "but how do you do?"

"Moo-moo," said Mr. Cow.

"Oh no! You frighten me." So Mr. Cow went away.

Pretty soon Mr. Dog passed by. "How beautiful you are, Miss Martinez Cockroach! Do you want to marry me?"

"Yes," said Miss Martinez Cockroach, "but how do you do?"

"Bow-wow," said Mr. Dog.

"Oh no! You frighten me." So Mr. Dog went away.

Pretty soon Mr. Perez Mouse passed by. "How beautiful you are, Miss Martinez Cockroach! Do you want to marry me?"

"Yes," said Miss Martinez Cockroach, "but how do you do?"

"Wee-wee," said Mr. Perez Mouse.

"Oh how good!" said Miss Martinez Cockroach. "I will marry you." So they were married.

One day Miss Martinez Cockroach had to go shopping, so she told Mr. Perez Mouse to watch the stew, but to be very careful and not look inside the pot as he might fall in. When she had left, Mr. Perez decided he would take just one little peep. When he looked inside, the stew smelled so good that he decided he would take one little sip, but when he was going to put in his nose, he fell over and was killed.

After a while Miss Martinez Cockroach came to the house. "Toon, toon," she knocked at the door, but Mr. Perez Mouse did not come to open the door. "Toon, toon," she knocked again, but still no answer. She was getting frightened. "Toon, toon," she knocked louder, but still the door did not open. So she called Mr. Carpenter to open the door. Mr. Carpenter came along with his hammer and crowbar and crashed the door down.

She ran to the kitchen and when she looked into the pot she saw Mr. Perez Mouse dead in the pot. So she seated herself on the porch and commenced to sing:

Pobre ratoncita Perez	Poor little rat Perez
Cayo en la olla,	Fell in the pot
Por la golocina	For the love
De una cebolla.	Of an onion.

The Monkey Who Sold His Tail

Once upon a time there was a little monkey and he decided to have a little fun. So he went to the barber shop and stole a pair of scissors. Then he cut off his tail into small pieces and made some *chicharones* (fried pork skins). He placed them in a basket and went out into the streets singing:

Chicharoncitos vendo yo	*Chicharoncitos* I sell
Muy sabrosito.	Very delicious.

Soon a man called him over and purchased a nickel's worth. Many others bought this crackling meat, until he had none. So then he seated himself on top of a pole and started to sing:

Chicharoncitos *Chicharoncitos*
Han comido They have eaten
De mi rabito. From my little tail.

When the people heard this, they became furious and chased the little monkey all over town, throwing bricks at him.

The Little, Little Hen

Once upon a time there was a little, little tiny woman who lived in a little, little tiny house.

Her furniture was little, little.

She had in her little, little tiny garden a little, little tiny hen.

One day the little, little tiny hen laid a little, little tiny egg.

The tiny, tiny little woman took the little tiny, tiny egg and made a little, little tiny cake that she put in her little, little tiny refrigerator to cool it down.

Around the little, little tiny house, there was a little, little tiny thief who had seen the tiny, tiny little woman put the little tiny little cake in the little, little refrigerator.

When the tiny, tiny little woman went to take a little tiny, tiny nap, the little, little tiny thief opened the tiny, tiny little refrigerator and ate the tiny, tiny little cake, and took the tiny, tiny little hen that used to lay the tiny, tiny little eggs.

Ésta historia ha termindado This story has finished
y la tuya no ha empezado. and yours has not started.

The Girl Who Turned into a Fig Tree

Once upon a time there was a beautiful little girl who had a stepmother, who was very mean. One day when the stepmother went out, she left some figs on the table and told the little girl not to touch the figs. However, the little girl was so hungry that she ate one fig.

Pretty soon the stepmother came back and when she looked at the figs, she said, "There is one fig missing. Now you must die." So she killed the little girl and buried her in the yard.

When the father came home, he said; "Where is my little daughter? I do not see her."

But the wicked stepmother said, "Oh, she went out to the woods."

When the father was seated at the table, he happened to look out of the window, and saw a beautiful fig tree growing in the yard. "Oh what a beautiful fig tree," said the father. "Go and bring

me that big fig, for I want to eat it. So the stepmother went out to the tree, but when she was about to pull the fig, she heard the stepdaughter singing:

Mamaita, mamaita, no me arranques mi cabello,
Que tu mismo me has matado
Por un higo que ha faltado.

Mama, mama, do not pluck my hair,
For you have killed me
For a fig that was missing

The stepmother was so frightened that she ran back into the house. So the father said, "I will go and pick the fig myself." When he was about to pull the fig, he heard the beautiful voice of his daughter singing:

Papaito, papaito, no me arranques mi cabello,
Que mi madre me ha matado
Por un higo que ha faltado.

Daddy, Daddy, do not pluck my hair,
For my mother has killed me
For a fig that was missing.

The father became so incensed that he went into the house and threw the wicked stepmother away. Then he unburied his daughter, and they both lived very happy ever after.

Tales of Quevedo
Throughout the Spanish-speaking world, Quevedo is the equivalent of the U.S.A.'s Paul Bunyan and John Henry and Florida's Old Pete and Daddy Mention. Whereas Bunyan was a lumberjack in ten-league boots, John Henry a railroad roustabout who refused to let the steam hammer get him down, Old Pete a Tampa longshoreman who could outbutt a billy goat, and Daddy Mention a chain gang escape artist who could outrun the longest shotgun, Quevedo was a grand rascal who had a way with women, especially royal ones.

Tales of Quevedo, risqué as they tend to be, have always been the stock-in-trade of Hispanic storytellers in Key West, Tampa, Miami, and wherever Spanish-speaking peoples have settled in Florida. During the middle of the twentieth century, in fact, there was a group of Hispanic students at the University of Florida in Gainesville who banded together in a club that they called *Los Picaros de Quevedo* (The Rascals of Quevedo).

Like almost all folk heroes, Quevedo was once a real-life character, whose full name was Francisco Gomez de Quevedo y Villegas, born near Madrid about 1580. The Quevedo family was one of the most influential in Spain during the Spanish Golden Age. Francisco's father was a royal secretary and his mother was the queen's maid.

Quevedo studied under the outstanding cultural leaders in Spain, but as he grew older he left the court and lived among the common people. He became a prolific writer of satiric essays and verse, which were critical of the regime and the nobility. For this he was frequently thrown into prison, where he produced some of his best works.

Quevedo the folk character has been greatly vulgarized, but he is still recognizable as a hero of the common people who dared to criticize the rulers of Spain. The innumerable tales that perpetuate his memory after more than four centuries are to be heard in Spanish-speaking communities the world over. Small pulp booklets of these tales were published illegally in Cuba and smuggled into the Florida Latin colonies, giving new life to the Quevedo tradition.

Most of the tales portray Quevedo as a cunning rogue who took great pleasure in outwitting the king and queen, doing impossible deeds, displaying his prowess with women, and artfully escaping from any predicament. The following stories are illustrative of these themes:

Once upon a time the King ordered that Quevedo be executed. So Quevedo was thrown into prison. At last the day set for his execution arrived. Quevedo asked that the king allow him to choose the manner in which he should die. The king replied that since he was to die one way or another he would grant him his wish. So Quevedo requested that he be allowed to die of old age. The king had given his word, so he had to let Quevedo go free.

Another time Quevedo happened to see the princess driving past in her carriage. He immediately fell in love with her and resolved to meet her. Having heard that she was very fond of eating black beans, Quevedo, with his customary cunning, went to the palace and was introduced to her. He told her that his name was Frijolito (little black bean).

Then one night he invited her to have some beans, which he said were exceptionally good, and she accepted. Quevedo, who was a natural-born rascal, entered her room, which adjoined that of the queen. Without a moment's hesitation he made advances to the princess and she began to cry for her mother.

"Mother," she called, "Frijolito is hurting me. Frijolito is hurting me terribly!" But the queen, not realizing what was taking place, replied, "You certainly deserve it! I've told you many times not to eat frijolitos."

The only time Quevedo was ever fooled was when he met two girls who slept on the second floor of their father's house. They promised Quevedo that at midnight, when everyone else was asleep, they would lower a large basket on a rope, and thereby hoist him to their room. Promptly at midnight Quevedo was under their window. The girls let down the basket, and Quevedo climbed in. Then the girls hauled him up until the basket was midway between their window and the ground; then they tied the rope and left him hanging there. In the morning all the passersby mocked Quevedo, and when one of them asked him what he was doing, Quevedo replied: *"Ni subo ni bajo; siempre estoy quedo."* (I neither go up nor down; always I am motionless.)

The Conch Diaspora

Last Redoubt of the Flower Children

Key West was made to order for the Flower Children who made
such a splash all across America during the 1960s. The hippies
rejected many of the values cherished by their ancestors, such
as the rat race, money-grubbing, Horatio Alger success stories,
success equated with affluence, bathing at least once a week, etc.
While rejecting the Old Order, they failed to come up with anything
precise in the way of a new one, except that it should be simplistic
and in tune with Mother Nature. When they stumbled upon Key
West, the Flower Children knew they had found their natural
habitat and those who have followed in their footsteps have made
Key West their home.

 The best time to see them was when they gathered along the
waterfront at Mallory Square to worship the sunset. Sunset on the
Keys is seldom anything less than spectacular, so its worshippers

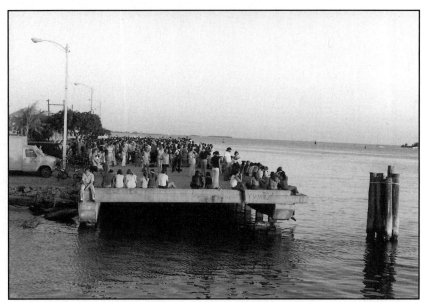

A 1960s hippie sunset celebration down at the waterfront.

were seldom disappointed. As the last rays dissolved into the long Keys twilight there was reverent silence. Then, in full regalia, they made music, sang, danced, chanted, smoked, meditated, and anything else they could think of short of self-immolation.

Throngs of tourists and townfolks became converts and joined the crowd. Since sunset coincides with happy hour, it was all very good business for Sloppy Joe's and all the other area watering places. The worshippers wandered about with their drinks in paper cups, and cops kept out of sight.

In addition to the sunsets, an added attraction was the rumor that some of the damsels got topless. It didn't always happen—but neither does the sunset (on those few cloudy days). But the crowds kept coming as an act of faith.

The tale is still told of "the biggest pot blast ever." It seems that the Navy decided to burn some three hundred tons of confiscated marijuana on the nearby isle where the city dumps its garbage. A big black cloud of smoke spread out over the waterfront.

When the word went out that it was pure pot, not just the Flower Children but much of the general population

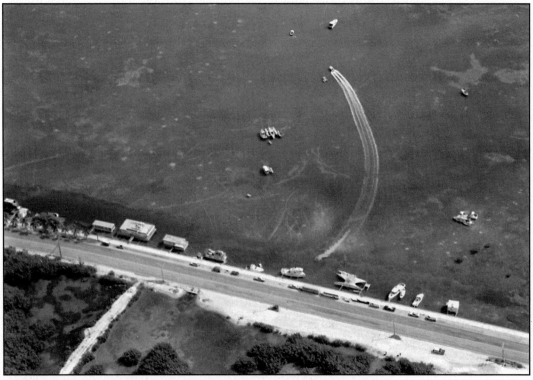

"Hippie Row" of dilapidated houseboats docked alongside south Roosevelt Boulevard. This was a happy hippie solution to the high cost of rent, until the City Fathers forced them to take their nudity elsewhere.

commandeered anything that would float, and floated into the cloud. Whether they inhaled normally or took deep breaths, much of the city was soon wafting hither and yon on Cloud Nine.

For quite some time the Flower Children solved the high cost of housing by living on makeshift houseboats anchored at the north end of Simonton Street. When landlubbing residents complained about nudity, the colony moved to Christmas Tree Island, farther offshore.

Nowadays, instead of going down to the docks to meet incoming ships from Cuba and Tampa, Key Westers have adopted the Flower Children's custom of going down to the docks to worship the sunset. Where there is a will to get together, people will find a way—and who can say that one is better than another?

Of Hermit Crabs and Conchs

The anomalous mix of traditional Cuban, Bahamian, and Afro elements that was Key West has been increasingly submerged by the influx of tourists and other "strangers," including a thriving gay community and spiritual children of the flower-children hippie generation of the 1960s. The net result is a far cry from the Key West of yore, but, for better or worse, there is no denying its vibrancy.

The prognosis for Key West's unique amalgamated culture, as reflected in this book and in Mario Sanchez's paintings, is not good. If we compare its prospects with the fate of that other once-thriving Florida Latin community, Tampa's Ybor City, we find that the latter has undergone both a physical and cultural dispersion into the American mainstream. And yet the Tampa Bay area telephone directory is replete with tens of thousands of names of Cuban, Spanish, and Italian origin—which attest that the genes are still there, and proliferating as of yore, even though their cultures and institutions are much more difficult to find. Within family circles some traditional ways have survived, but among the younger generations English has long since triumphed over all.

The Latin community that existed in Key West, and its clone in Ybor City, were once just as vibrant as that which currently exists in Miami. There, sheer numbers will assure the preservation of Hispanic culture for many generations to come, and perhaps forever. But the traditional Key West cultural scene is akin to countless others worldwide that are on the endangered or vanished lists.

As their sources of livelihoods vanished one by one—and sometimes two by two—Key Westers have always adjusted as best they could.

Piracy was bad for business, so once business gained the upper hand, piracy had to go. Wrecking was likewise bad for business, so warning lights were installed on the reefs, and the steamboats that took the place of sail were able to steer clear, fair weather or foul. Rumrunning came to an abrupt end when newly elected President Franklin D. Roosevelt made good on his promise to repeal Prohibition.

Sponging got hit by a blight and the invention of synthetic sponges. Fishing found the bounteous sea, for all its fecundity, unable to keep up with an expanding global appetite for seafood of every description. And then came "progress" in the form of high-tech fish-finders and ship-to-ship radio for summoning the entire fishing fleet, and finally toxic destruction of the food chain.

Cigarmaking on The Rock was first hit by fire, and then came the City Fathers of Tampa, with promises of cheap land, low taxes, and union busting if the factories would come unto them. And so they did.

Defense jobs at armed forces installations on The Rock, abundant whenever there were wars or rumors of wars, came to an end in 1974 after air power and intercontinental ballistic missiles robbed the "Gibraltar of the Gulf" of its strategic significance.

Tourism held forth the promise of "good jobs for all," but rich folks bid poor folks out of house and home, and rent rose so high that to work in Key West you have to commute from Big Pine Key or Marathon, about an hour away.

Cultural anthropologists have not yet examined the phenomenon in any depth, but there is such a thing, as the Keys demonstrate, as cultural genocide by taxation. Space to live on The Rock was not at a premium until the invasion by people with too much money and no need to work for a living. Their bidding for a place under the Keys sun at any price drove property values sky-high in short order. Keys natives began to be presented with tax bills based on property valuations in the $400,000 and $500,000 range for cottages they had purchased for a few thousand.

An update of the scope of the problem was written by Carol J. Williams and published in the *Los Angeles Times* in 2008. This account begins with the story of Millie Bringle, a sixth-generation Conch, and her husband. The two had to hold down four jobs in order to make the payments on a tiny house they built on a trailer lot. The amount of the mortgage: $450,000. They lost their home, got a divorce, and left Key West.

They were just two of the two thousand workers who had left Monroe County since the 2000 census. It is a county of only 75,000 residents, but 2,250,000 overnight visitors per year. On the one

hand, the county has a thirty-eight percent vacancy rate, but at the same time, rental of a one-bedroom apartment may start at $1,600 per month. Many working households have to spend up to fifty percent of their income on housing. And mobile homes offer no solution—2,400 of them have been obliged to leave the Keys since 1990.

Money talks, but megabucks dictate. There was really nothing most Key Westers could do but leave homes, sea, sun, breezes, memories, and gravestones and go off as exiles into a strange world in search of shelter they could afford.

Once the Conch (meaning Key Wester) Diaspora got under way, where did they go? Many are to be found in—of all places—Ocala, located in central Florida north of the frost line. They could not take the sea with them, but they did take along such necessities as Cuban bread, Cuban coffee, yellow rice, plantains, and black beans. Periodically, when they get really homesick, they send to Key West for a Cuban band—or visit The Rock for a "Conch reunion."

They find that most of the landmarks and homes they left behind are still there, albeit glamorized by paint and gardens almost beyond recognition. But the people they knew are for the most part gone. What was once their town is now occupied by "strangers"—as they used to call all mainlanders.

Nonconformists themselves, the Key Westers could have taken the hippie and gay incursions in stride. No problem. Live and let

Signs of the times.

live. But the rich folks wouldn't let them live—analogous to the manner in which the hermit crab takes over any available Conch shell it encounters.

What Future on the Rock?

When speaking at the 1987 Key West Literary Seminar, the author asked the audience, "If we can't save the Key Wester, can't we at least save the Key West dog?"

Everybody laughed, thinking I was just kidding. But I was not. I don't propose closing Key West's borders to all stranger canine breeds, but we could bring in some Labrador and Newfoundland retrievers to augment the dwindling gene pool of that unique Lab-Newfoundland mix brought in by seafarers long ago.

But there is much more to the Key West legacy than the dog. Thanks to the Historic Florida Keys Preservation Foundation and other caring groups, structural Key West has been largely preserved, even though the human beings who built and occupied those structures are gone. It was as though The Rock had taken a direct hit from one of those new-fangled bombs, which wipe out all life but leave the buildings standing and ready for the new occupants to move in.

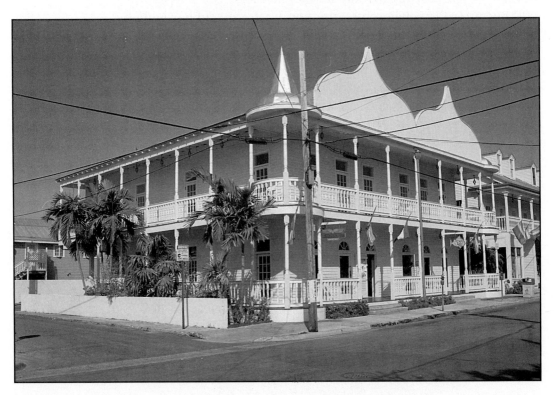

The Cuban Club following its transformation into a restaurant and gift shop.

But the legacy of Key West does not just consist of sticks and stones either. The need, as I see it, is for the establishment of a Key West Cultural Restoration Commission to flesh out the work of Historic Florida Keys Preservation Foundation. It would not take much to recapture the ambience of the old Key West by bringing back some of the island's most memorable institutions, characters, sights, sounds, tastes, and smells (careful about the latter). This could be a joint venture by both the public and private sectors— and there could be money in it, for proprietors and community.

Potential candidates for restoration might include Cuban and Caribbean restaurants, a tropical fruit ice cream parlor, Latin dance bands reminiscent of Havana's Buena Vista Social Club, and aromatic curbside *bollito* stands. Bring back the *piruli* all-day-sucker man, pushcart street peddlers chanting their wares, the *comparza* street dancers, *ñañigo* voodoo dancers, Latin and Bahamian music ensembles, wandering troubadours, barkeeps to push Key West's *compuesta* and *mojito* (the way New Orleans sells its sazerac), and, at parade-time, some of the characters described in this book.

No need to reconstruct a community frozen in time like Williamsburg. Key West is not Williamsburg; but then, Williamsburg is not Key West. The buildings and cultures of Key West, like those of New Orleans and Williamsburg, are a national and global treasure, to be cherished, cared for, and passed on to future generations.

My Thanks

First, to my first wife, Edith Aguilar Ogden, who said yes to me in Key West in 1937 at age seventeen when she should have known better. Although she often implored me to "first write at least one best-seller" before dabbling in things like folklore and civil rights, she and her extended family promptly naturalized me as a Key Wester by marriage, and never tired of my endless questioning about life on The Rock. Her home at 1210 Duval Street was overflowing with Ogdens, two Ogden brothers having married her mother Carmen and sister Rachel, which made for complex relationships between their respective children. Then, and all down through the years, they were all—especially Gilbert, Henry, Norberto, and Alicia and her husband Warren—eager to share with me their knowledge of Key West culture.

While it was Edith and her family who enabled me to put down roots on The Rock, and compile much of the material herein, it remained for my last wife, Sandra Parks, to dust off me and my manuscript some seventy-five years after I started it, and provide countless days and nights of assistance needed to finish it. In addition, we have Sandra to thank for the abundance of photographs, in search of which she drove me to repositories all over Florida, and carried out the tedious task of procurement and integration into the text.

To my dear friend Susan Brandenburg I am indebted for many long hours of poring over faded pages of manuscript, and impeccably retyping the whole onto a computer disk. Without that, Sandra and I would have been hard put to complete the supplementing and editing which has at long last brought the book to full term.

To Anamaria Vasquez, anthropologist/activist and rainforest artist who introduced me to Pacha Mama and teaches children the importance of talking to trees, I am indebted for a quarter-century of comradeship and her professional translation of much of the Hispanic lore herein.

Jill Bowen, my good neighbor and fishing buddy at Lake Beluthahatchee, like Sandra and Susan, more than once beat 911 to the draw when I was in extremis (thus enabling me to finish this book) and, like Anamaria, has served as a living demonstration of what our species could be like if only we would live in harmony with nature.

Special thanks are also due to Claudia Pennington, director of the Key West Art and Historical Society, for making available the bas relief carved art of Key West street scenes created by Mario Sanchez in their possession; and to Nance Frank for also making Mario's art available from her books, *Mario Sanchez: Once Upon a Way of Life* and *Mario Sanchez: Before and After*; and to Mario himself for authorizing me to use his art on the cover of this book.

A major contribution was made by Joan Langley, who made available a number of photographs from the unsurpassed collection put together with her late husband Wright Langley. His photo books on the old Key West and Keys, along with his lengthy career in directing Key West's historic preservation, place him alongside Mario Sanchez as a perpetuator of Key West culture.

Other archivists who have generously assisted in the compilation of photographs include the curator of the Florida Collection at the University of Florida Library; Adam Watson, curator of the Florida Photograph Collection in Tallahassee; the South Florida Historical Museum in Miami; and Tom Hambright of the Monroe County Public Library in Key West. To my lifelong friend Charles Foster I am indebted for permission to use his many splendid photographs of Key West. (Charles was a member of the CCC and the WPA Art Project, and we collaborated on his book *Conchtown, USA*. His mother, Jean Taylor owned the Bahama House in Key West.)

Many thanks to Norman Aberle and especially Brewster Chamberlin, who were kind enough to review the book and offer their insight.

Others who have in various ways propped me up and strengthened my arm while I was engaged in completing this book include my stepdaughter Karen Roumillat, Joanelle Mulrain, Davette Turk, Todd Johnson, and Marina Stone. My heartfelt thanks to all y'all!

Bibliography

Artman, Jr. L.P. *Old Key West Stories.* Key West: L.P. Artman, Jr., 1975.

Browne, Jefferson B. *Key West: The Old and the New.* Facsimile reproduction of the 1912 edition. Gainesville: University of Florida Press, 1973.

Bucuvalas, Tina, Peggy A. Bulger, and Stetson Kennedy, eds. *South Florida Folklife.* Jackson: University Press of Mississippi, 1994.

Caemmerer, Alex. *The Houses of Key West.* Sarasota: Pineapple Press, Inc., 1992.

Castellanos, Gerardo Garcia. *Contribución a la historia de las emigraciones revolucionarias cubanas en los Estados Unidos.* Habana: Úcar Garcia and Ca., 1935.

Cox, Christopher. *A Key West Companion.* New York: St. Martin's Press, 1983.

Frank, Nance. *Mario Sanchez: Before & After.* Key West: Key West Press, 1997.

Frank, Nance and Brewster Chamberlin. *Mario Sanchez: Once Upon a Way of Life.* Key West: Key West Press, 2006.

Frawley-Holler, Janis. *Key West Gardens and Their Stories.* Sarasota: Pineapple Press, Inc., 2000.

Gilfond, M.E. *Key West Under the New Deal.* Key West: Federal Emergency Relief Administration, 1934.

Hambright, Tom and Lynda. *Key West Historic Memorial Sculpture Garden: Key West's 36 Most Influential People & Their Times.* Key West: Friends of Mallory Square, Inc. 1997.

Harrison, Ben. *Undying Love: The True Story of a Passion That Defied Death.* New Jersey: St. Martins Press, 2001.

Kennedy Stetson. "Aventura y Extravaganza de von Cosel," Havana: *Bohemia* magazine, 1939.

Kennedy, Stetson. "Here Hung Isleño, for Living with a Brown." Darien: *Direction* magazine, 1941.

Kennedy, Stetson. *The Key West Historical Pageant: Overseas Highway Celebration*. Key West WPA Writers, Music, Art, Theater, and Recreation Projects. July 2, 3, 4, 1938.

Kennedy, Stetson. "Key West WPA Workers Strike: For Ice Water and More than $6.05 Per Week." *The Nation* magazine, October 1935.

Kennedy, Stetson. "Keys Folk." *South Florida History Magazine*, 1989.

Kennedy, Stetson. "Keys Tour" chapter in *Florida: A Guide to the Southernmost State*. American Guide Series. New York, Oxford University Press, 1939.

Kennedy, Stetson. "Ñáñigo in Florida." *Southern Folklore Quarterly*. Gainesville: University of Florida, v. IV. No. 3, 1940.

Kennedy, Stetson. *Palmetto Country*. American Folkways Series edited by Erskine Caldwell. New York: Duell, Sloan, and Pearce, 1942.

Kennedy, Stetson. *What Makes Mario Great*. Tampa: Ybor City Folk Festival Commission, 1989.

Langley, Joan and Wright. *Key West: Images of the Past*. Key West: Images of Key West, Inc., 1982.

Langley, Joan and Wright. *Key West and the Spanish-American War*. Key West: Langley Press, Inc., 1998.

Langley, Wright, and Stan Windhorn, eds. *Yesterday's Key West*. Miami: E. A. Seemann Publishing, Inc., 1973.

Lomax, Alan. Research, Stetson Kennedy. "South of the South: Key West's support role in WW II." New York: Columbia Broadcasting System, TransAtlantic Call, People-to-People, November 28, 1943.

Little, Lawson, and Sharon Wells, eds. *Portraits: Wooden Houses of Key West*. Key West: Historic Florida Keys Preservation Board, 1991.

Maloney, Walter C. *A Sketch of the History of Key West, Florida*. Gainesville: University Press of Florida, 1968 (facsimile of 1876 edition).

McIver, Stuart. *Glimpses of South Florida History*. Miami: Florida Flair Books, 1988.

Ogle, Maureen. *Key West: History of an Island of Dreams.* Gainesville: University Press of Florida, 2003.

Ortiz, Dr. Fernando. *Los Negros Brujos.* La Habana: Editorial de Ciencias Sociales, 1995.

Porter, Jeane. *Key West: Conch Smiles [A Native¹s Collection of Legends, Stories, Memories].* Key West, Mancorp Publishing: Heritage House, 1999.

Proby, Kathryn Hall. *Mario Sanchez: Painter of Key West Memories.* Key West: Southernmost Press, Inc., 1981.

Rolo, Juan Pérez, *Mis Recuerdos de Cayo Hueso.* 1927(?). (Available at the University of Florida Library, Gainesville, and the Monroe County Public Library, Key West.)

Sawyer, Norma Jean, and LaVerne Wells-Bowie, eds. *Black America Series: Key West.* Chicago: Arcadia Publishing, 2002.

Viele, John. *The Florida Keys: A History of the Pioneers.* Sarasota: Pineapple Press, Inc., 1996.

Wells, Sharon. *Forgotten Legacy: Blacks in Nineteenth Century Key West.* Key West: The Historic Key West Preservation Board, 1982.

WPA Writers' Project. *A Guide to Key West: Compiled by Workers of the Writers' Program of the Work Projects Administration in the State of Florida.* New York: Hastings House, 1941.

Mario Sanchez Art

For Mario Sanchez's depictions of Key West street scenes on the cover and throughout the book, we are indebted to Nance Frank, director of The Gallery on Greene, and to Claudia Pennington, director of the Key West Art and Historical Society. Originals of Mario's art may be viewed at both places. Many thanks to Nance and Claudia for enabling us to make this book such a multidimensional memento of "the Key West that was."

Photograph Credits

Numbers refer to the page number on which the illustration appears.

Copyright © 2008 Ivy Bigbee Photo Restoration/Stetson Kennedy Collection: 90, 94, 95

Carlene Fredericka Brennen: 105

Farm Security Administration: 109

Florida Album, Key West, 1989: 168

Florida State Archives, Florida Photographic Collection: ii, 1, 3, 6, 7, 21, 23 bottom, 26 middle, 28 top, 28 bottom, 29 top, 29 bottom, 31 (Charles Foster photo), 32, 33, 43 top, 43 bottom, 45 top, 45 bottom, 46 top, 46 bottom, 48 top, 48 bottom, 58, 60 top, 60 bottom, 66, 72 (Charles Foster photo), 73 (Charles Foster photo), 74, 108, 114 bottom, 132 top, 134 top, 134 bottom, 135 top, 150, 189, 190, 194, 195

The Estate of Leicester Hemingway: 102

Historical Museum of Southern Florida: 25, 144

Stetson Kennedy: 12, 14, 34, 36, 38, 39, 75, 87 bottom, 193

Stetson Kennedy Foundation: 167

Key West Art and Historical Museum: x–xi, 5, 79

Library of Congress (photo by Arthur Rothstein): 24 top

From *Los Negros Brujos*, Dr. Fernando Ortiz: 140 all

From the collections of The Mariners' Museum, Newport News, Virginia: 18

Monroe County Public Library: 8, 9 top, 13, 26 top, 76, 98, 112 bottom, 126, 131, 153

F. Townsend Morgan, Federal Emergency Relief Administration (FERA) artist: 42 top

FERA collection at the University of Florida: 2 bottom, 4 top (Charles Foster photo) and bottom (Charles Foster photo), 11, 22, 24 bottom, 101, 112 top, 119 top, 124, 132 bottom, 135 bottom

Glenn Westfal Collection, University of South Florida: 35

Courtesy of Clemente Wolf: 63

Wright Langley Archives: 2 top, 23 top left, 23 top right, 26 bottom, 27, 42 bottom, 44, 87 top, 92, 93, 113, 116, 119 bottom, 128, 148, 149

All line art and sketches are by artists sent to Key West in the 1930s by the Federal Emergency Relief Administration.

Index

Page numbers in **bold** refer to illlustrations.

Here are some other books from Pineapple Press on related topics. For a complete catalog, write to Pineapple Press, P.O. Box 3889, Sarasota, Florida 34230-3889, or call (800) 746-3275. Or visit our website at www.pineapplepress.com.

The Houses of Key West by Alex Caemmerer. This book offers a selection of what are probably the most historically interesting, esthetically appealing, and photogenic of the nineteenth-century houses in the Key West historic district. Some are examples of well-known architectural styles, whereas others were completely individually conceived. (pb)

The Streets of Key West by J. Wills Burke. Simonton, Duval, Eaton, Whitehead, Southard, Truman—if you discover how these Key West streets, and all the others, came by their names, you will know much of the history of this little island at the nethermost end of the continental United States. You will learn of the rise and fall and rise again of the fortunes of this island town, which has played such a rich role in the history of the country as a whole. (hb)

Key West Gardens and Their Stories by Janis Frawley-Holler. Sneak a peek into the lush, tropical gardens of old Key West. Enjoy beautiful views of the islanders' sanctuaries as well as fascinating stories and histories of the grounds where the gardens now grow. (pb)

Over Key West and the Florida Keys by Charles Feil. A gorgeous album featuring aerial photographs of islands large and small, glistening waters, and serene communities. Captions provide bits of Keys history. (hb)

Hemingway's Key West, 2nd Edition by Stuart McIver. This vivid portrait of Ernest Hemingway's Key West reveals both Hemingway, the writer, and Hemingway, the macho, hard-drinking sportsman. His Key West years turned out to be his most productive: he finished *A Farewell to Arms*, started *For Whom the Bell Tolls*, and wrote several other books, including *Green Hills of Africa*, *Death in the Afternoon*, and *To Have and Have Not*, as well as some of his best short stories. There was plenty of time left over for eating, drinking, fighting, fishing, chasing women, and hanging out with "the Mob." On the two-hour walking tour, you will explore his favorite Key West haunts. (pb)

Florida Keys Impressions by Millard Wells. Famed watercolorist Millard Wells offers his unique impressions of the Keys, with their blend of Caribbean cultures, interesting architecture, lush vegetation, laid-back attitude, and beautiful tropical marine environment. (pb)

Florida's Great Ocean Railway by Dan Gallagher. The incredible story of the building of the Key West Extension of the Florida East Coast Railway from Miami to Key West from 1905 to 1916, told with clear, engaging text and nearly 250 old photographs, many taken by the engineers themselves and most never before published. (hb)

The Florida Keys by John Viele. The trials and successes of the Keys pioneers are brought to life in this series, which recounts tales of early pioneer life and life at sea. **Volume 1:** *A History of the Pioneers* (hb); **Volume 2:** *True Stories of the Perilous Straits* (hb); **Volume 3:** *The Wreckers* (hb)